MODE 2001 LANDED-GELAND

LAND LAND ED-GE LAND

WALTER VAN BEIRENDONCK & LUC DERYCKE ED.

MERZ

ANTWERPEN OPEN

FLANDERS FASHION INSTITUTE

#2

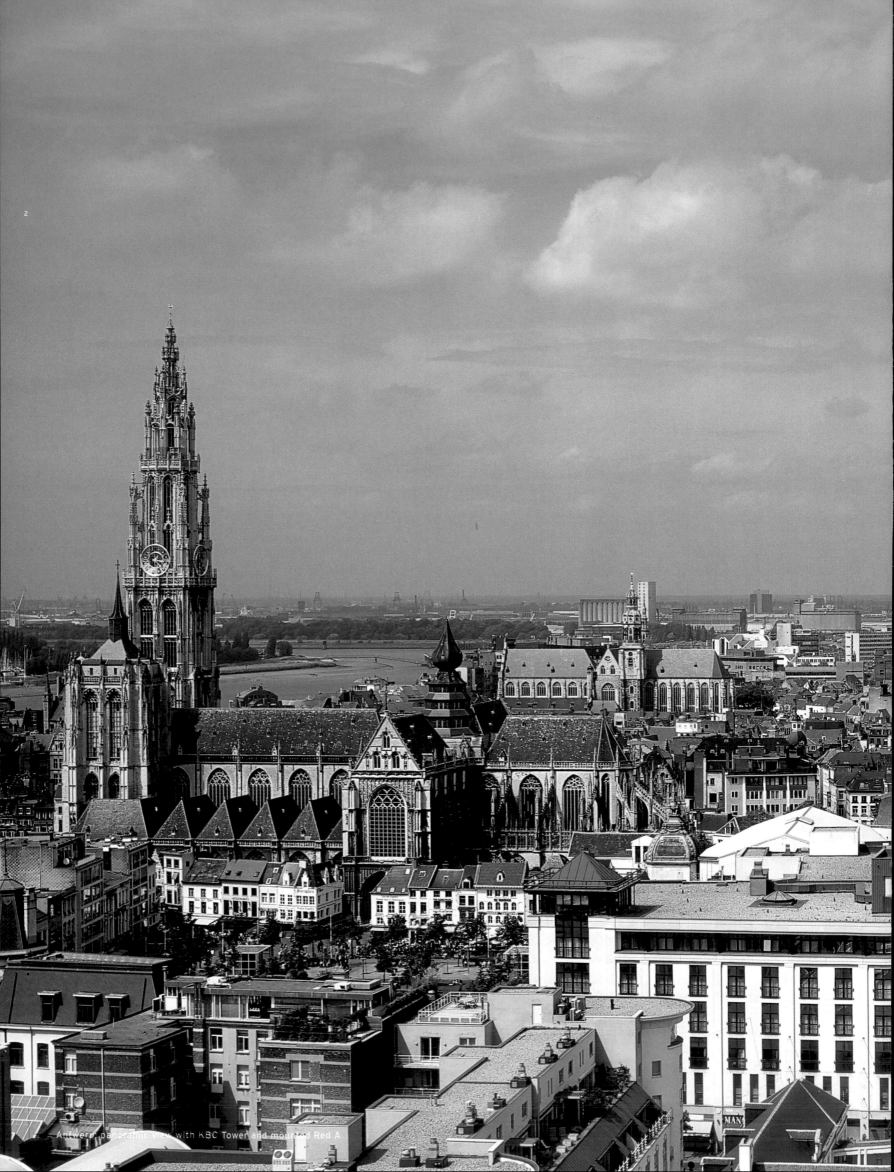

2

Antwerp panoramic view with KBC Tower and mounted Red A

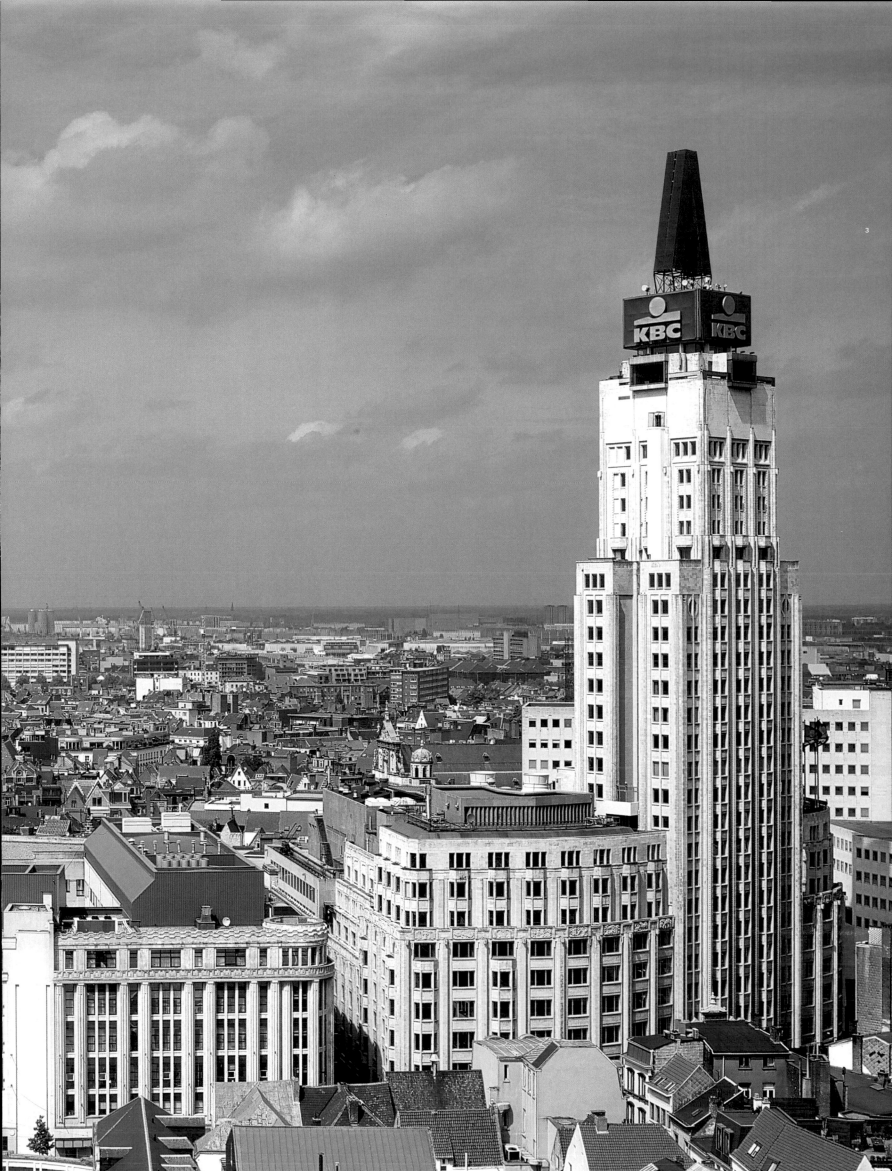

Fluorescent landmark on theatre building

'Why is a museum director standing here and addressing you today? Could it be because the Boijmans Van Beuningen Museum in Rotterdam has shown and purchased work by several 'Antwerp' fashion designers in recent years? Maison Martin Margiela and Walter van Beirendonck showed their 'whims of fashion' there in 1997 and 1998 respectively. Margiela injected a new line with colourful fungi spores, temporarily turning the myth of the Egyptian goddess covered in vegetation into reality. A year later Walter van Beirendonck, in cooperation with the designer Marc Newson and other associates, created a 'Walter shop', where he actually sold his clothes and, for the opening, made changes to the bodies of artist Orlan and many of the museum staff. And more recently we showed magnificent white paper dresses by Dirk van Saene. We are proud that these and other contemporary fashion items are part of the museum's Applied Art and Design collection. Yet there must be another reason why I have been invited to speak here as the official representative of visual art. I can think of only one: that visual art is closely bound up with fashion!

During the course of the twentieth century, visual works of art became visual fetishes. Fashion played a more and more prominent role in that development, as an object and as a story. From the 1920s and the beginning of Surrealism – think of Man Ray – through the Pop Art of the 1960s, with Andy Warhol as the most important protagonist, to the lifestyle events of the 1990s, captured by photographers like Wolfgang Tillmans, fashion has raised its head time and time again in visual art. Did fashion start to colonize visual art with the Paris avant-garde of the 1920s and are we now seeing the final flowering of that process? Or is the visual art of the last century essentially surrealist and is that why fashion had an increasingly important role to play in it?

In a 1997 manifesto about the crisis in art criticism, Olivier Zahm, editor-in-chief of the magazine *Purple Prose*, argued: 'Fashion is the representative model and discourse of the new century. Fashion will begin to take the place of the cinema, the major art form of the twentieth century.' He added: 'Fashion, like the cinema, is characterized by many technical and financial limitations but also knows an almost infinite number of ramifications and mutations. Unlike the cinema, however, fashion is literally and figuratively on our backs. Fashion makes for a kind of permanent revolution.'

Indeed, fashion is the manifestation of new, previously unknown forms of expressing individualization, and in some cases is even a real politicization of the art of living for the individual. 'All the problems of contemporary visual art,' concluded the man behind *Purple Prose*, 'eventually find expression in fashion.'

Seventy years earlier Walter Benjamin, the philosopher and author of *The Work of Art in an Age of Mechanical Reproduction*, had declared in his famous *Passages* that all the problems of art would find their eventual resolution in the cinema. But in the end Benjamin too discovered fashion. He regarded the cinema as the ultimate form of communication for the experiences of modern metropolitan life – the expression par excellence of the new. The commonplace blossomed at once thanks to its portrayal in the cinema. A product or consumer item lives only when it is new. But the new can appear only by the grace of 'what is always the same'. The main thrust of Benjamin's argument is the fetish character of 'what is always the same', which through the 'new' takes on an as yet unknown significance. Walter Benjamin found all that in fashion. Fashion is after all the perpetual rebirth of the new.

Surrealist artists, such as Man Ray, also revered the products of fashion. Their surprising transformations of the everyday and their attribution of unexpected meanings to ordinary objects were a revolutionary experience for Benjamin. Moreover, the fetishization 'of things' by Surrealism corresponded to Benjamin's interest in the new. Fashion as an object and as a social phenomenon played a central role in that context too. Indeed, there will always be objects that are 'out of fashion'. They become independent, they become time capsules, and this reinforces their status as a fetish – like the colours and jewellery of Chanel in a museum display. So now we can better understand the interest of Surrealist artists in ethnographic objects, an interest which is also apparent in the way Walter van Beirendonck approaches fashion. Our own fetishes are coupled with those of others and all the objects are reduced to a particular time! Fashion is BIG SURREALISM and BIG SURREALISM is fashion.

FASHION IS NOT VISUAL ART, BUT VISUAL ART IS CLOSELY BOUND UP WITH FASHION.

With Pop Art, for example with Andy Warhol, we see a surge of interest in fashion. And in their turn fashion magazines begin to show an interest in his representation of fashion and that of others. Andy Warhol's 'economy of attention', which finds expression, for instance, in the endlessly repeated series of pictures of the artist, is moreover a further development of the strategic relationship with 'the new which is always the same'. Visual art should not be afraid of fashion. Visual art has long since made fashion its own. Hopefully you now know why you are being addressed by the director of a museum that is known for collectors' items made by early and contemporary Surrealists: by visual artists like Man Ray, Salvador Dalí, Francis Picabia, Andy Warhol and Richard Prince, but also by fashion designers such as Martin Margiela, Walter van Beirendonck, Dirk van Saene and even by the architect Rem Koolhaas.

In his recent work for the Italian fashion label PRADA, Koolhaas does and says the same as his beloved Surrealists and the Pop Artist Andy Warhol. In imitation of Warhol's 'economy of attention', Koolhaas is working on a new communication and marketing strategy for PRADA with *Luxury is attention* as its slogan. As Koolhaas says: 'When the sound level rises, as in Times Square [isn't that Walter Benjamin we can hear?], the demands on our nervous system redouble as we are compelled to differentiate, to decide, to buy. The ultimate luxury is concentration and clarity.' Koolhaas even makes recommendations that extend to the museum world. 'Museums are popular, not because of their content, but because of their lack of content: you come, you see, you leave. No decisions, no pressure. Our ambition is to hold people's attention...' He cleverly replaces the word 'fetish', however, with 'intelligence' – for Koolhaas realizes that the policy of fetishization should not be allowed to become fetishistic: 'Applying intelligence to an object... is the only way forward... Intelligence is an altruistic gesture, which enhances the value of an object. Intelligence frequently takes the form of innovation but does not need to do so...' Finally he also notes that the new can manifest itself only if things are always the same: 'Change on a massive scale makes stability exciting. If you want to make stability part of a system of systematic innovation (fashion), then use the model of dynamic equilibrium. The more stable the label, the more you change.'

Benjamin – Warhol – Koolhaas: now it is easier to understand the main characteristic that is reserved for the intensification of fashion and media, as expressed in **LANDED**. **LANDED** is a good but hardly radical example – or not radical enough – of the contours mapped by the aforementioned BIG SURREALISTS. There is still a great deal to be done. Today we have just landed. Now it is time to get out and explore. The freedom that characterizes fashion – free, that is, in comparison with the current lack of freedom in visual art, now that the fetishism of the art object has turned against itself – is the opportunity to develop an autonomous cultural system. Even if fashion is subject to great limitations – the limitation of capital, for one – the real paradox affecting it is the need to adapt constantly and at the same time to resist that need, which explains why fashion holds such a great attraction for intellectuals and artists. Moreover, the link between fashion, designers and media designers opens up new opportunities through which fashion can avail itself of new experimental fields and become a vehicle for new aesthetic, technological and conceptual practices. So fashion can take its mediation by the media to extremes. But first and foremost it must strive for a form of aesthetic autonomy which should be interpreted as an effect that relates to the users, the wearers themselves. What challenges lie in store!

The strategy of Walter Benjamin and the tactics of artists like Man Ray, Andy Warhol, Rem Koolhaas and Walter van Beirendonck light the way. Scores of other shining examples from the last century – BIG SURREALISM! – are there waiting for us. They must be brought back to life in the Flanders Fashion Institute. After all, we need to know and understand what has already been done if we are to go forward. Any number of cracks have opened up in Antwerp in recent years to reveal fashion. We have landed and now it's time to get out!

Closing address by **Chris Dercon**, Director of the Boijmans Van Beuningen Museum in Rotterdam, at the opening of FASHION2001 LANDED, **RADICALS** exhibition, Antwerp, 25 May 2001.

View from the Police Tower

Waarom spreekt hier een museumdirecteur? Zou het kunnen zijn omdat het Museum Boijmans Van Beuningen in Rotterdam de afgelopen jaren regelmatig werk van enkele 'Antwerpse' mode-ontwerpers heeft getoond en aangekocht? In 1997 en 1998 toonden respectievelijk Maison Martin Margiela en Walter van Beirendonck er hun 'modekuren'. Margiela injecteerde een nieuwe lijn met kleurige schimmelbacteriën, waardoor de mythe van die Egyptische godin, overwoekerd met plantaardig groen, voor een paar weken in Rotterdam werkelijkheid werd. Een jaar later richtte Walter van Beirendonck, in samenwerking met de ontwerper Marc Newson en andere medeplichtigen, een heuse 'Walter-shop' in. Hij bracht er niet alleen op figuurlijke en letterlijke wijze zijn kleren aan de man en de vrouw, maar sierde bij de opening ook de kunstenares Orlan en vele museummedewerkers met lichaamsveranderingen. En onlangs toonden wij in Rotterdam prachtige witte papieren jurken van Dirk van Saene. We zijn er trots op dat deze en andere hedendaagse mode is opgenomen in onze collectie Kunstnijverheid en Vormgeving. Toch moet er een andere reden zijn voor het feit dat ik hier als officiële vertegenwoordiger van de beeldende kunst mag spreken. Ik kan er maar één bedenken: beeldende kunst heeft voortdurend met mode te maken!

Het beeldend kunstwerk is in de 20ste eeuw veranderd in een beeldfetisj. In die ontwikkeling trad de mode, als object en als verhaal, steeds sterker op de voorgrond. Vanaf de jaren 1920 en het begin van het surrealisme, denk aan Man Ray, over de pop-kunst van de jaren 1960 met als belangrijkste protagonist Andy Warhol, tot aan het lifestyle-gebeuren van de jaren 1990, in beeld gebracht door fotografen als Wolfgang Tillmans, het is telkens de mode die in de beeldende kunst de kop opsteekt. Begon de mode vanaf de Parijse avant-garde van de jaren 1920 aan een kolonisatieproces van de beeldende kunst en zien we daar nu de laatste uitwassen van? Of is de beeldende kunst van de voorbije eeuw in essentie surrealistisch en speelt daarom de mode er een steeds belangrijkere rol in?

In 1997 stelde Olivier Zahm, hoofdredacteur van het magazine *Purple Prose* in een manifest over de crisis van de kunstkritiek: 'Mode is het representatiemodel en het discours van de nieuwe eeuw. De mode zal de cinema, de belangrijkste kunstvorm van de 20ste eeuw, gaan verdringen.' Hij voegt er aan toe: 'De mode wordt, net zoals de cinema, gekenmerkt door vele technische en financiële beperkingen maar kent ook oneindig veel vertakkingen en mutaties. In tegenstelling tot de cinema zit de mode je echter letterlijk en figuurlijk op de huid. De mode zorgt voor een soort van permanente revolutie.'

Inderdaad, de mode is de uitdrukking van nieuwe, totnogtoe ongekende uitingsvormen van individualisering en in sommige gevallen zelfs van een heuse politisering van de levenskunst van het individu. 'Alle problemen van de hedendaagse beeldende kunst', concludeert de bedenker van *Purple Prose*, 'vinden hun uiteindelijke formulering in de mode.'

Zeventig jaar eerder predikte Walter Benjamin, filosoof en auteur van *Het kunstwerk in het tijdperk van zijn technische reproduceerbaarheid*, in zijn beroemde *Passagen*-werk nog, dat alle problemen van de kunst hun uiteindelijke formulering zouden vinden in de cinema. Maar uiteindelijk kwam ook Benjamin uit bij de mode. De cinema was voor hem de ultieme communicatievorm voor de ervaringen van het moderne leven in de grootstad. Hij was de uitdrukking *par excellence* van het nieuwe. Het alledaagse leefde dankzij de uitbeelding door de cinema onmiddellijk op. En een product of gebruiksgoed leeft alleen op het moment dat het nieuw is. Maar het nieuwe kan alleen maar verschijnen bij de gratie van 'datgene wat altijd hetzelfde is'. In de kern van Benjamins betoog is het fetisj-karakter opgesloten van 'datgene wat altijd hetzelfde is', maar door het 'nieuwe' een nog ongekende betekenis krijgt. Walter Benjamin vindt dat alles terug in de mode. De mode is immers de eeuwige opstanding van het nieuwe.

Ook surrealistische kunstenaars, bijvoorbeeld Man Ray, verafgoodden de producten van de mode. Hun verrassende transformaties van het alledaagse en hun toekenning van verrassende betekenissen aan alledaagse objecten waren voor Benjamin een revolutionaire ervaring. De fetisjizering 'van dingen' door het surrealisme sloot bovendien perfect aan bij Benjamins interesse voor het nieuwe. Ook in die context speelde de mode, als object en als sociaal fenomeen, een centrale rol. Altijd blijven er immers objecten achter die 'uit de mode' zijn. Ze worden onafhankelijk, tijdcapsules, wat hun status als fetisj versterkt. Net zoals de kleren en sieraden van Chanel in de uitstallingen van een museum. We begrijpen nu ook beter de belangstelling van surrealistische kunstenaars voor etnografische objecten, een belangstelling die ook zichtbaar is in de manier waarop Walter van Beirendonck de mode benadert: de eigen fetisjen worden gepaard met die van andere en alle objecten worden gereduceerd tot een zelfde tijd! Mode is BIG SURREALISM en BIG SURREALISM is mode.

In de popkunst, bijvoorbeeld bij de popsurrealist Andy Warhol, krijgen we een verhevigde interesse voor de mode. Andersom beginnen de modebladen zelf belangstelling te tonen voor zijn en andermans verbeelding van de mode. De 'economy of attention' van Andy Warhol, die onder meer tot uitdrukking komt in de eindeloos herhaalde beeldreeksen van de kunstenaar, is bovendien een verdere ontwikkeling van het strategisch omgaan met 'het nieuwe dat altijd hetzelfde is'. De beeldende kunst moet niet bang zijn van de mode. De beeldende kunst heeft de mode zich reeds lang eigen gemaakt. Hopelijk weet u nu waarom ik hier aan het woord ben als directeur van een museum dat bekend staat om zijn verzamelobjecten, gemaakt door oude en hedendaagse surrealisten: van beeldend kunstenaars als Man Ray, Salvador Dalí, Francis Picabia, Andy Warhol, Richard Prince, maar ook van modeontwerpers als Martin Margiela, Walter van Beirendonck, Dirk van Saene en zelfs van de architect Rem Koolhaas.

Koolhaas doet en zegt hetzelfde als de door hem zo geliefde surrealisten en de popkunstenaar Andy Warhol in zijn recente werkzaamheden voor het Italiaanse modemerk PRADA. In navolging van Warhols 'economy of attention' schrijft Koolhaas de firma PRADA een nieuwe communicatie- en marktstrategie voor met als slogan *Luxury is attention*. Koolhaas: 'Als het geluidsniveau toeneemt, zoals op Times Square (horen we daar niet Walter Benjamin?), vermenigvuldigen de eisen aan ons zenuwstelsel om te differentiëren, te beslissen, te kopen. De ultieme luxe is concentratie en duidelijkheid.' Koolhaas doet zelfs aanbevelingen waarin hij de museumwereld betrekt. 'Musea zijn populair, niet omwille van hun inhoud, maar omwille van hun gebrek aan inhoud: je gaat, je kijkt, je vertrekt. Geen beslissingen, geen druk. Onze ambitie is de aandacht vasthouden...'
Hij vervangt het woord 'fetisj' echter op slimme wijze door de term 'intelligentie' - Koolhaas ziet immers in dat de politiek van fetisjizering zelf niet fetisjistisch mag worden: 'Intelligentie toepassen op een object... is de enige manier om vooruit te komen... Intelligentie is een altruïstisch gebaar dat een waarde aan een object toevoegt. Intelligentie neemt dikwijls de vorm aan van vernieuwing maar hoeft dat niet te doen...'. Tenslotte noteert ook Koolhaas dat het nieuwe pas verschijnt als de dingen altijd hetzelfde zijn: 'Massale veranderingen maken stabiliteit opwindend. Wil je stabiliteit opnemen in een systeem van stelselmatige vernieuwing (mode), gebruik dan het model van dynamisch evenwicht. Hoe stabieler het merk, hoe meer je verandert.'

Benjamin - Warhol - Koolhaas: we begrijpen nu ook beter de centrale karakteristiek die weggelegd is voor het intensifiëren van mode en media, zoals die tot uiting komt in **GELAND**. **GELAND** is een goed voorbeeld, maar nog geen radicaal voorbeeld - of niet radicaal genoeg -, van de lijnen die zijn uitgezet door de voornoemde BIG SURREALISTS. Er is volop werk aan de winkel. We zijn heden nog slechts geland. Het is tijd om uit te stappen en de landingsplek te verkennen. De vrijheid die de mode kenmerkt - vrij in vergelijking met de huidige onvrijheid van de beeldende kunst, nu het fetisjisme van het kunstobject zich tegen zichzelf heeft gekeerd - geeft de mogelijkheid om een autonoom cultureel systeem te ontwikkelen. Zelfs al is de mode onderworpen aan grote beperkingen, zoals de beperking van het kapitaal, dan is het juist de paradox waaraan de mode zo onderhevig is, namelijk het zich voortdurend moeten aanpassen en tegelijkertijd het zich tegen die aanpassing verzetten, die maakt dat de mode een grote aantrekkingskracht uitoefent op intellectuelen en kunstenaars. Bovendien geeft de band tussen de mode- en de mediaontwerpers nieuwe mogelijkheden, waardoor de mode zich kan bedienen van nieuwe experimenteervelden en ze een vehikel kan worden voor nieuwe esthetische, technologische en conceptuele praktijken. De mode mag daarom haar bemiddeling door de media tot het uiterste bespelen. Toch moet ze in de eerste plaats een vorm van esthetische autonomie nastreven die zich dient te vertalen als een effect dat betrekking heeft op de gebruiker, de drager zelf. Wat een uitdagingen liggen er in het verschiet! De strategie van Walter Benjamin en de tactieken van kunstenaars als Man Ray, Andy Warhol, Rem Koolhaas en Walter van Beirendonck wijzen ons de weg. Talloze andere voorbeelden uit de afgelopen eeuw - BIG SURREALISM! - liggen voor het oprapen. Ze moeten in het Flanders Fashion Institute opnieuw tot leven worden gewekt. We moeten immers weten en begrijpen wat al gedaan is om verder te kunnen. In Antwerpen is het sinds enige jaren vergeven van barsten en openingen om op een radicale manier de mode verder te laten doorwerken. Wij zijn geland! Nu uitstappen!

Toespraak van **Chris Dercon**, directeur van het Museum Boijmans Van Beuningen in Rotterdam, bij de opening van de tentoonstelling **RADICALS-RADICALEN** van het evenement **MODE2001 LANDED-GELAND**, Antwerpen, 25 mei 2001.

Fluorescent landmark at the ModeNatie, Nationalestraat

Pourquoi avoir donné ici la parole à un conservateur de musée? Serait-ce parce que le Museum Boijmans Van Beuningen de Rotterdam a régulièrement exposé et acquis ces dernières années des œuvres de certains créateurs de mode «anversois»? En 1997 et 1998, la Maison Martin Margiela et Walter van Beirendonck y ont respectivement exhibé leurs «frasques» vestimentaires. A Rotterdam, une nouvelle ligne de Margiela fut injectée de bactéries fongiques multicolores, faisant pendant quelques semaines du mythe de la divinité égyptienne envahie par la végétation une réalité. Un an plus tard, Walter van Beirendonck, en coopération avec le designer Marc Newson et d'autres comparses, créa une véritable «boutique Walter». Non seulement il y proposait, au sens propre et figuré, ses vêtements à tout un chacun, mais, lors du vernissage, il orna aussi de prothèses corporelles l'artiste Orlan et de nombreux membres du musée. Récemment, nous avons encore présenté les superbes robes blanches en papier de Dirk van Saene. Nous nous réjouissons du fait que ces créations, ainsi que d'autres propositions de mode contemporaines, soient reprises dans notre collection Arts décoratifs et Design.

Il doit pourtant y avoir une autre raison pour laquelle je m'adresse à vous comme porte-parole des arts plastiques. Je n'en vois qu'une: les arts plastiques sont constamment liés à la mode. Au cours du XXe siècle, l'œuvre d'art s'est transformée en image fétiche. Cette évolution a propulsé la mode, en tant qu'objet et récit, sur le devant de la scène. Depuis les années 1920 et le début du surréalisme - que l'on pense à Man Ray -, par-delà le pop art des années 1960, avec comme acteur principal Andy Warhol, jusqu'aux mises en scène du *life style* des années 1990 par des photographes comme Wolfgang Tillmans, c'est à chaque fois la mode qui passe la tête dans les arts plastiques. La mode s'est-elle lancée depuis l'avant-garde parisienne des années 1920 dans un processus de colonisation des arts plastiques dont nous observerions aujourd'hui les derniers soubresauts? Ou est-ce parce que les arts plastiques du siècle écoulé sont par essence surréalistes que la mode y a joué un rôle de plus en plus marqué?

En 1997, Olivier Zahm, rédacteur en chef du magazine *Purple Prose*, déclara dans un manifeste à propos de la crise de la critique d'art: «La mode est le modèle de représentation et le discours du nouveau siècle. La mode est sur le point d'évincer le cinéma, la forme artistique la plus importante du XXe siècle.» Et il ajoute: «La mode, comme le cinéma, souffre de nombreuses restrictions techniques et financières mais présente aussi d'innombrables ramifications et mutations. Contrairement au cinéma, la mode se vit à fleur de peau, au sens propre et figuré. La mode permet une sorte de révolution permanente.»

En effet, la mode est l'expression de formes d'individualisation jusqu'ici inconnues et même dans certains cas d'une véritable politisation de l'art de vivre de l'individu. «Tous les problèmes de l'art contemporain, conclut le concepteur de *Purple Prose*, trouvent leur formulation ultime dans la mode.»

Soixante-dix ans plus tôt, Walter Benjamin, le philosophe de *L'œuvre d'art à l'époque de sa reproduction mécanisée*, affirmait, dans son célèbre *Livre des passages*, que tous les problèmes de l'art trouveraient leur formulation définitive dans le cinéma. Mais en fin de compte, il ne tarderait pas, lui aussi, à aboutir... la mode. Le cinéma était pour Benjamin la forme idéale pour communiquer les expériences de la vie urbaine moderne, le véhicule par excellence de la nouveauté. Grâce au cinéma, le quotidien se trouve immédiatement sublimé. Et un produit ou une marchandise n'offre d'intérêt que tant qu'il est neuf. Mais cette nouveauté ne peut surgir qu'à la lueur de «ce qui est toujours pareil». Au centre du discours de Benjamin se trouve l'idée du caractère fétiche de «ce qui est toujours pareil» mais qui, grâce à la «nouveauté», revêt une signification inconnue jusque-là. Pour le philosophe, la mode contient tout cela! La mode est bien un éternel retour de la nouveauté.

Des artistes surréalistes tels que Man Ray ont eux aussi idolâtré les produits de la mode. Aux yeux de Benjamin, leurs surprenantes transformations du quotidien et l'attribution de significations étranges aux objets les plus communs constituent une expérience révolutionnaire. La fétichisation des «objets» par le surréalisme rejoint parfaitement l'intérêt du philosophe pour la nouveauté. Dans ce contexte également, la mode, en tant qu'objet et phénomène social, a joué un rôle capital. Toujours en effet restent des objets qui sont «passés de mode». Ceux-ci deviennent indépendants, comme des machines à remonter le temps, ce qui accroît leur statut de «fétiche». Exactement comme les vêtements et les bijoux de Chanel dans les vitrines des musées. On comprend mieux alors l'intérêt des surréalistes pour les objets ethnographiques, un intérêt dont on perçoit aussi les traces dans la façon dont Walter van Beirendonck aborde la mode: ses propres fétiches côtoient ceux d'autrui, et tous les objets sont ramenés à une seule et même époque! La mode, c'est le BIG SURREALISM, et le BIG SURREALISM, c'est la mode.

LA MODE NE RELEVE PAS DES ARTS PLASTIQUES, MAIS LES ARTS PLASTIQUES ONT CONSTAMMENT A VOIR AVEC LA MODE.

Le pop art, par exemple avec le pop-surréaliste Andy Warhol, manifeste un intérêt accru pour la mode. En sens inverse, les magazines de mode eux-mêmes commencent alors à se préoccuper de la conception de la mode chez les artistes. L'«*economy of attention*» de Warhol, qui s'exprime entre autres dans les séries d'images inlassablement répétées, est d'ailleurs un développement du recours stratégique au «nouveau qui est toujours pareil». Les arts plastiques n'ont rien à craindre de la mode, ils l'ont assimilée depuis longtemps. Sans doute comprenez-vous mieux pourquoi je m'adresse aujourd'hui à vous en tant que conservateur d'un musée réputé pour sa collection d'objets de surréalistes anciens et contemporains: des artistes comme Man Ray, Salvador Dalí, Francis Picabia, Andy Warhol et Richard Prince, mais également des créateurs de mode tels que Martin Margiela, Walter van Beirendonck ou Dirk van Saene, et même l'architecte Rem Koolhaas.

Koolhaas fait et dit la même chose que les surréalistes et Warhol, auxquels il voue une grande admiration, dans ses récentes entreprises pour la marque italienne de mode Prada. En prolongement de l'*economy of attention* de Warhol, Koolhaas développe pour la firme Prada une nouvelle stratégie de marketing et de communication avec pour slogan *Luxury is attention*. Koolhaas: «Au fur et à mesure que le niveau sonore augmente, comme à Times Square [n'entendons-nous pas là Walter Benjamin?], se décuplent les efforts demandés à notre système nerveux pour différencier, décider, acheter. Le luxe absolu, c'est la concentration et l'évidence.» Les recommandations de Koolhaas concernent même les musées: «Les musées sont populaires, non pas à cause de leur contenu, mais bien de leur manque de contenu: on y va, on regarde, on sort. Pas de décision à prendre, pas de stress. Notre ambition est de capter l'attention [...].» Koolhaas prend soin cependant de remplacer le mot «fétiche» par «intelligence» - il réalise en effet que la politique de fétichisation ne doit pas elle-même devenir fétichiste: «Donner de l'intelligence à un objet [...], c'est la seule façon d'avancer. [...] L'intelligence est un geste altruiste qui ajoute de la valeur à un objet. L'intelligence prend souvent la forme d'une innovation, mais pas nécessairement [...].» Enfin, Koolhaas note aussi que la nouveauté arrive seulement quand les choses restent toujours les mêmes: «Les changements brutaux rendent la stabilité passionnante. Afin d'incorporer la stabilité dans un système d'innovation permanente (la mode), adoptez un modèle d'équilibre dynamique. Plus votre marque est stable, plus vous changez.»

Benjamin - Warhol - Koolhaas: nous comprenons également mieux la caractéristique centrale qui justifie l'intensification de la relation entre la mode et les médias, comme celle qu'exprime LANDED-ATTERRI. LANDED-ATTERRI est un bon exemple, mais pas encore un exemple radical - ou assez radical -, des grandes lignes suivies par les BIG SURREALISTS précités. Il reste beaucoup à faire, nous venons seulement d'atterrir. Il est temps de débarquer et d'explorer le site d'atterrissage. La liberté propre à la mode - liberté par rapport à la non-liberté des arts plastiques maintenant que la fétichisation de l'œuvre d'art s'est retournée contre elle-même - permet à celle-ci de développer un système culturel autonome.

Même si la mode est limitée par des contraintes importantes, comme celle des capitaux par exemple, c'est précisément le paradoxe qui la caractérise, à savoir qu'elle doit continuellement s'adapter et en même temps se rebeller contre cette adaptation, qui explique son pouvoir de fascination auprès des intellectuels et des artistes. De plus, grâce au lien qu'elle noue avec les concepteurs de médias, la mode peut explorer de nouveaux champs d'expérimentation et devenir le véhicule de nouvelles pratiques esthétiques, technologiques et conceptuelles. Si la mode peut jouer au maximum la carte de sa diffusion par les médias, elle doit cependant rester en premier lieu à la recherche d'une forme d'autonomie esthétique centrée sur le rapport avec l'utilisateur, avec celui qui la porte. Que de défis en perspective!

La stratégie de Walter Benjamin et la tactique d'artistes tels que Man Ray, Andy Warhol, Rem Koolhaas et Walter van Beirendonck ouvrent la voie. De nombreux autres exemples du siècle précédent - BIG SURREALISM! - attendent d'être exploités. Le Flanders Fashion Institute a pour devoir de les rappeler à la vie. Il faut en effet connaître et comprendre ce qui a été fait pour avancer. Depuis quelque temps à Anvers, des brèches et des ouvertures se sont créées de toute part pour faire avancer la mode d'une façon radicale. Nous avons atterri, tout le monde descend!

Discours prononcé par **Chris Dercon**, conservateur au Museum Boijmans Van Beuningen de Rotterdam, à l'ouverture de l'exposition **RADICALS-RADICAUX** organisée dans le cadre de l'événement **MODE2001 LANDED-ATTERRI**, Anvers, le 25 mai 2001.

Green landmark: grass carpet at the Groenplaats

Blue landmark at Police Tower

RAD
IC
AL
S

RADICALEN
RADICAUX

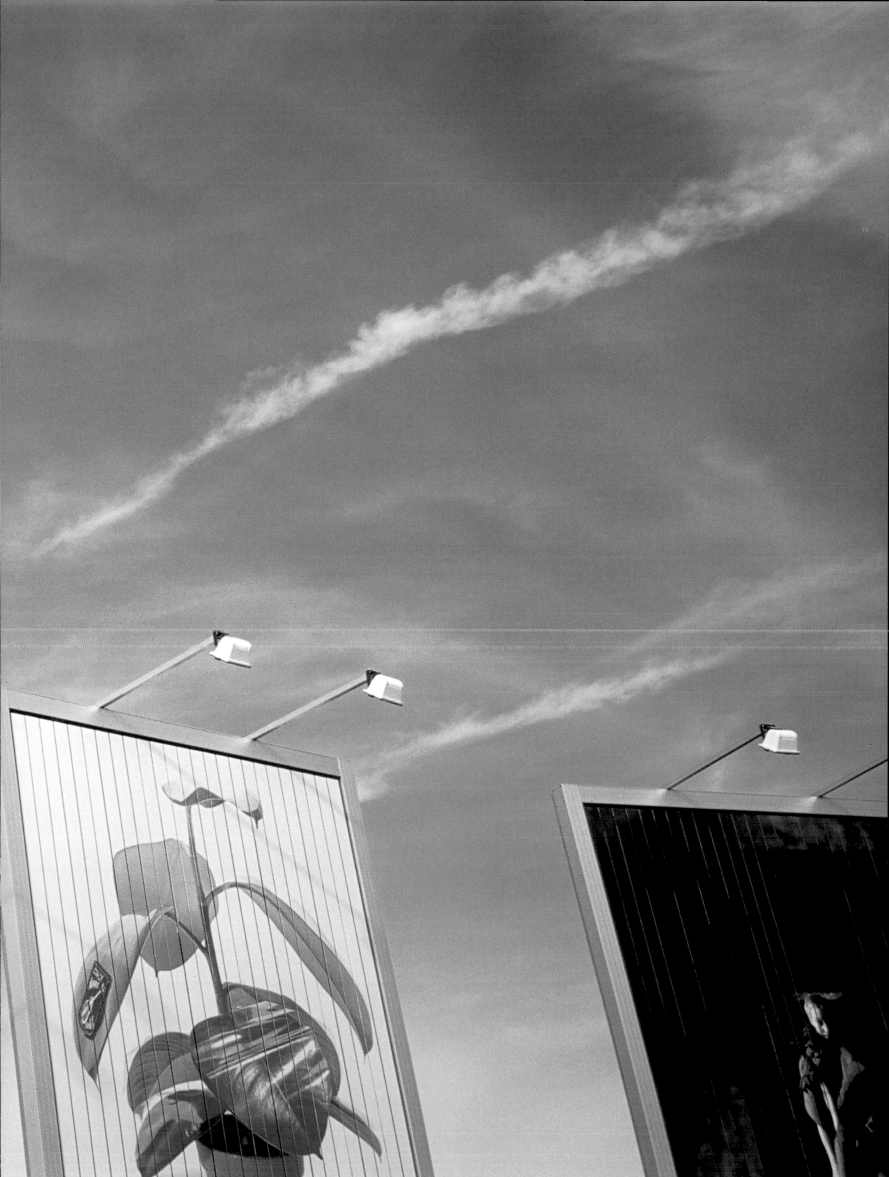

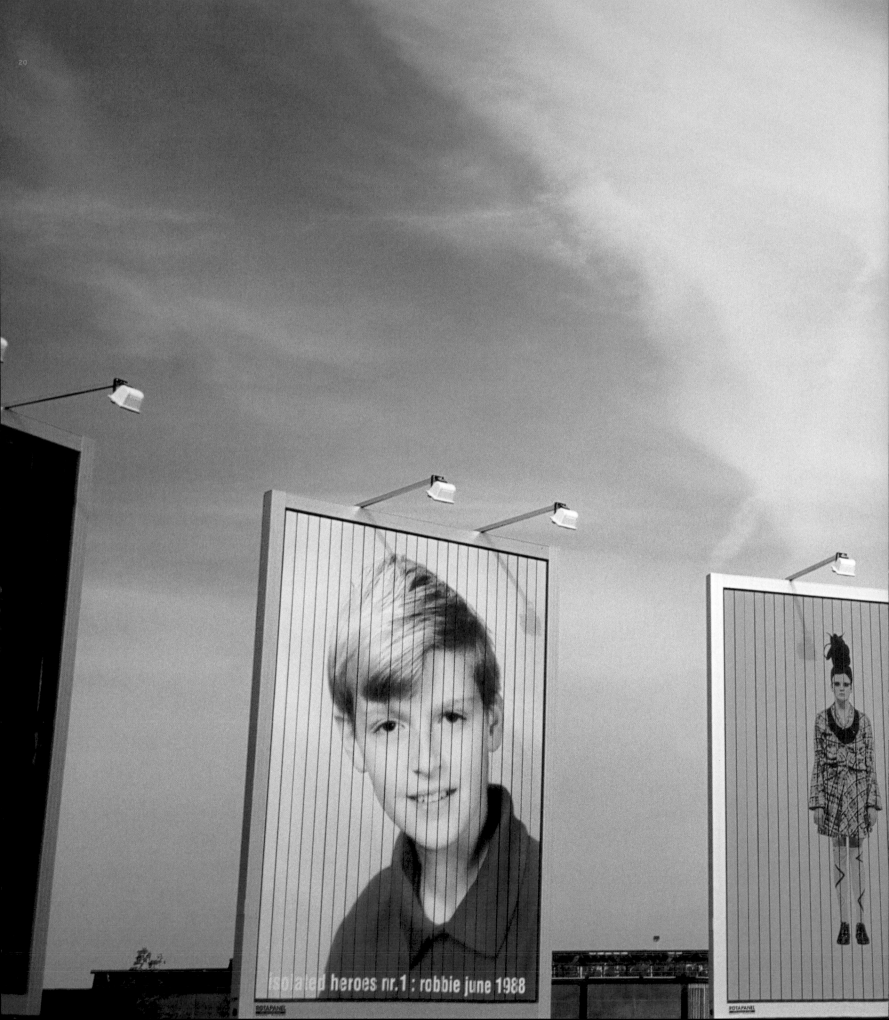

isolated heroes nr.1 : robbie june 1988

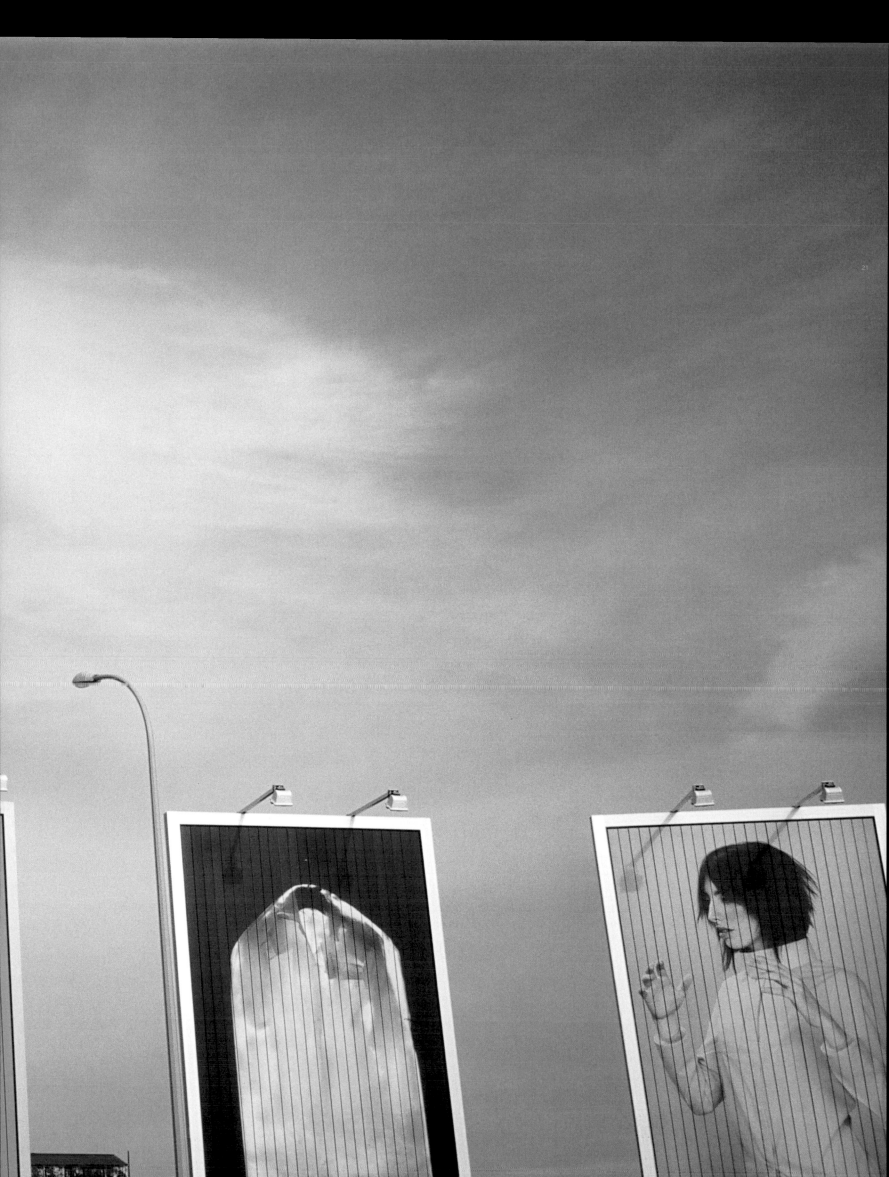

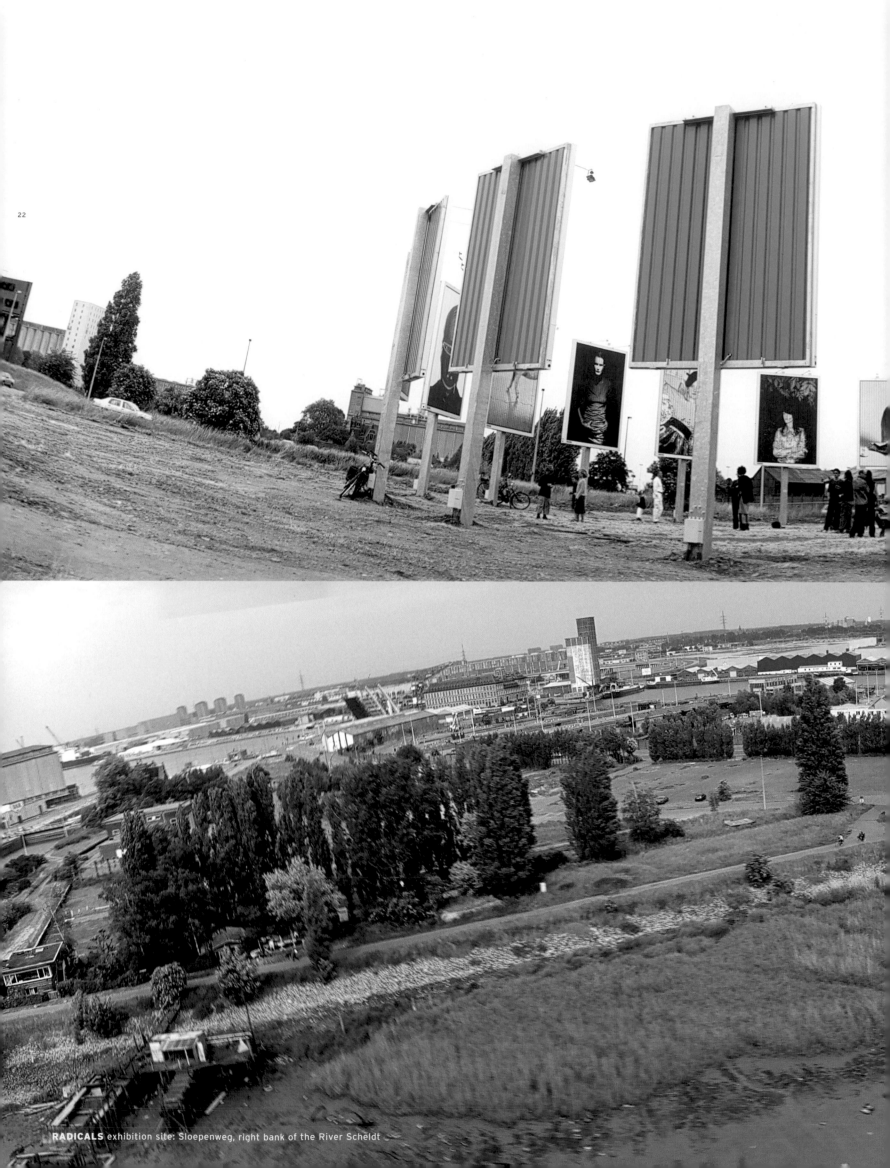

22

RADICALS exhibition site: Sloepenweg, right bank of the River Scheldt

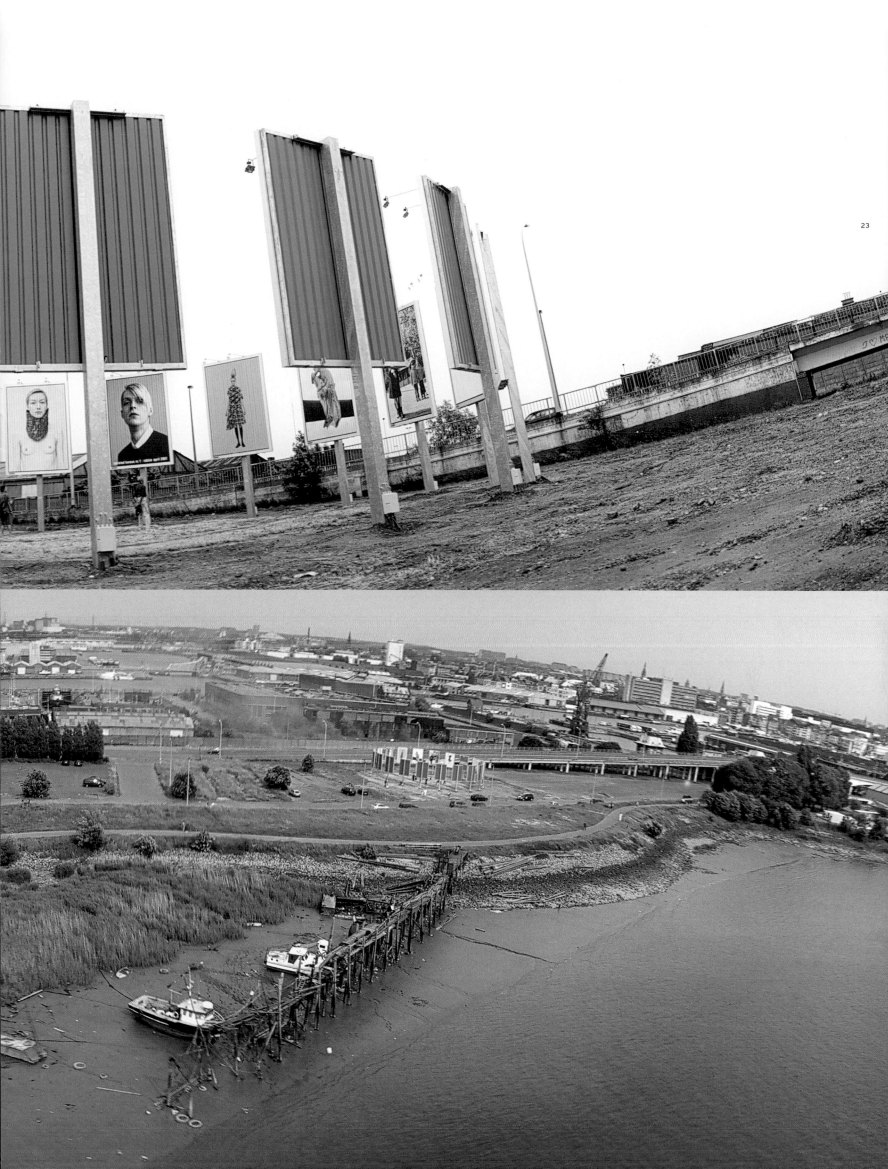

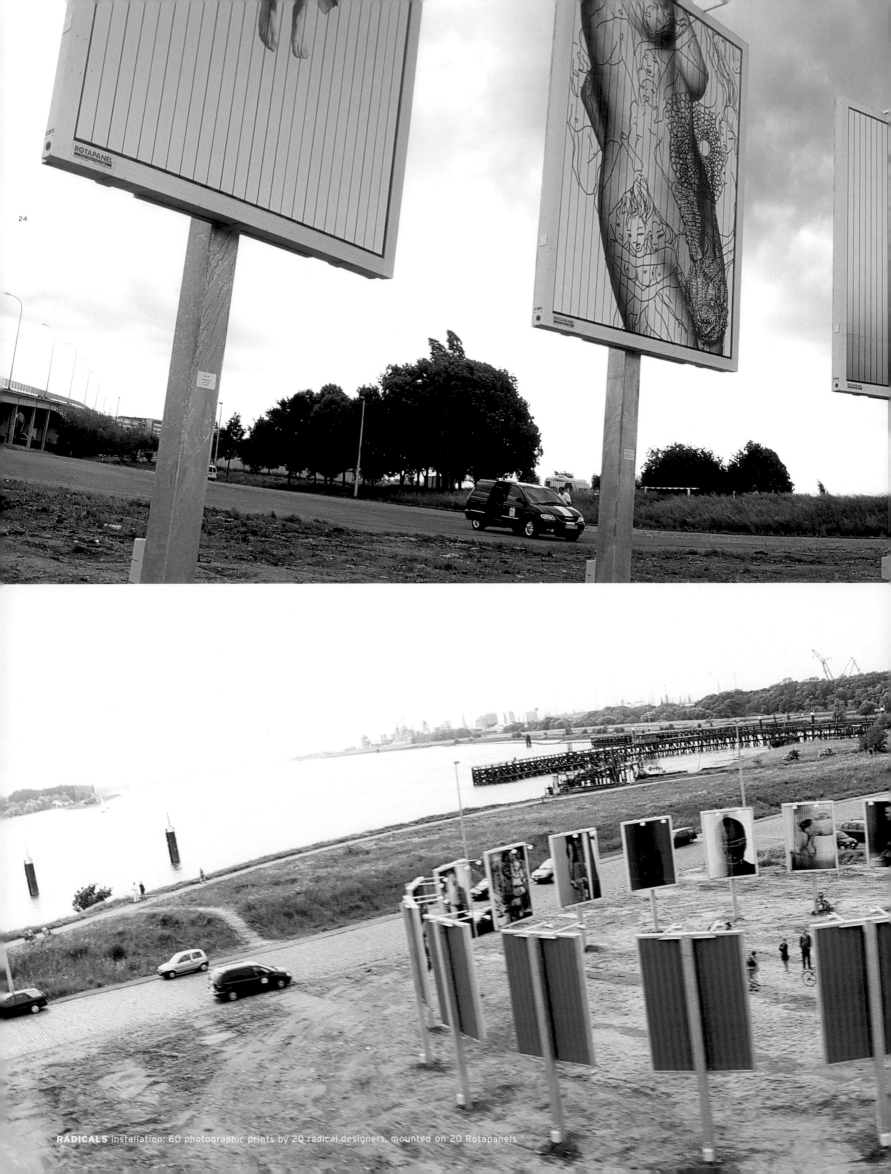

24

RADICALS installation: 60 photographic prints by 20 radical designers, mounted on 20 Rotapanels™

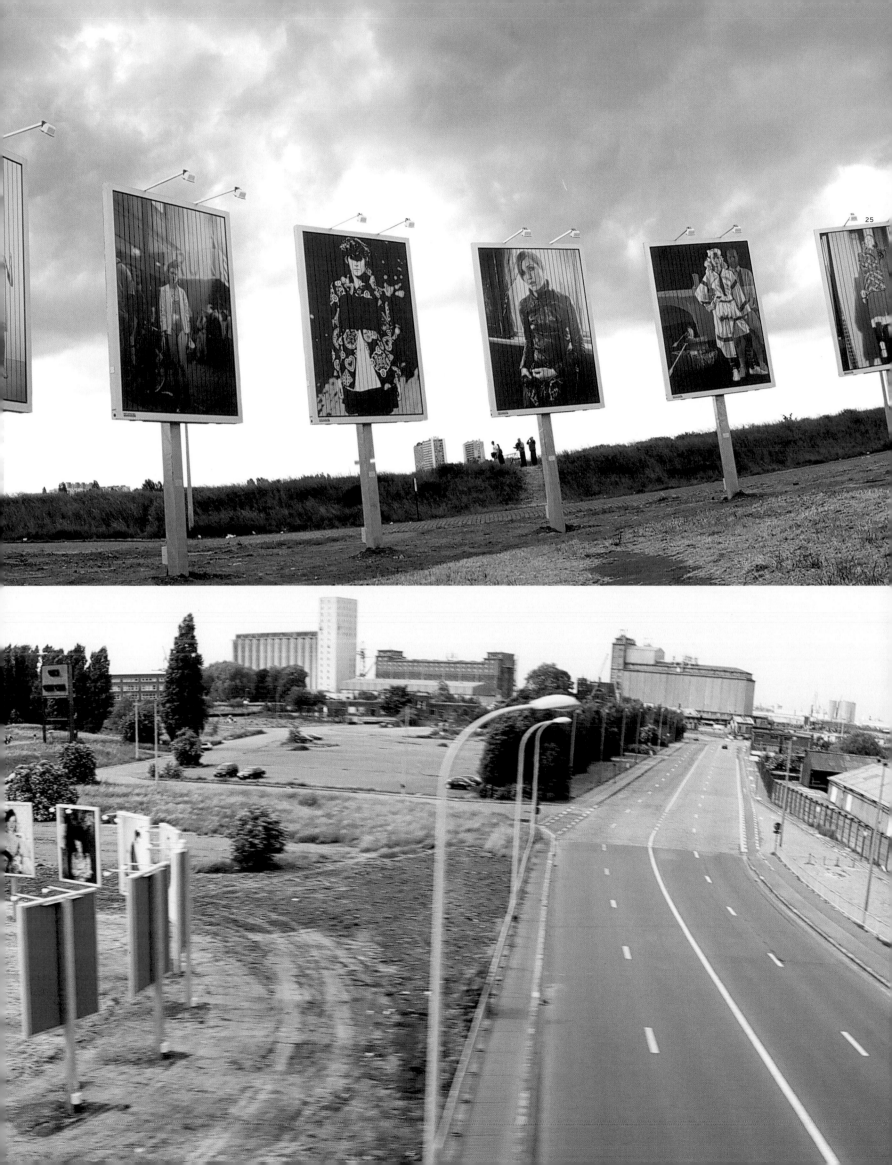

BLESS	JURGI PERSOONS
VERONIQUE BRANQUINHO	CAROL CHRISTIAN POELL
HUSSEIN CHALAYAN	RAF SIMONS
SUSAN CIANCIOLO	OLIVIER THEYSKENS
COMME DES GARÇONS	WALTER VAN BEIRENDONCK
ANGELO FIGUS	A.F. VANDEVORST
G+N	DIRK VAN SAENE
ANKE LOH	VIKTOR & ROLF
JESSICA OGDEN	JUNYA WATANABE
MARJAN DJODJOV PEJOSKI	BERNHARD WILLHELM

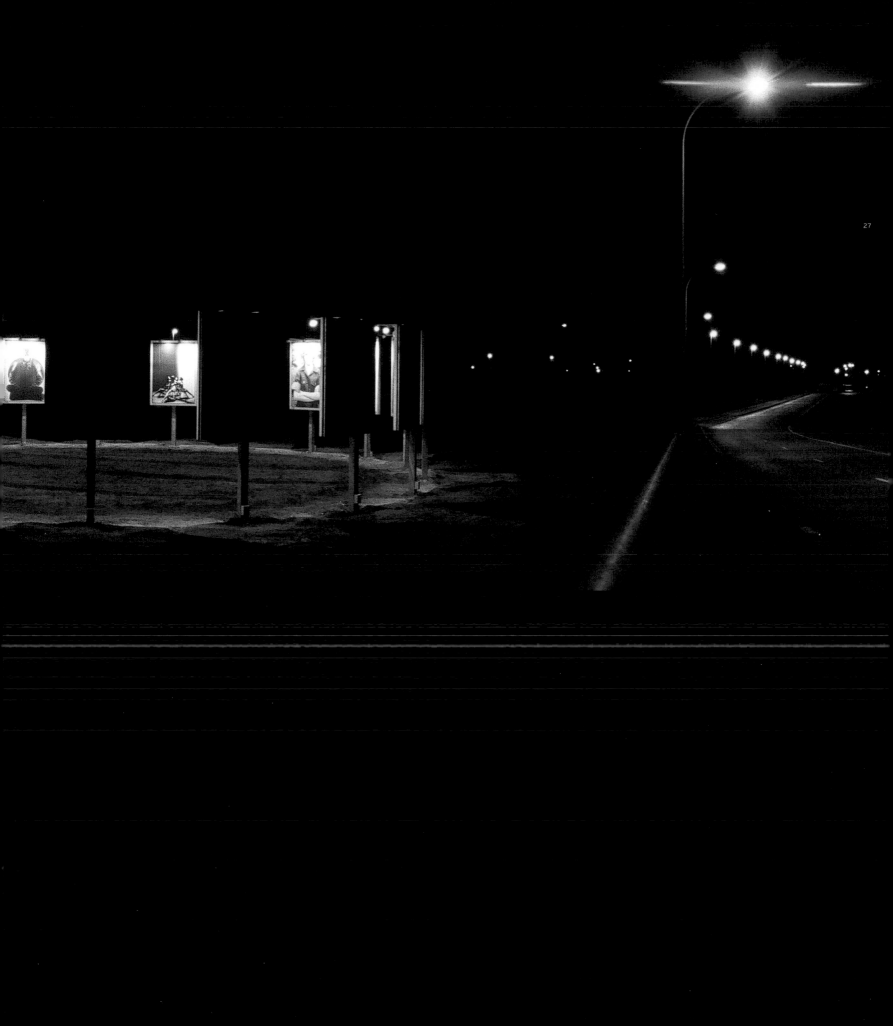

River Scheldt with fluorescent yellow landmark on the left bank

2
W
OM
EN

2VROUWEN
2FEMMES

GABRIELLE CHANEL exhibition at former Royal Palace

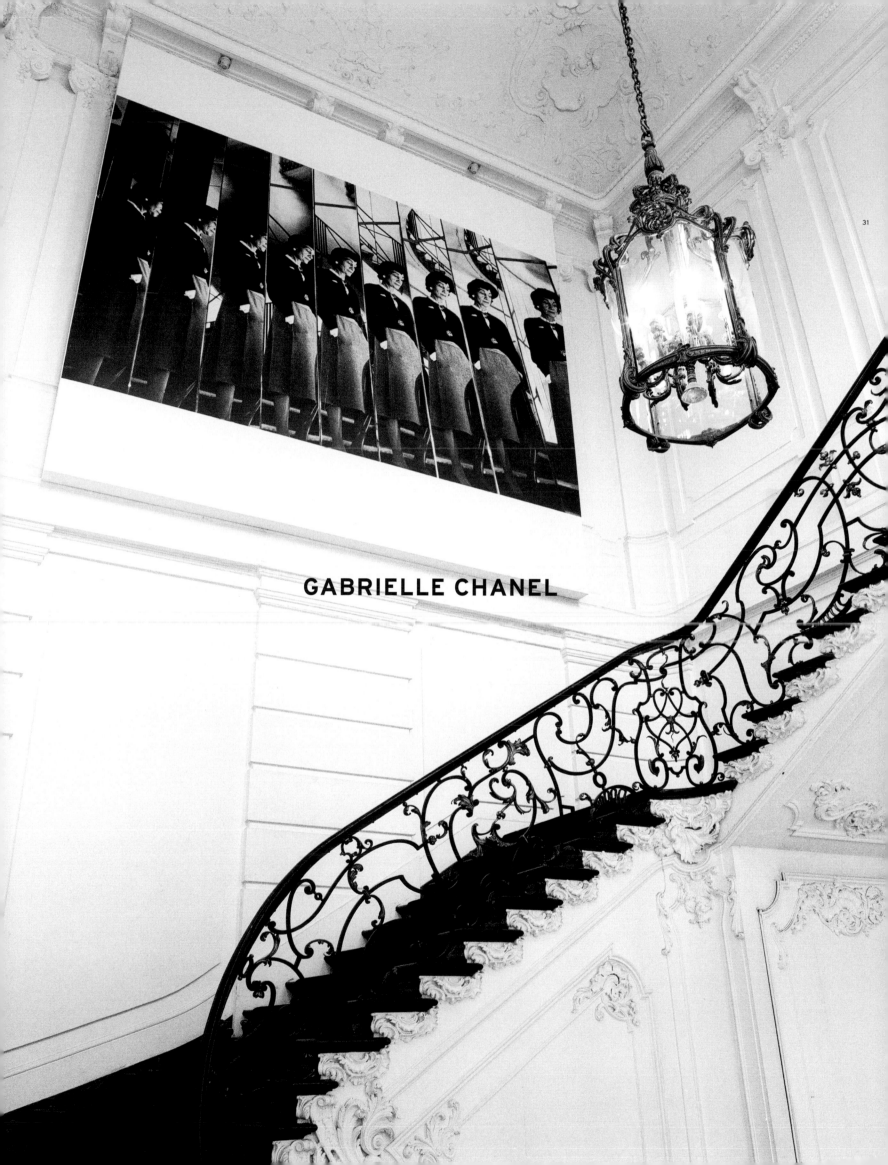

GABRIELLE CHANEL

LA CHAMBRE DES TAILLEURS

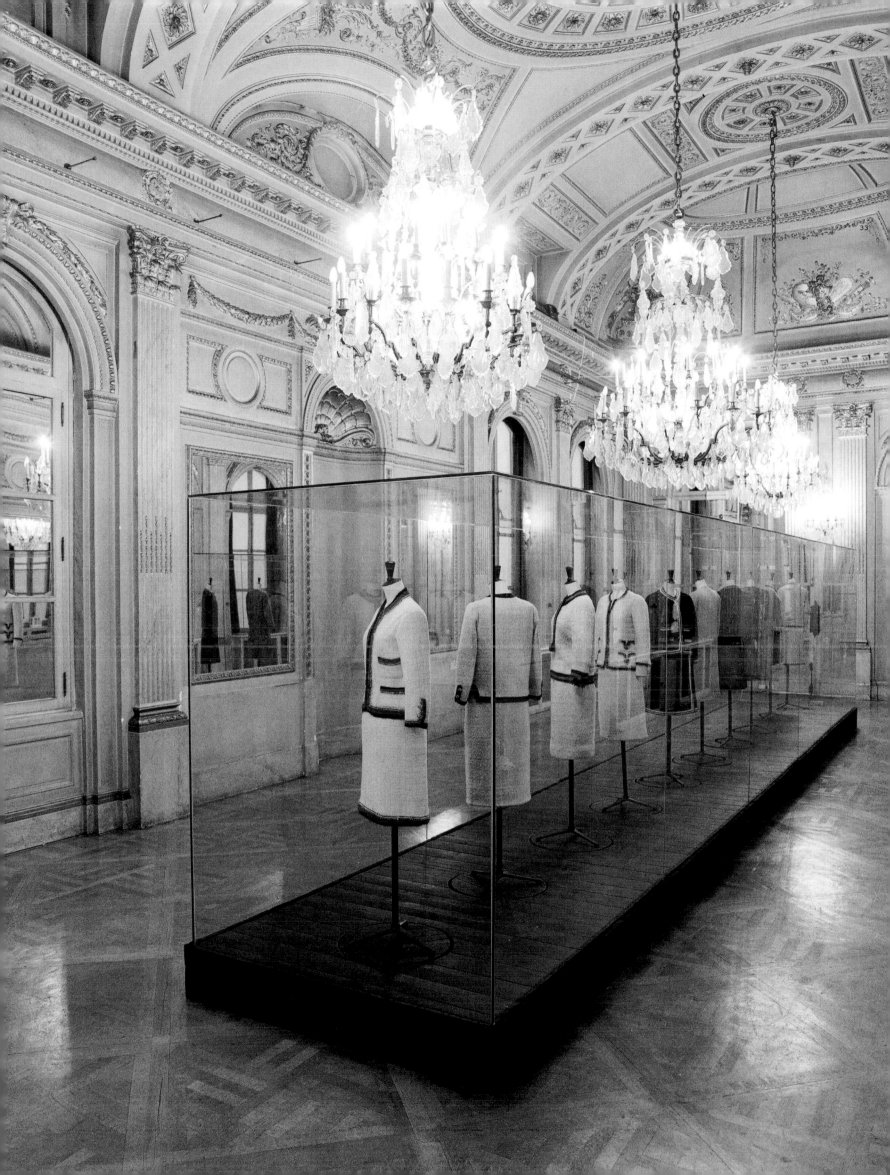

34

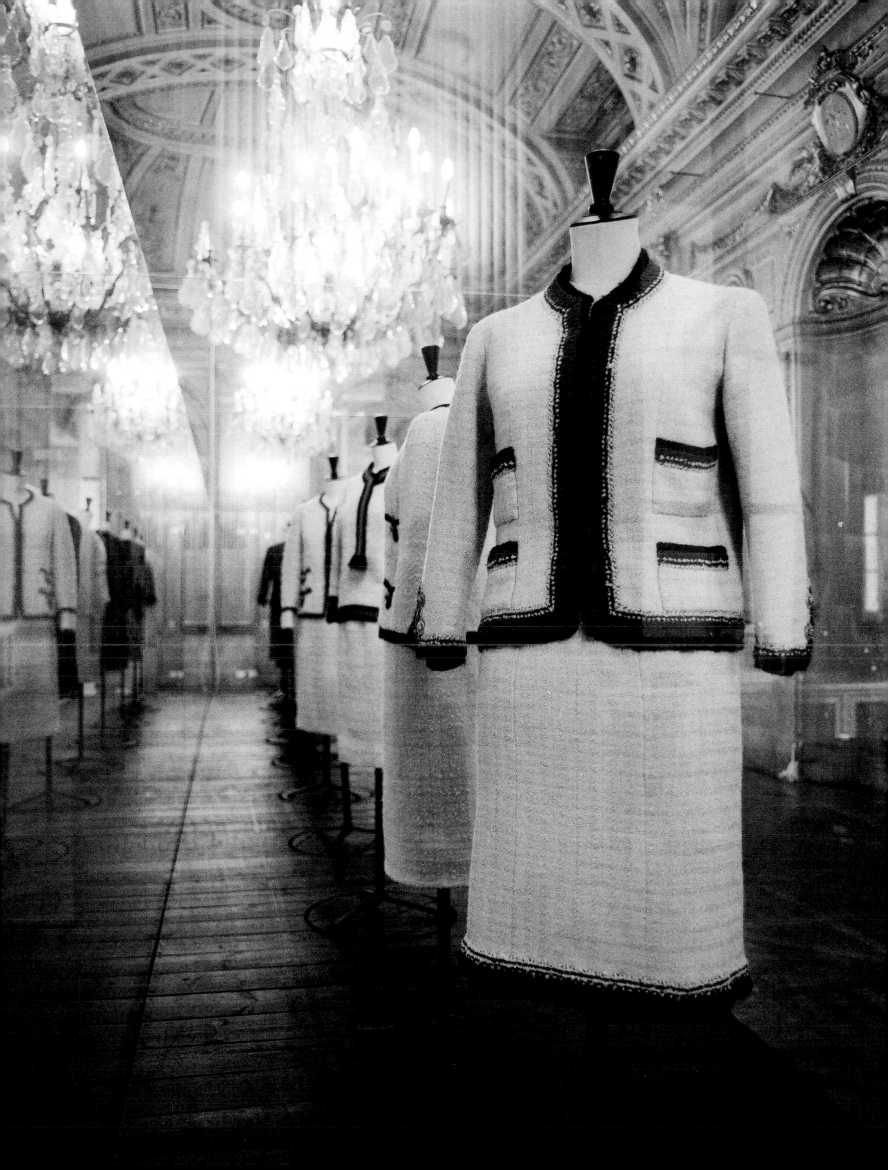

LA CHAMBRE DES BIJOUX

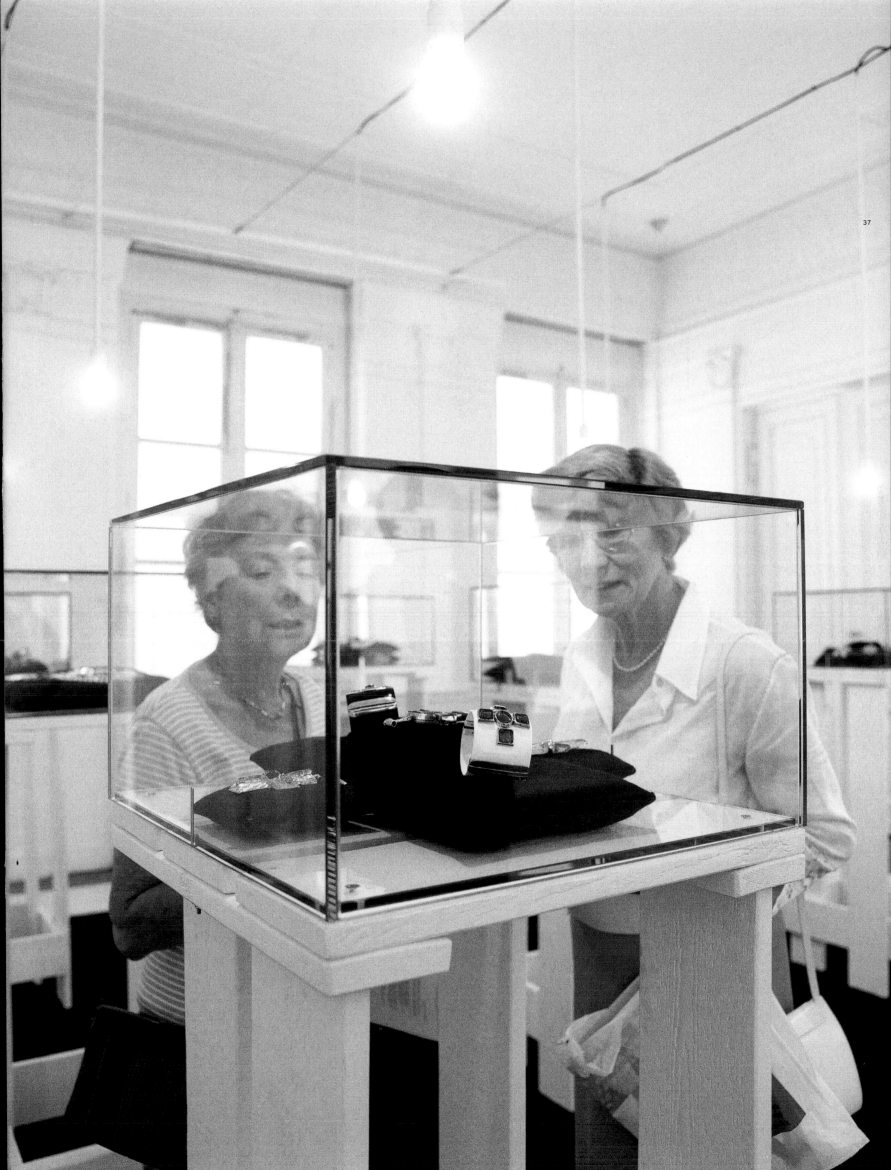

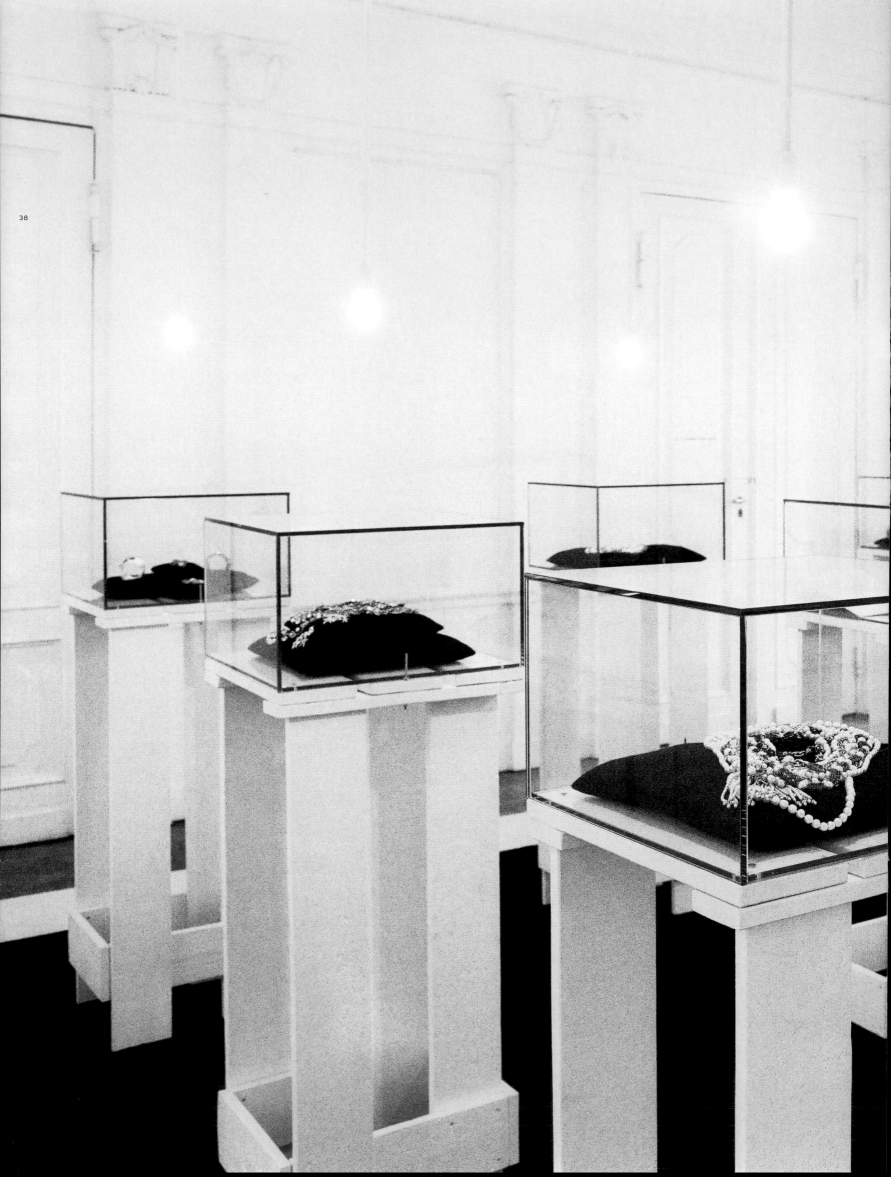

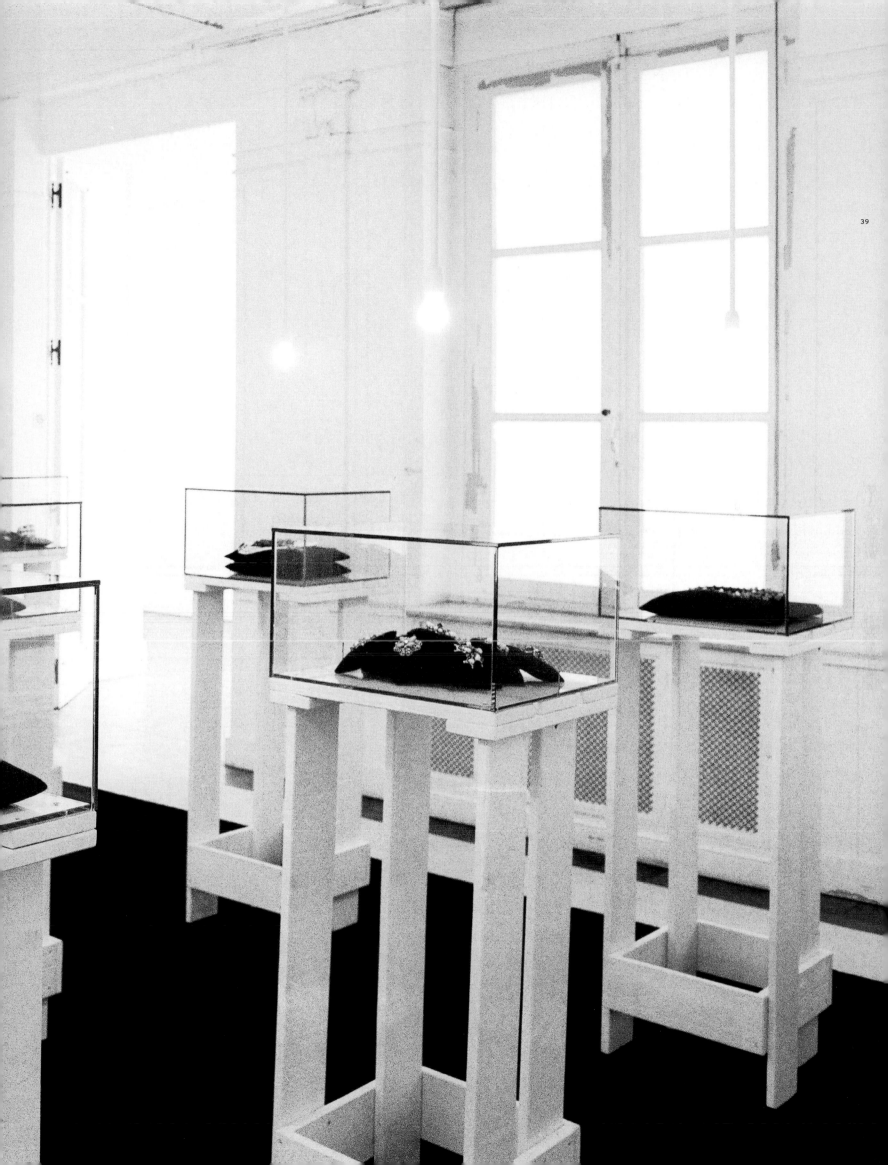

LA CHAMBRE PARLANTE

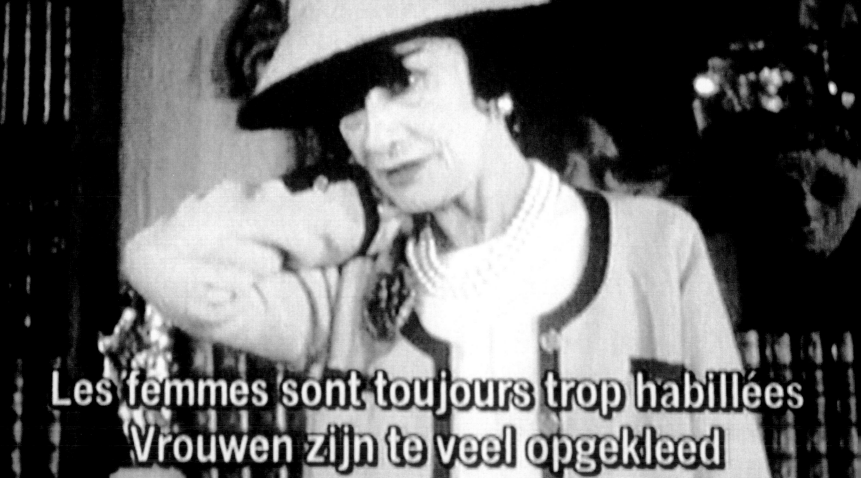

Vous posez des questions difficiles.
U stelt wel moeilijke vragen.

Les femmes sont toujours trop habillées
Vrouwen zijn te veel opgekleed

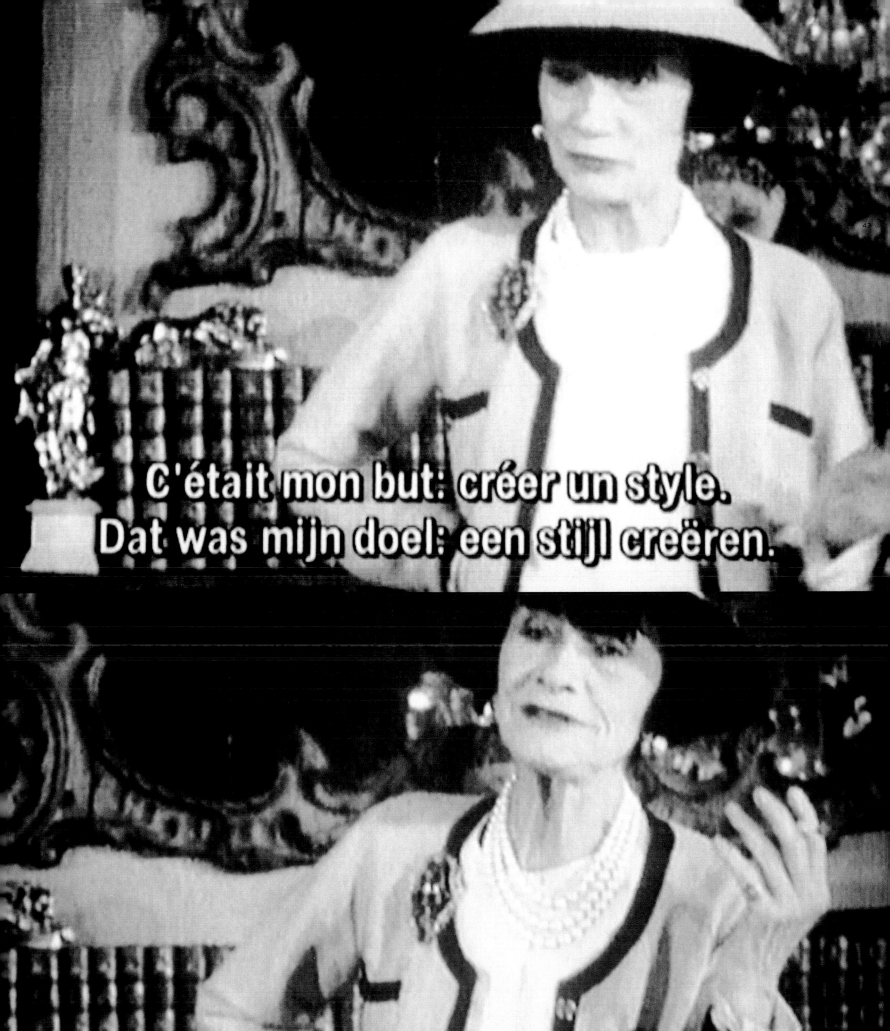

C'était mon but: créer un style.
Dat was mijn doel: een stijl creëren.

Pour moi, la copie, c'est le succès.
Voor mij betekent kopiëren succes.

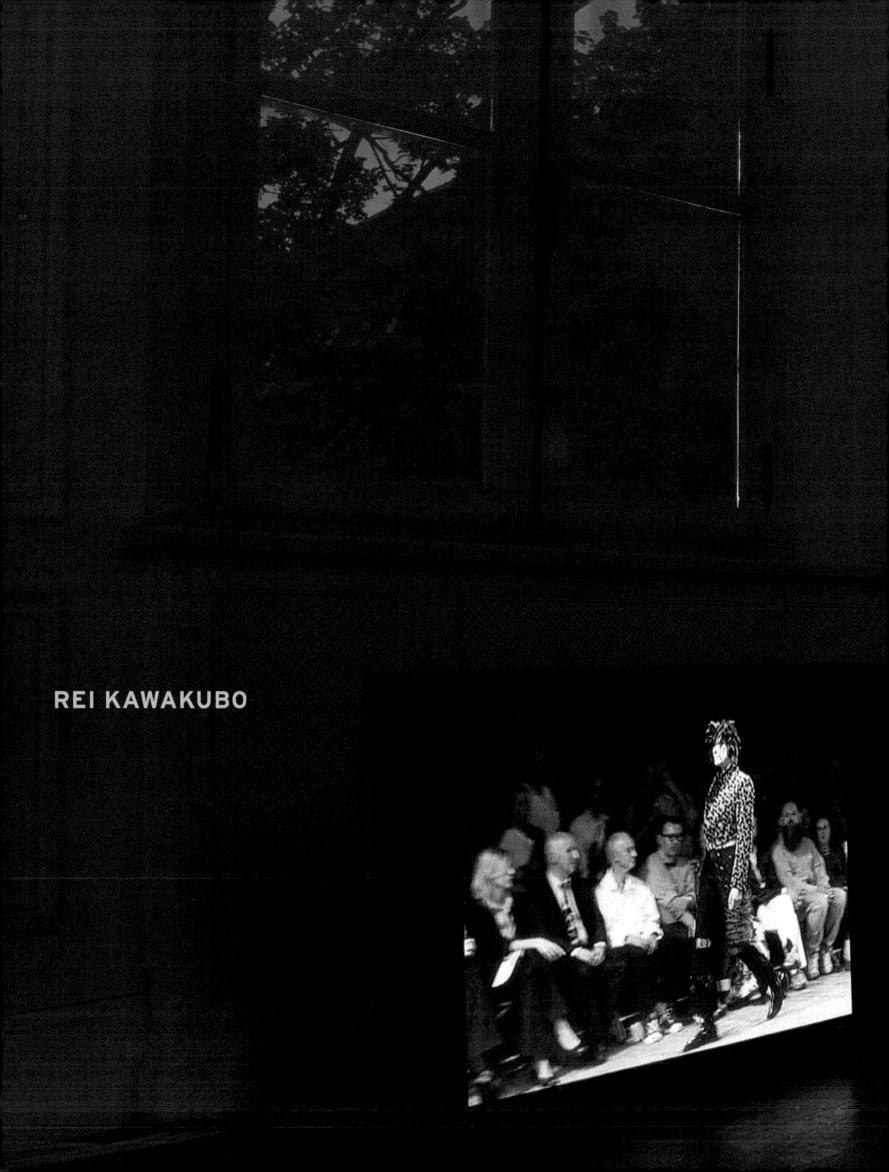

REI KAWAKUBO

REI KAWAKUBO lounge at the former Royal Palace

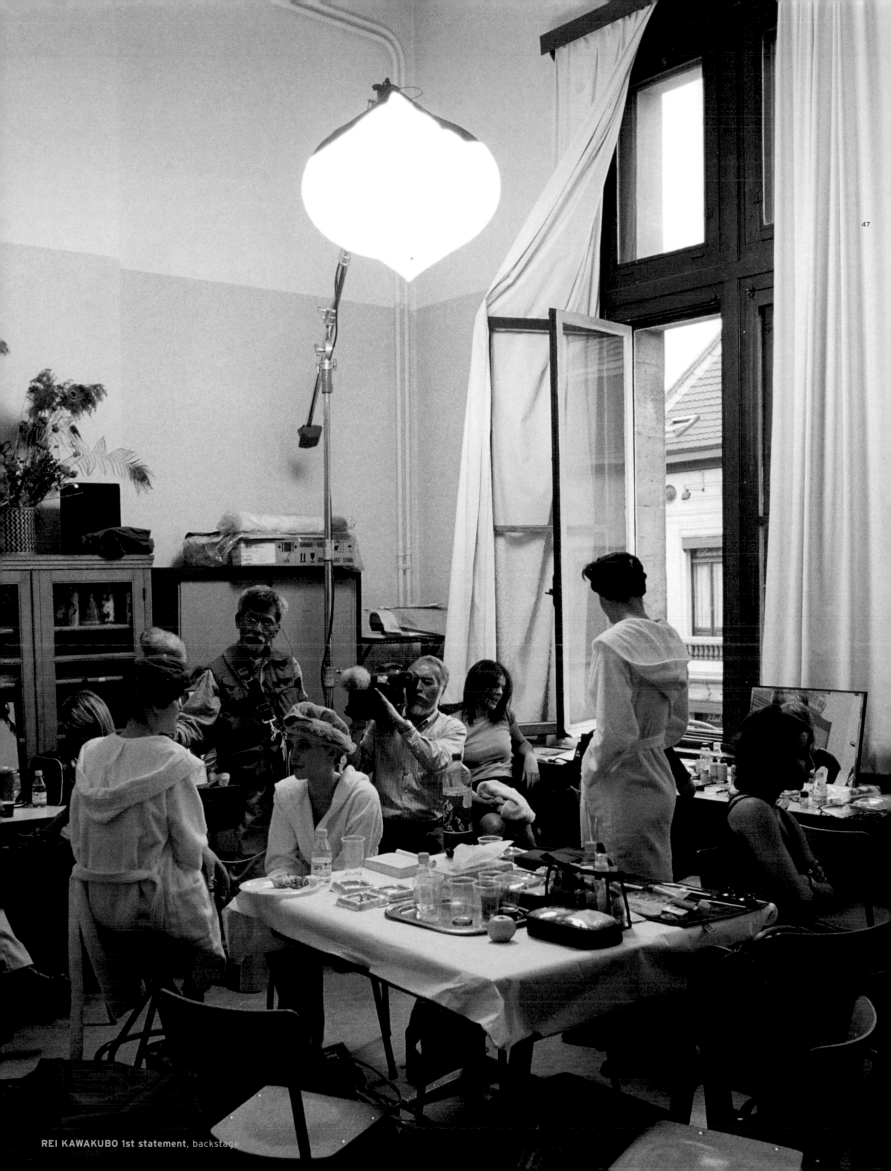

REI KAWAKUBO 1st statement, backstage

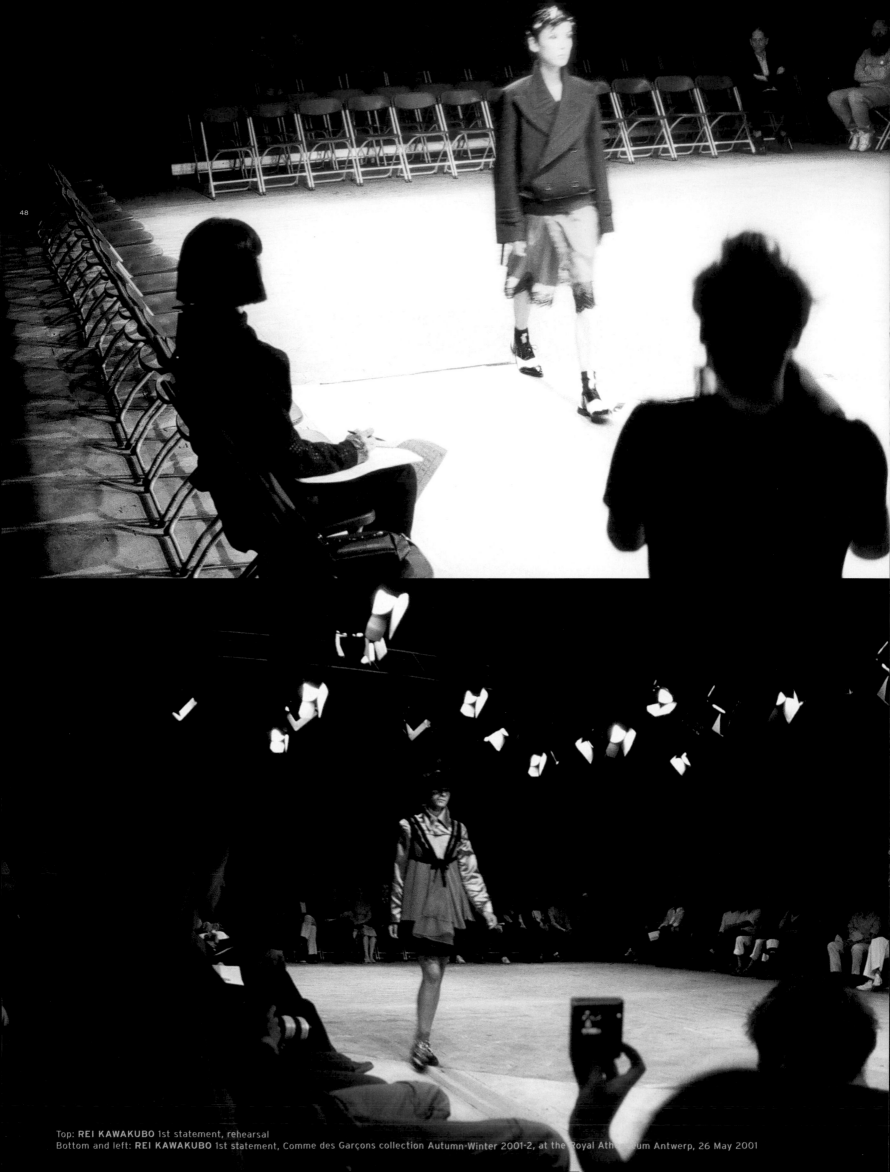

48

Top: **REI KAWAKUBO** 1st statement, rehearsal
Bottom and left: **REI KAWAKUBO** 1st statement, Comme des Garçons collection Autumn-Winter 2001-2, at the Royal Athenaeum Antwerp, 26 May 2001

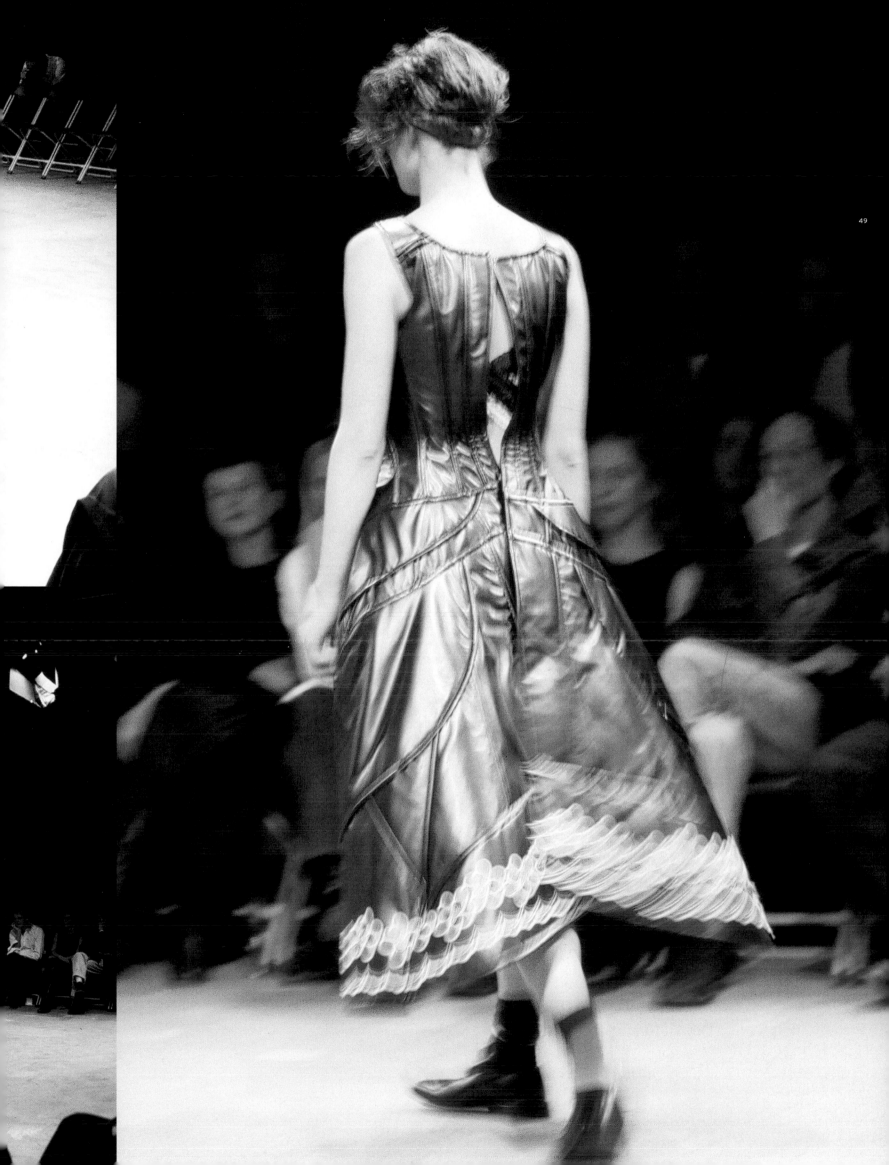

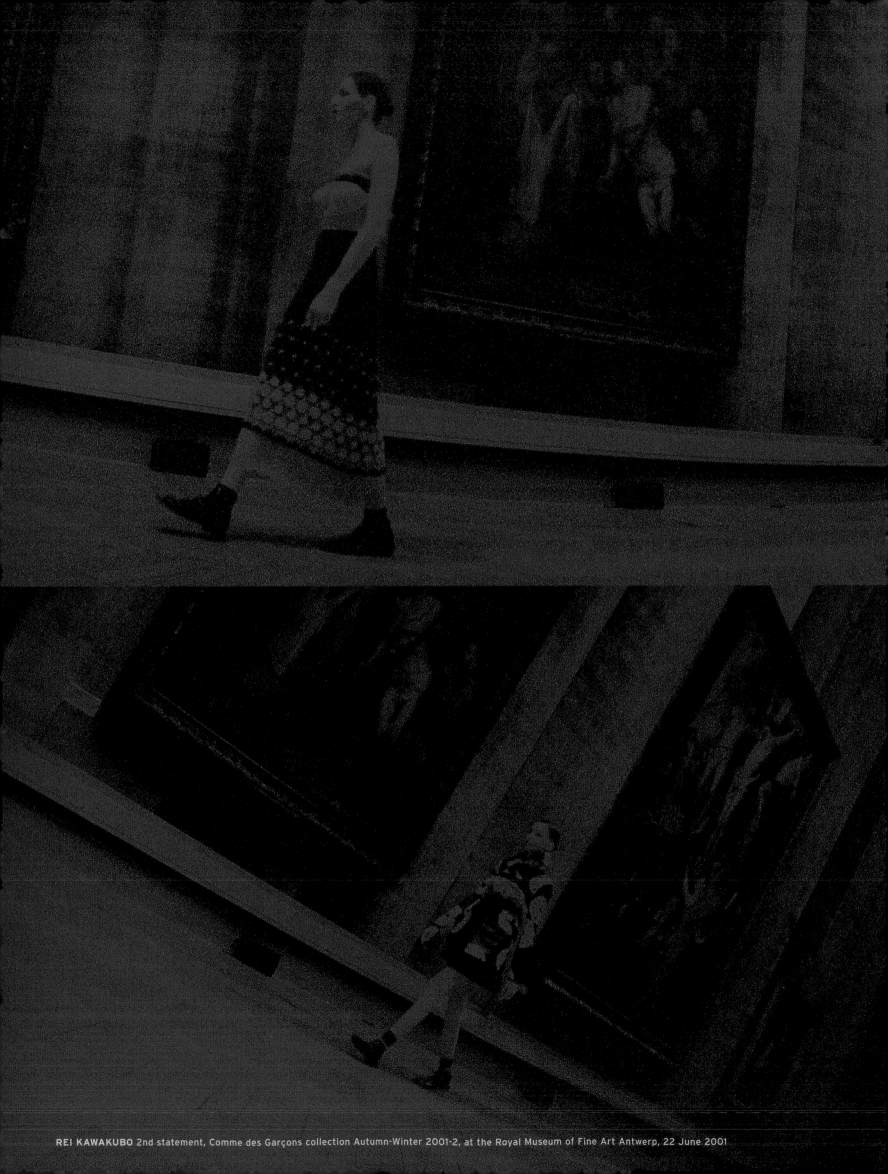

REI KAWAKUBO 2nd statement, Comme des Garçons collection Autumn-Winter 2001-2, at the Royal Museum of Fine Art Antwerp, 22 June 2001

LA CHAMBRE DU COMMENTAIRE

TCR 02:13:37:15
UBR 01:00:00:00

" J'ai rendu au corps ___ ___mes sa liberté:
ce corps suait dans ___ ___bits de parade,
sous les dentelles, ___ ___ets, les dessous,
le rembourrage " ___ des fe___
___s des Ha___
___ les c___rs

Chanel a l'idée de relier l

LA CHAMBRE DES SECRETS

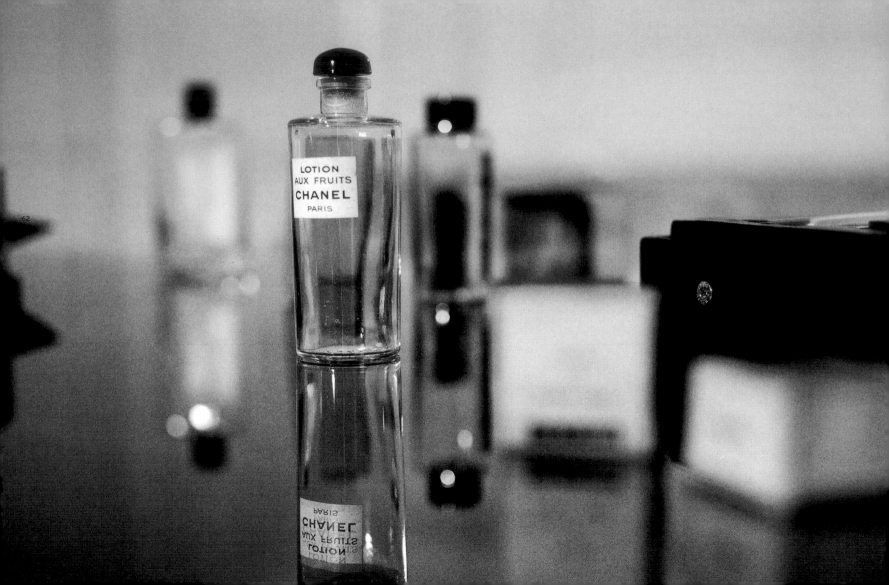

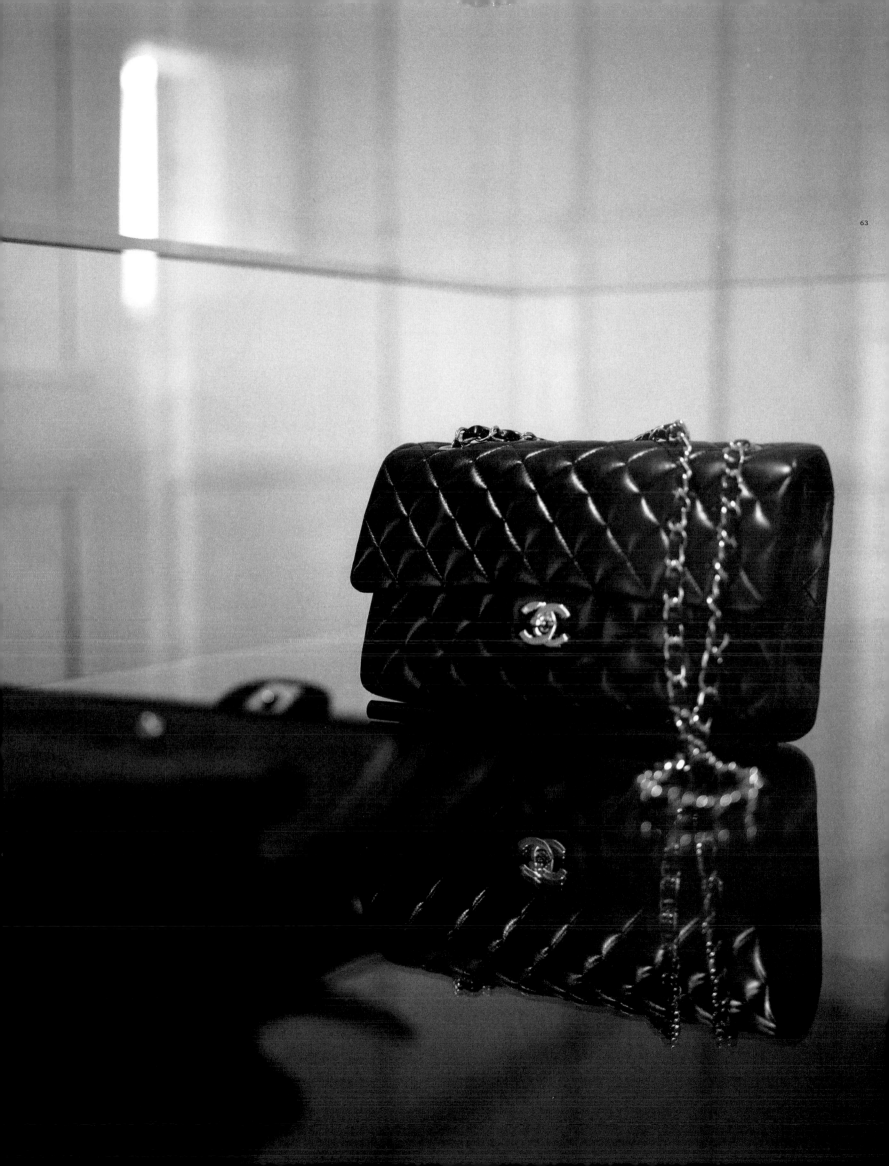

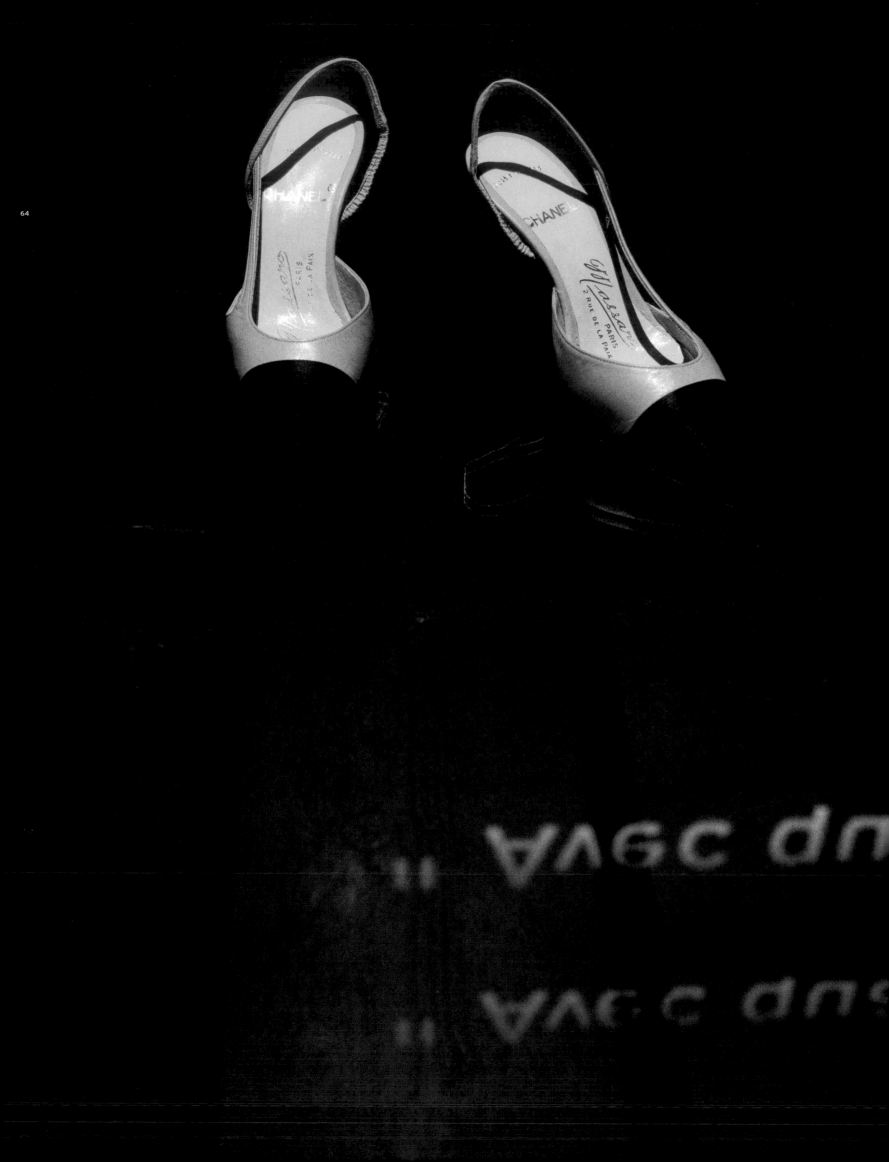

LA CHAMBRE N°5

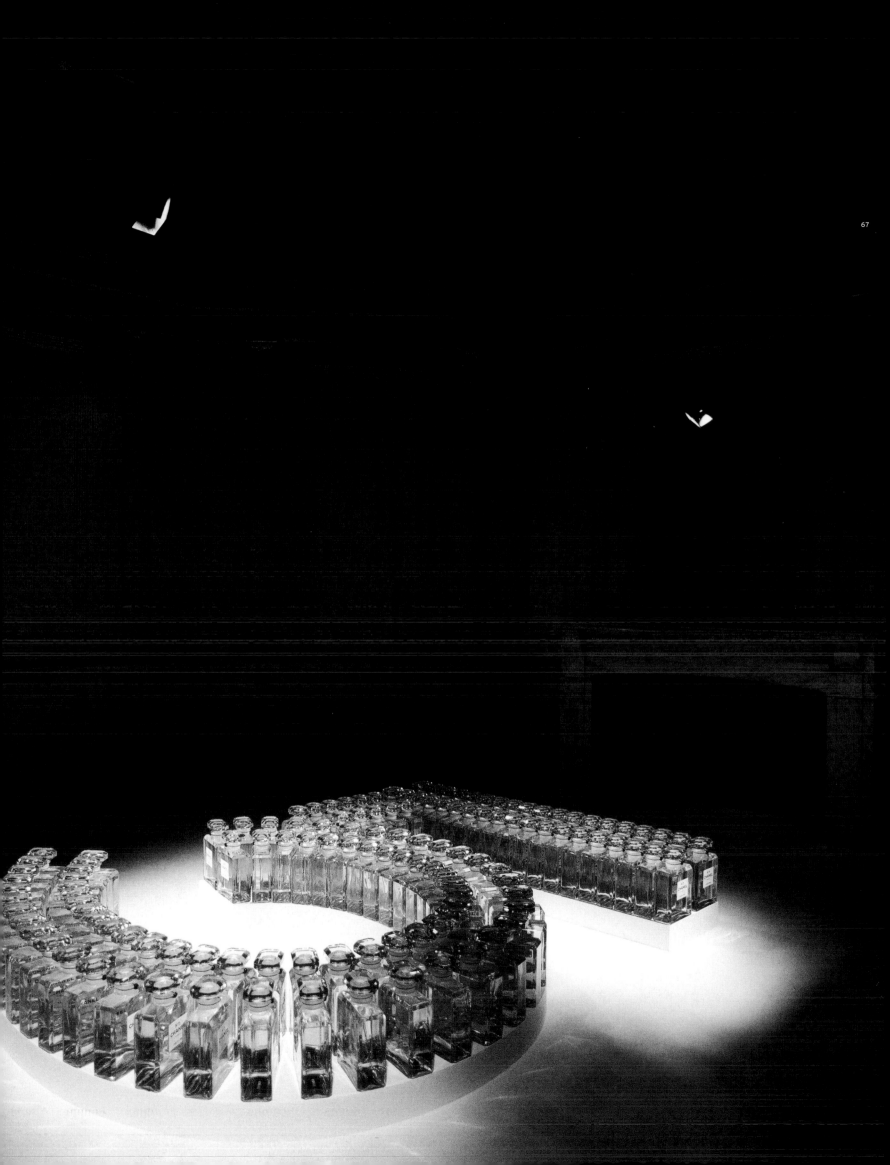

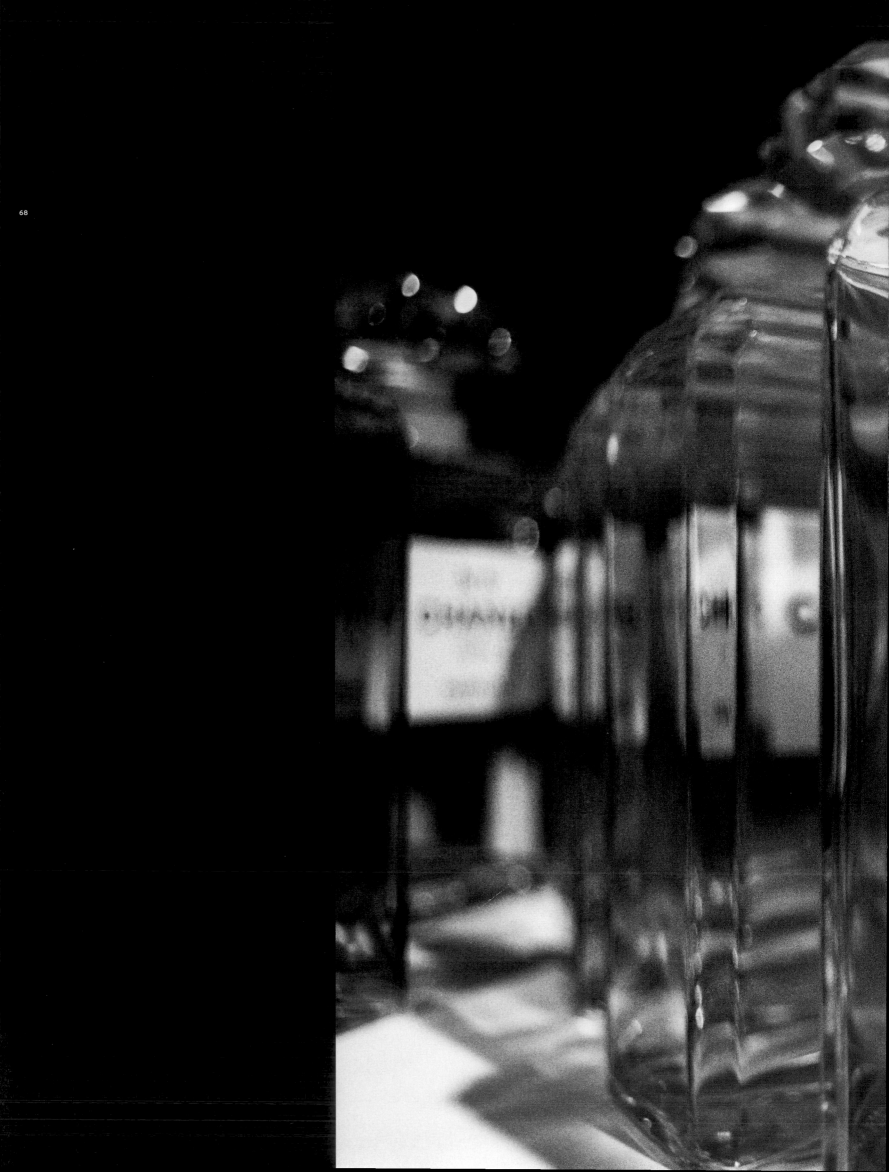

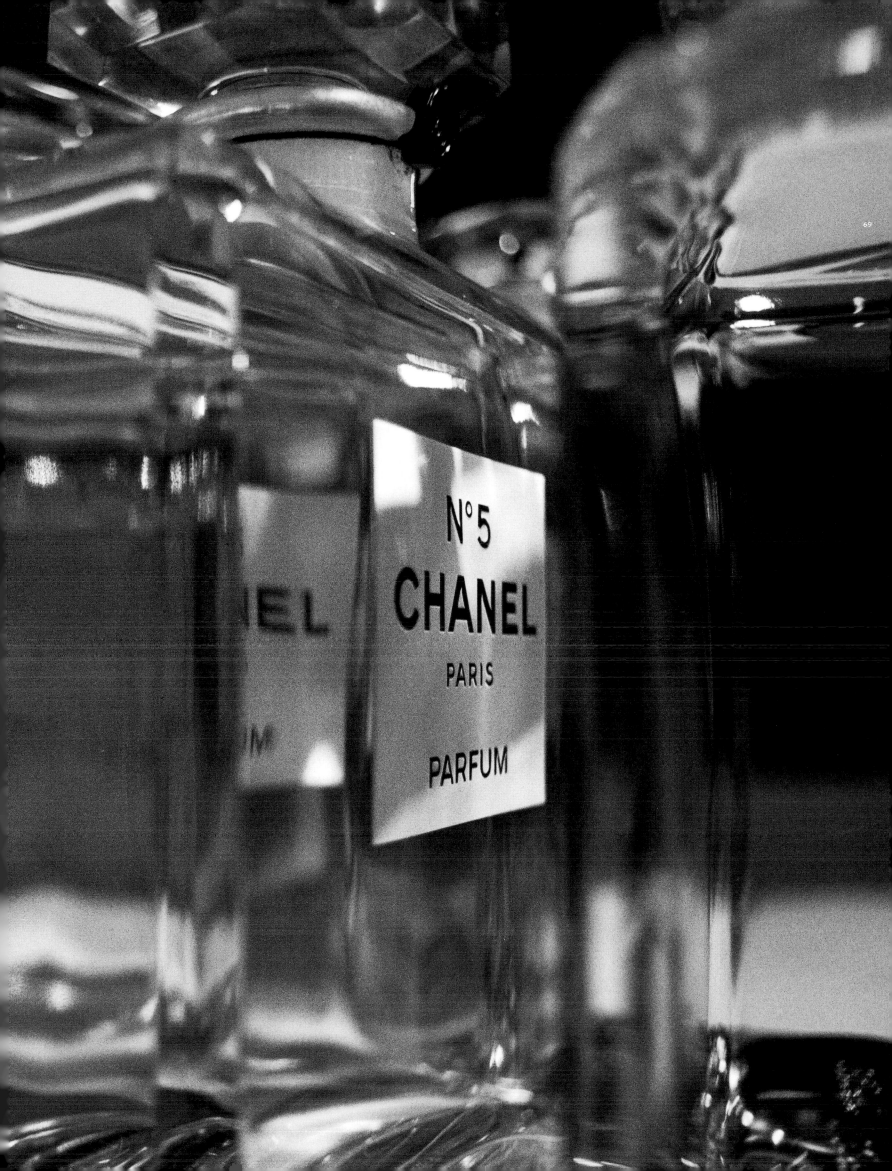

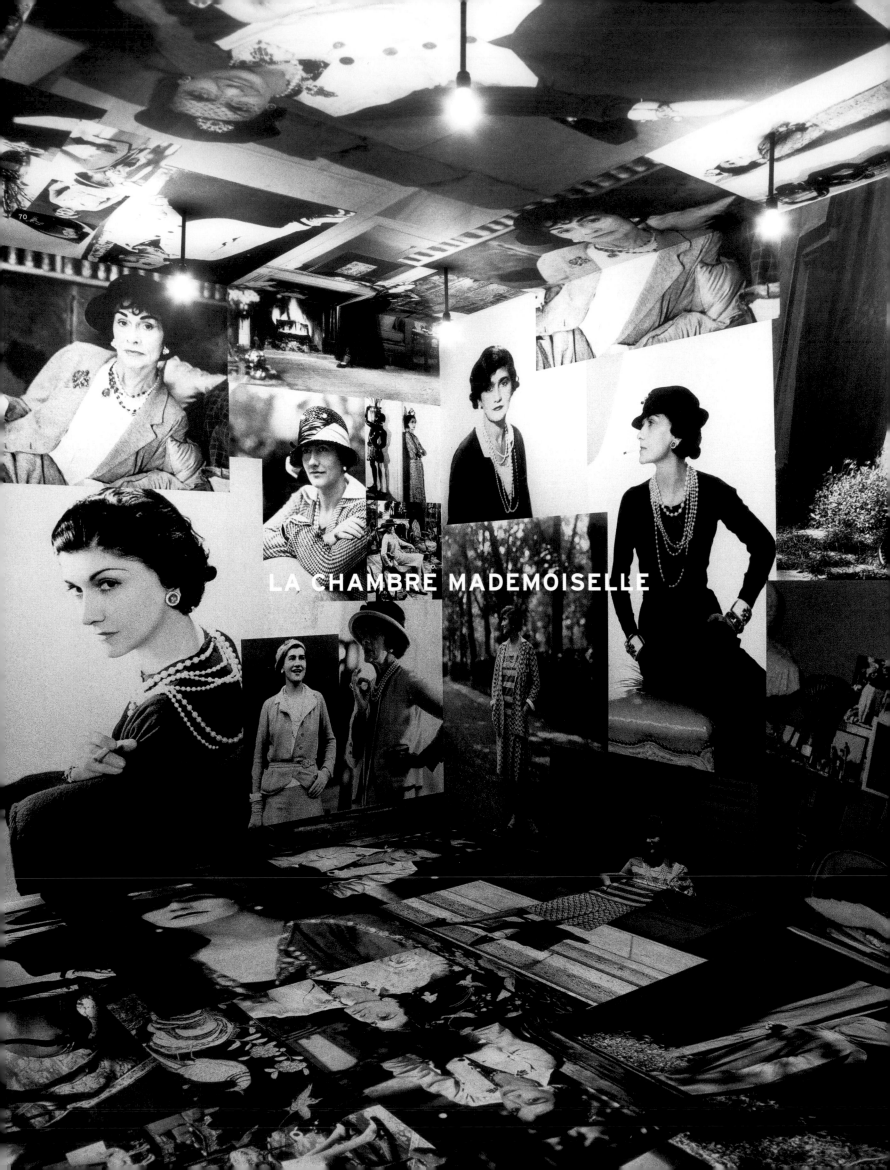

LA CHAMBRE MADEMOISELLE

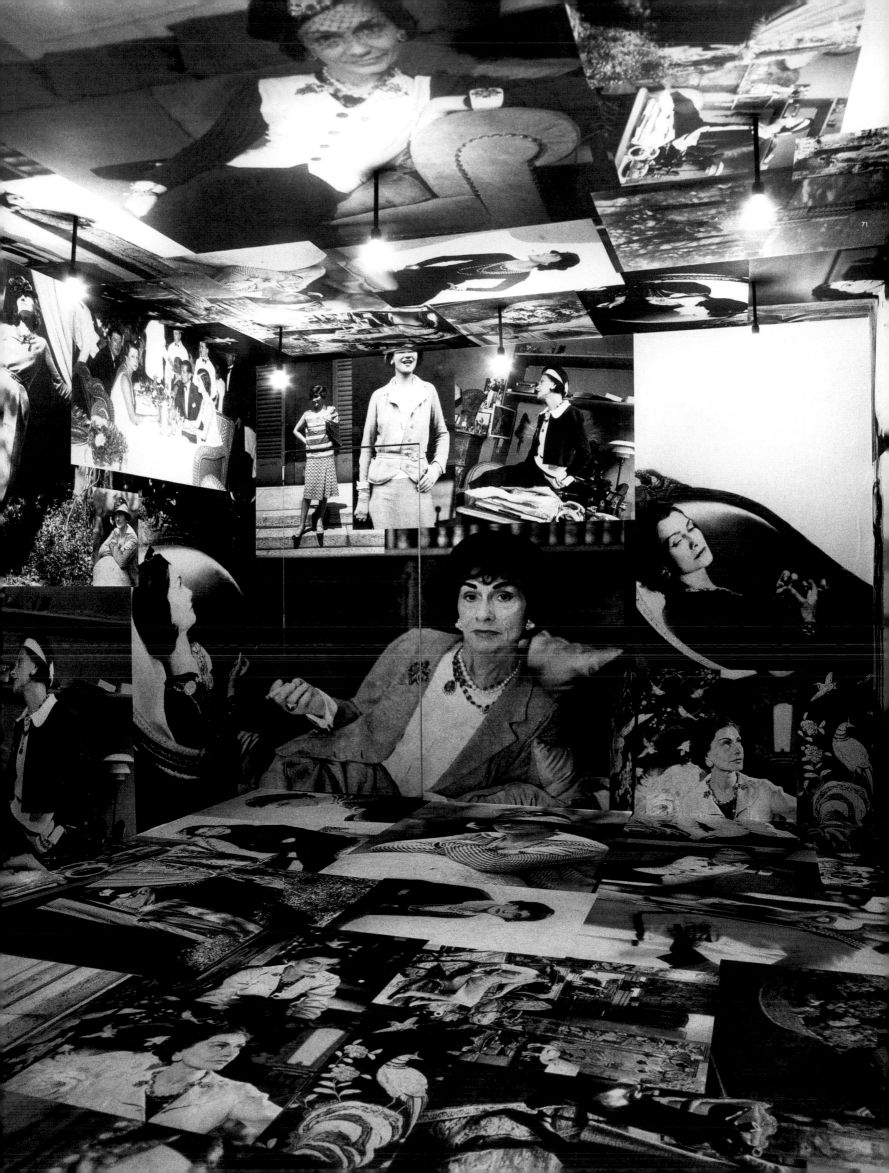

LA CHAMBRE DU STYLE

LA CHAMBRE DU STYLE

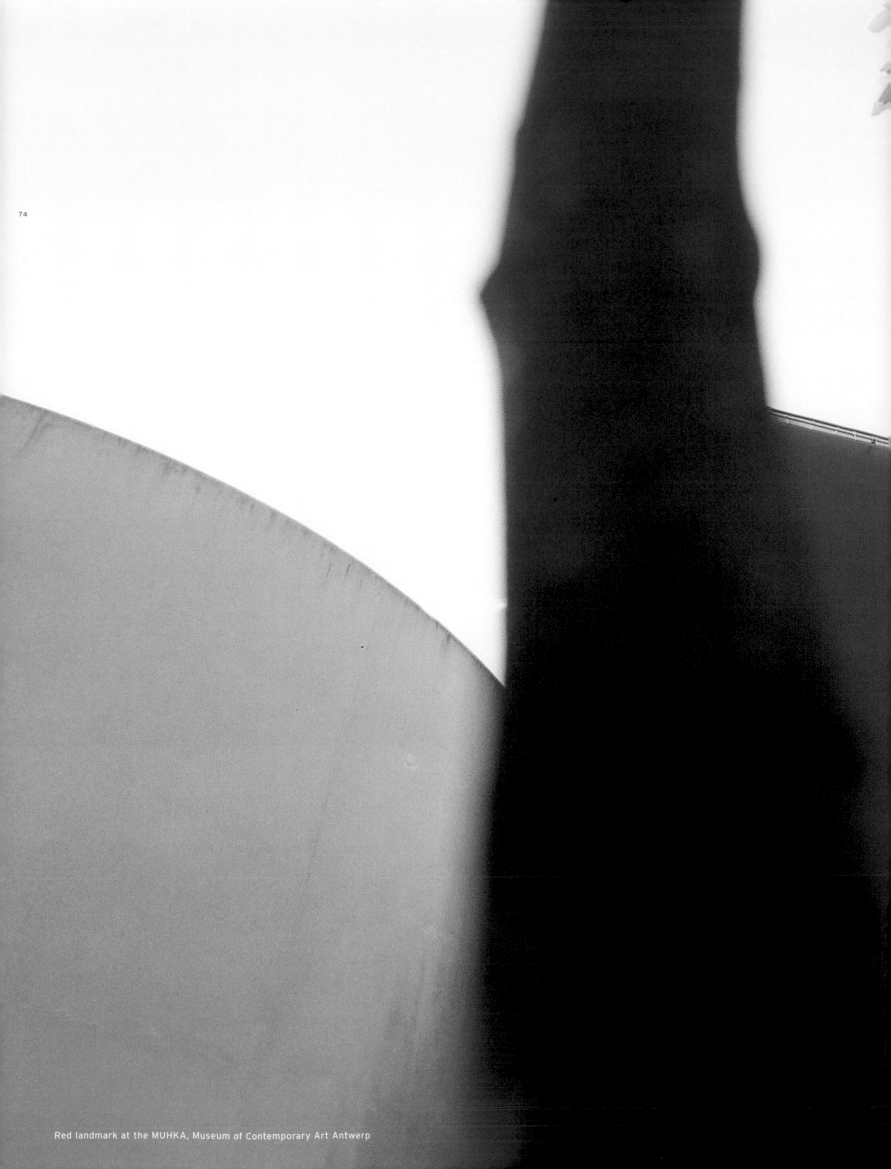

Red landmark at the MUHKA, Museum of Contemporary Art Antwerp

MUT
ILA
TE
?

VERMINK?
MUTILATION?

CONFRONTATIONS

CONSTRUCTIONS

TRANSFORMATIONS

BODY ART

FASCINATION

AVATARS

CONTEMPORARY FASHION

CONF

CONFRONTATIES

REALISATIE INSTALLATIE: SET BVBA, AARTSELAAR
VIDEOPROJECTIE: VIDISQUARE NV, ZANDHOVEN

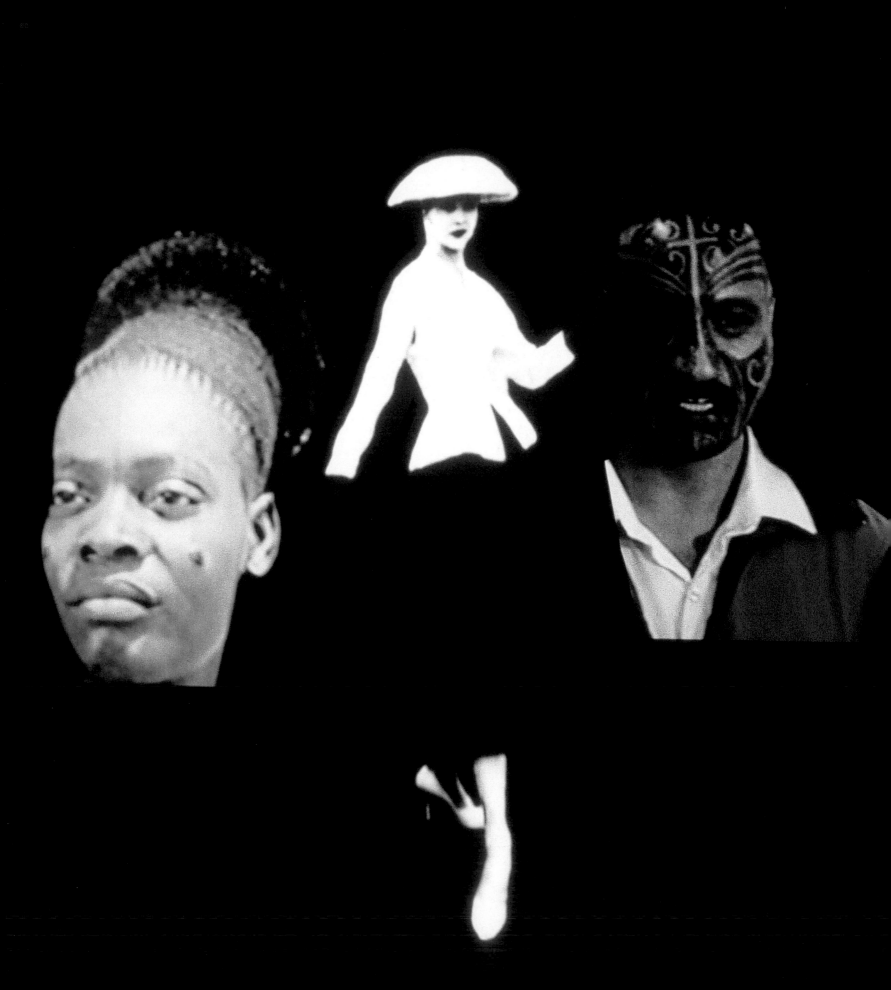

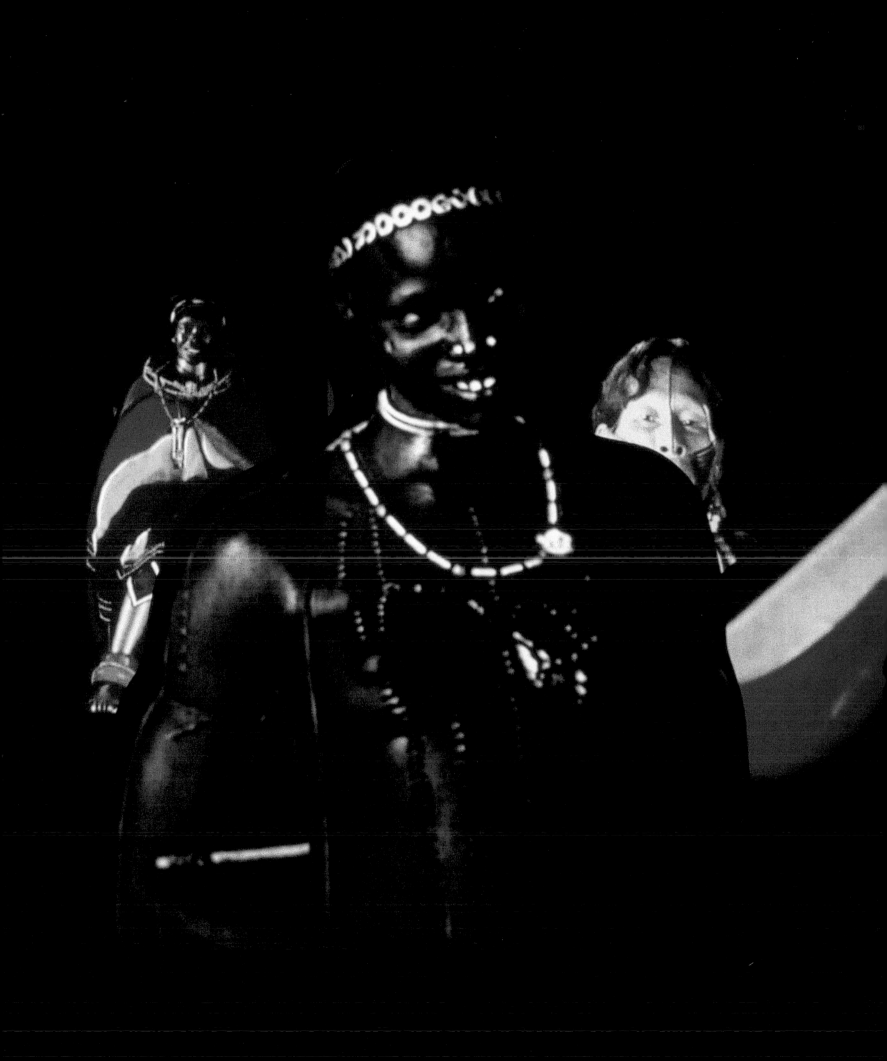

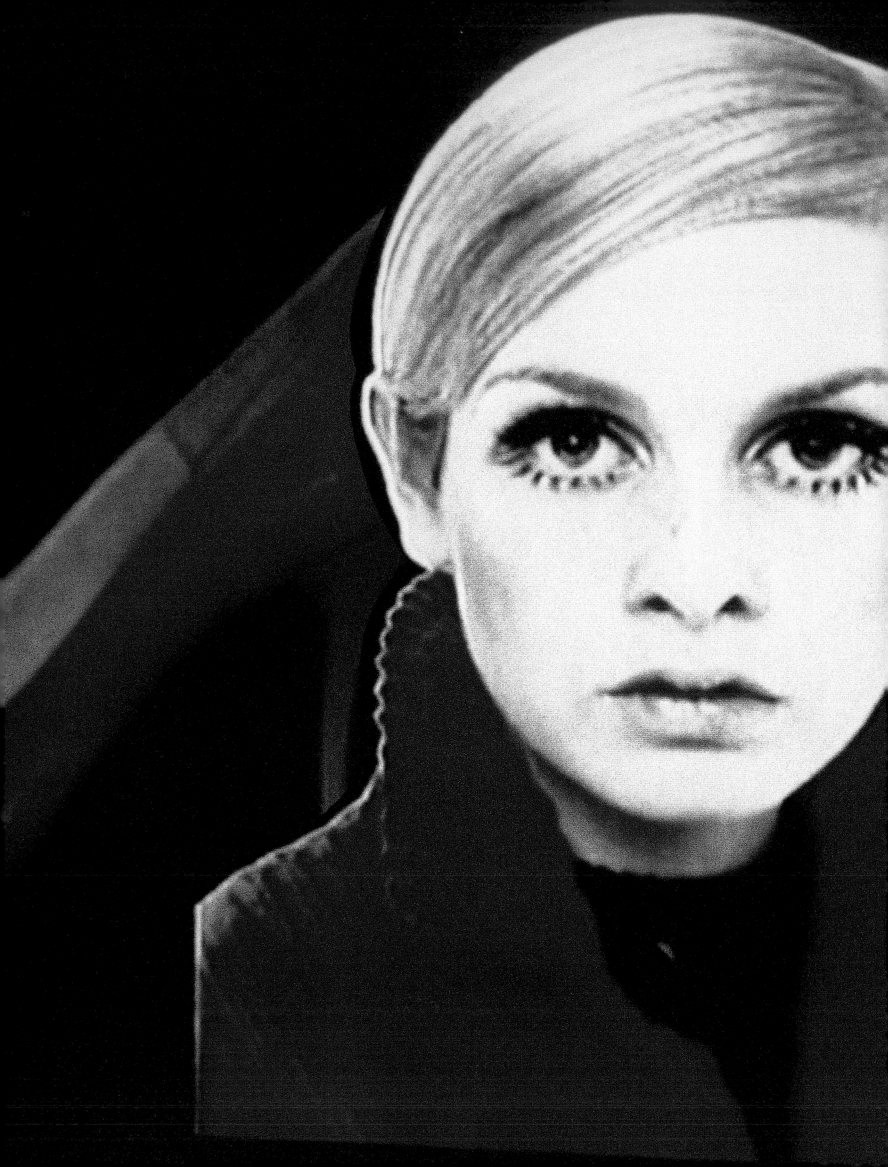

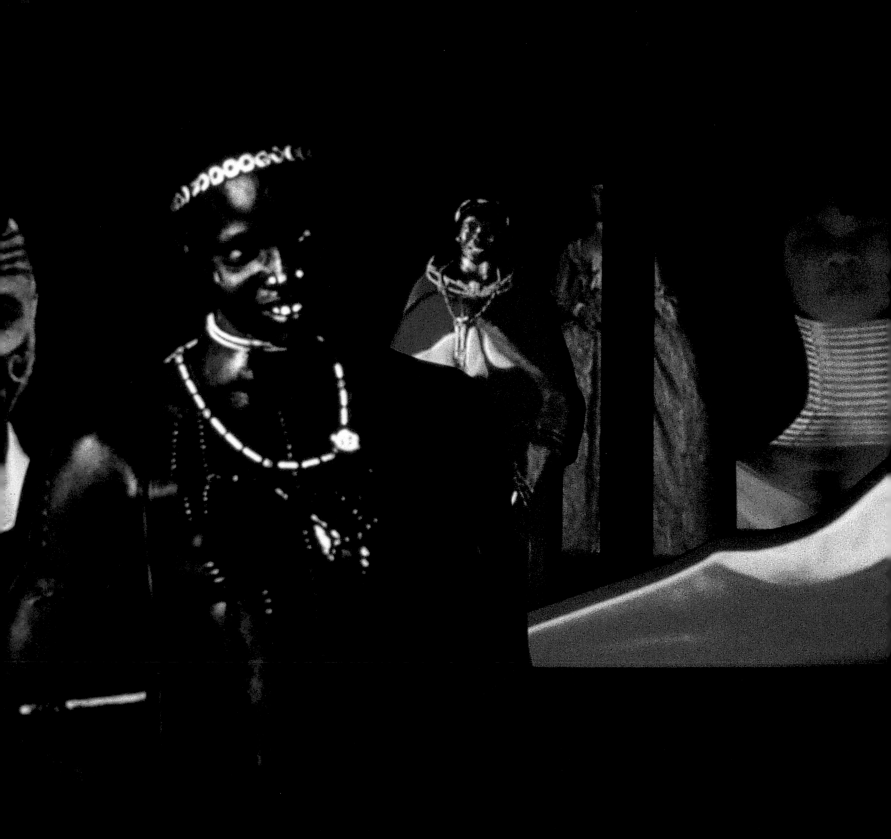

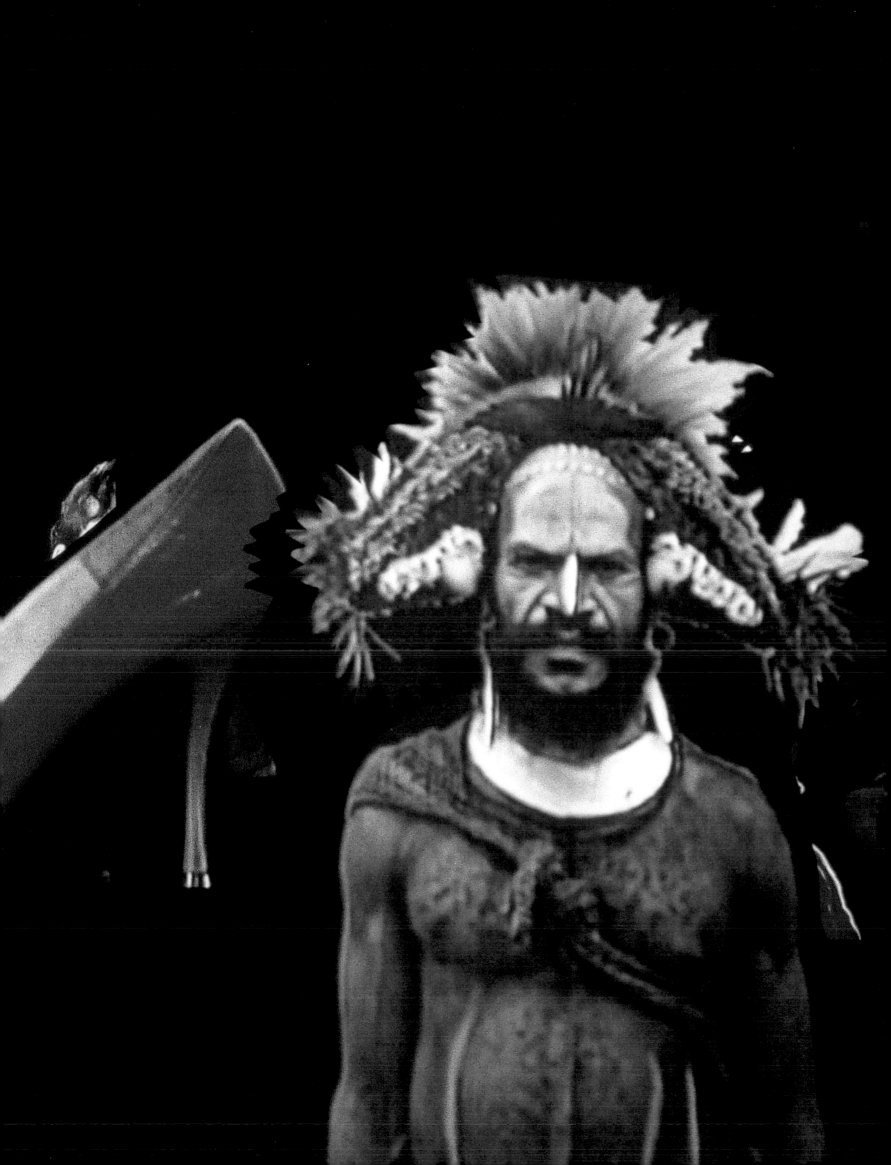

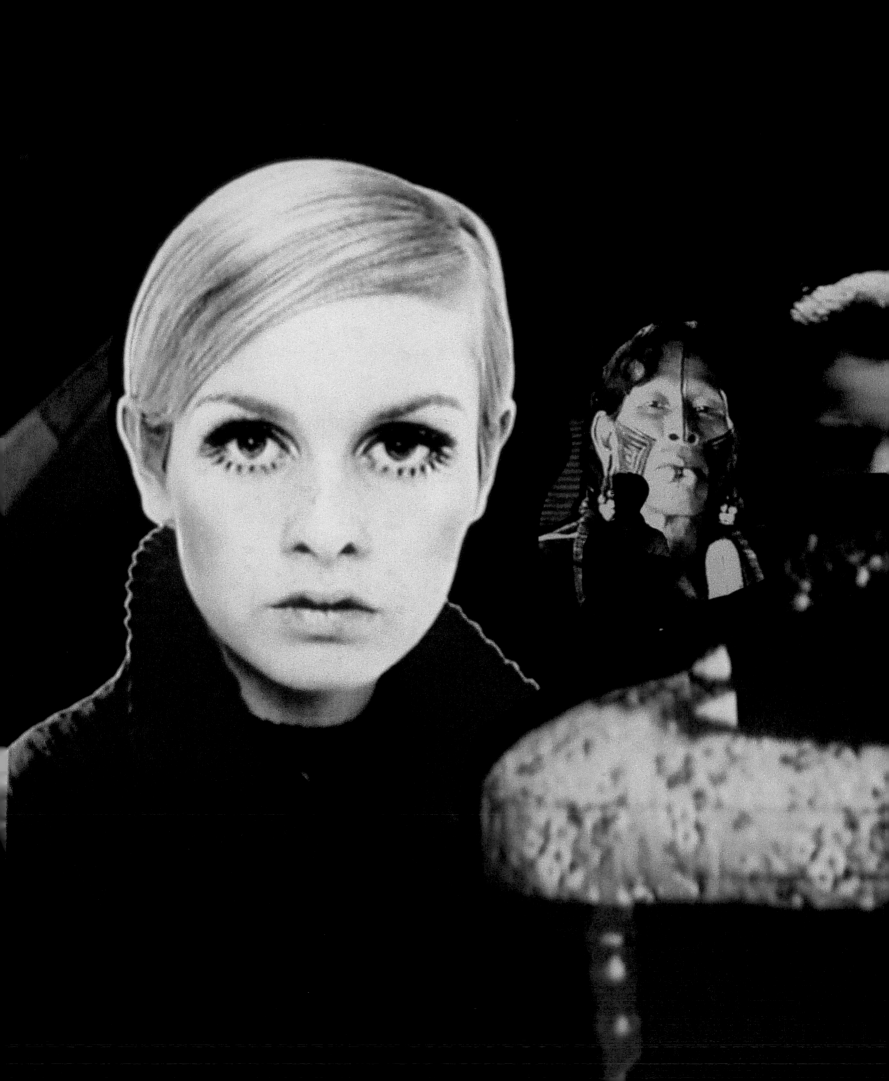

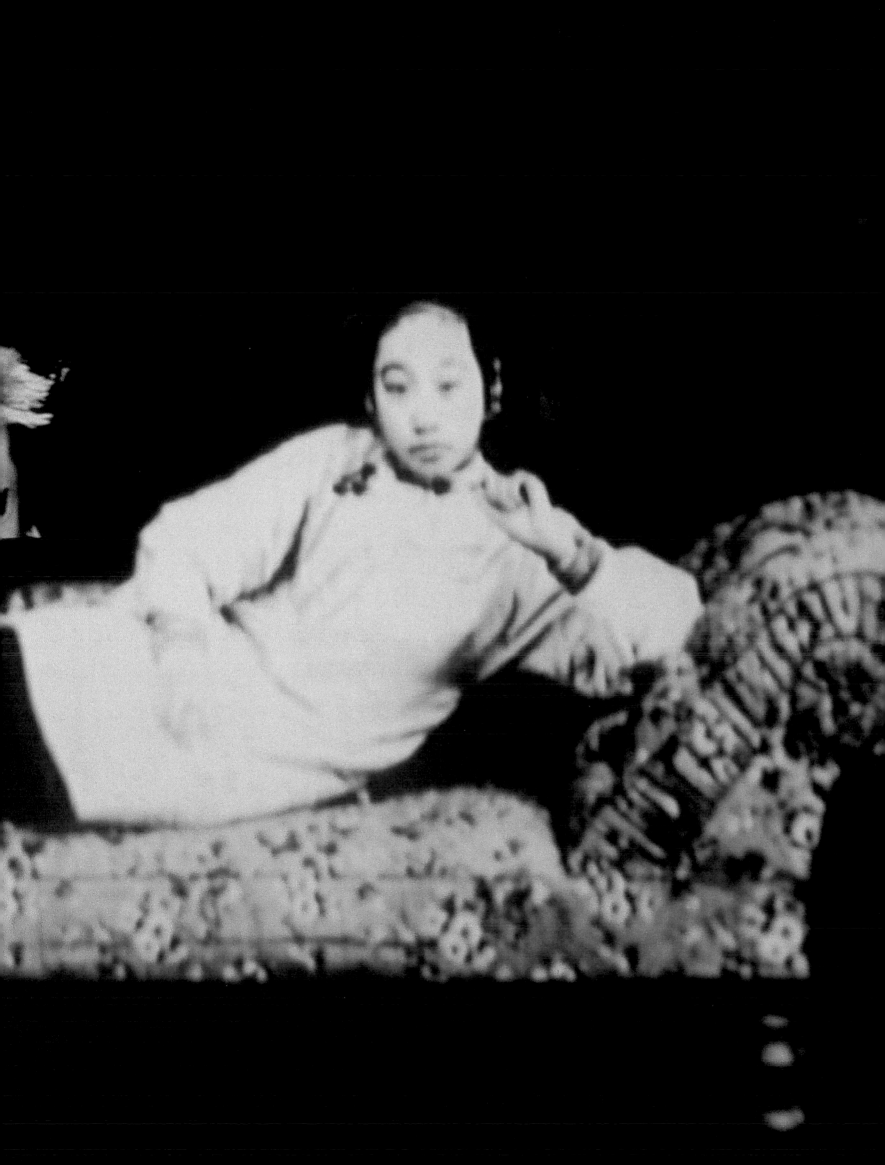

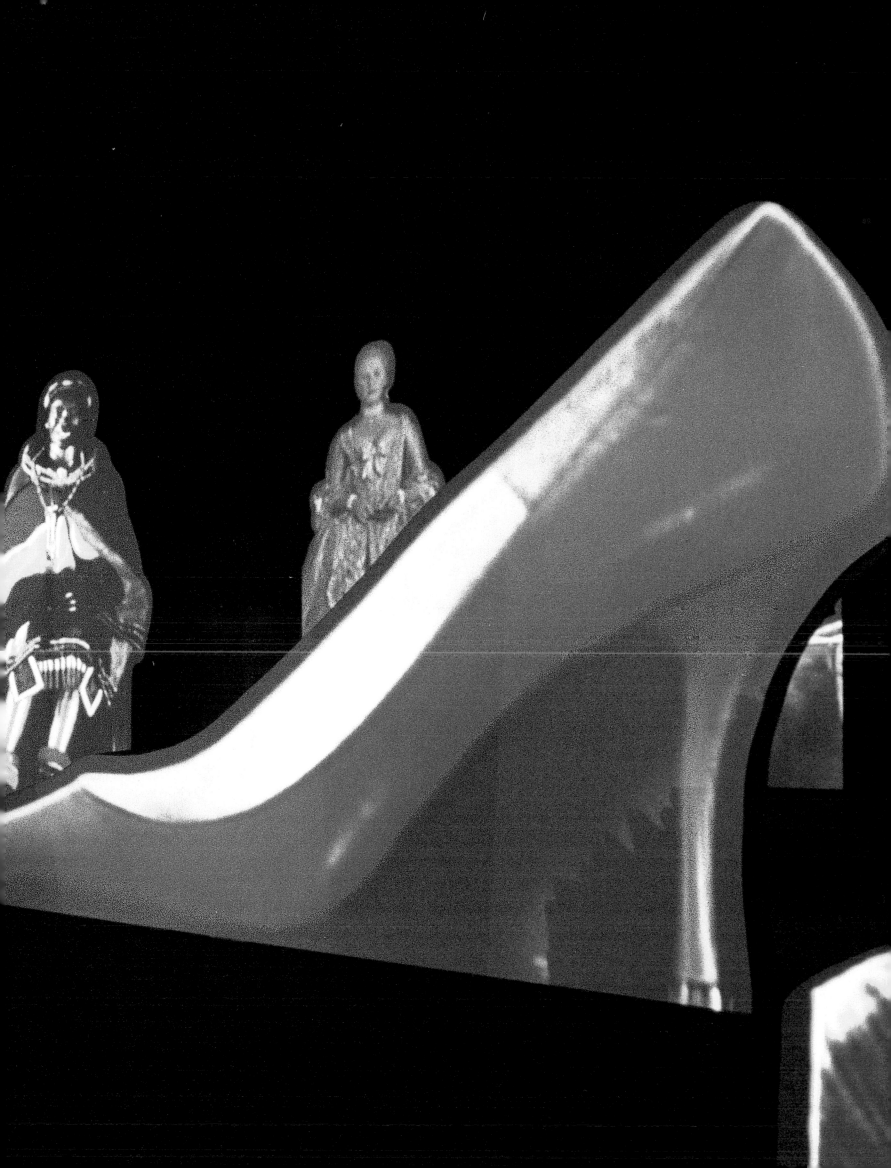

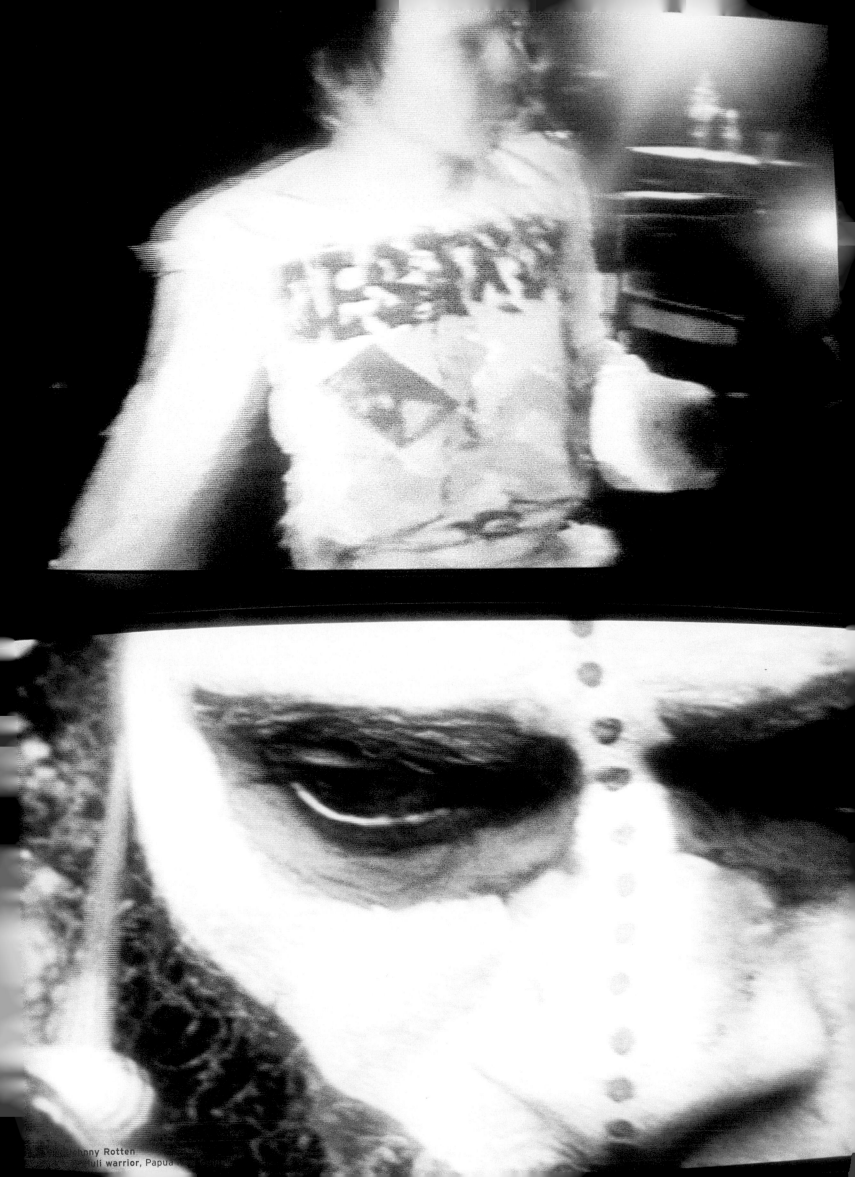

Johnny Rotten
...Huli warrior, Papua...

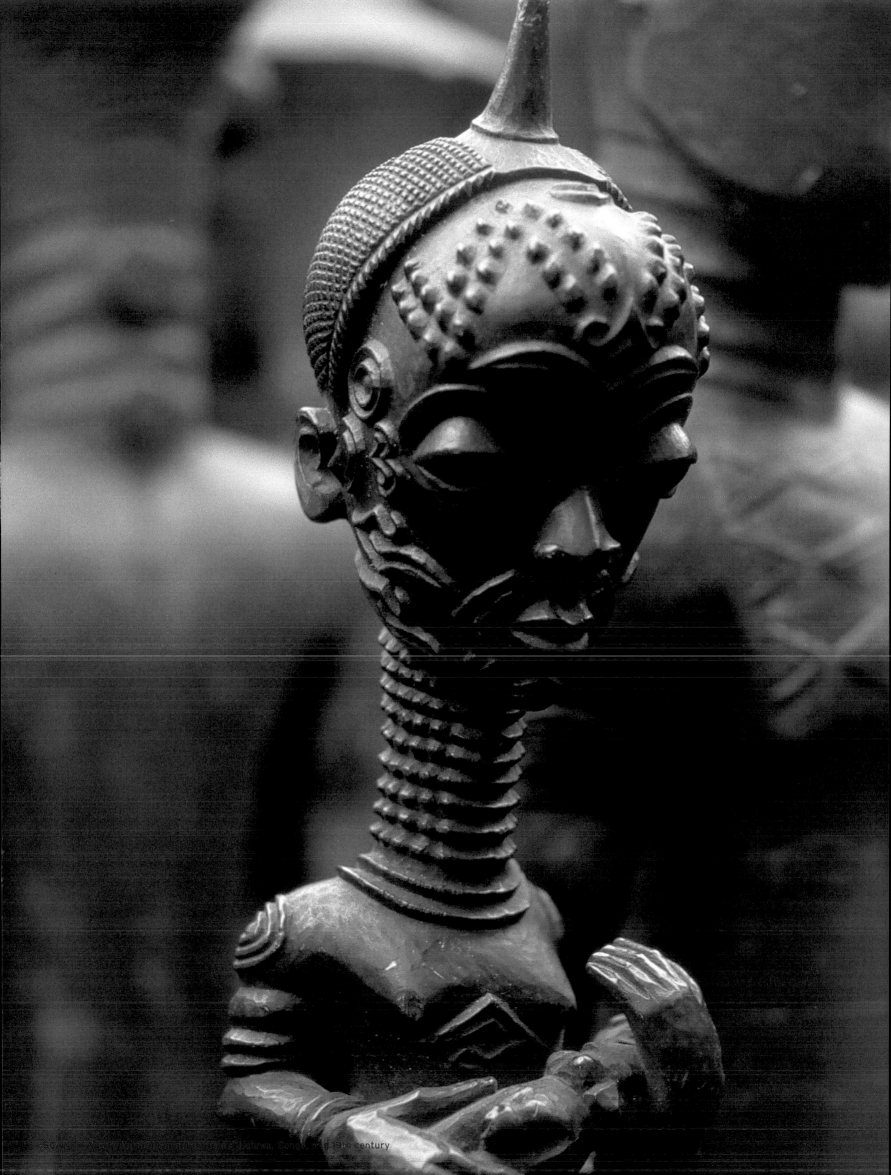

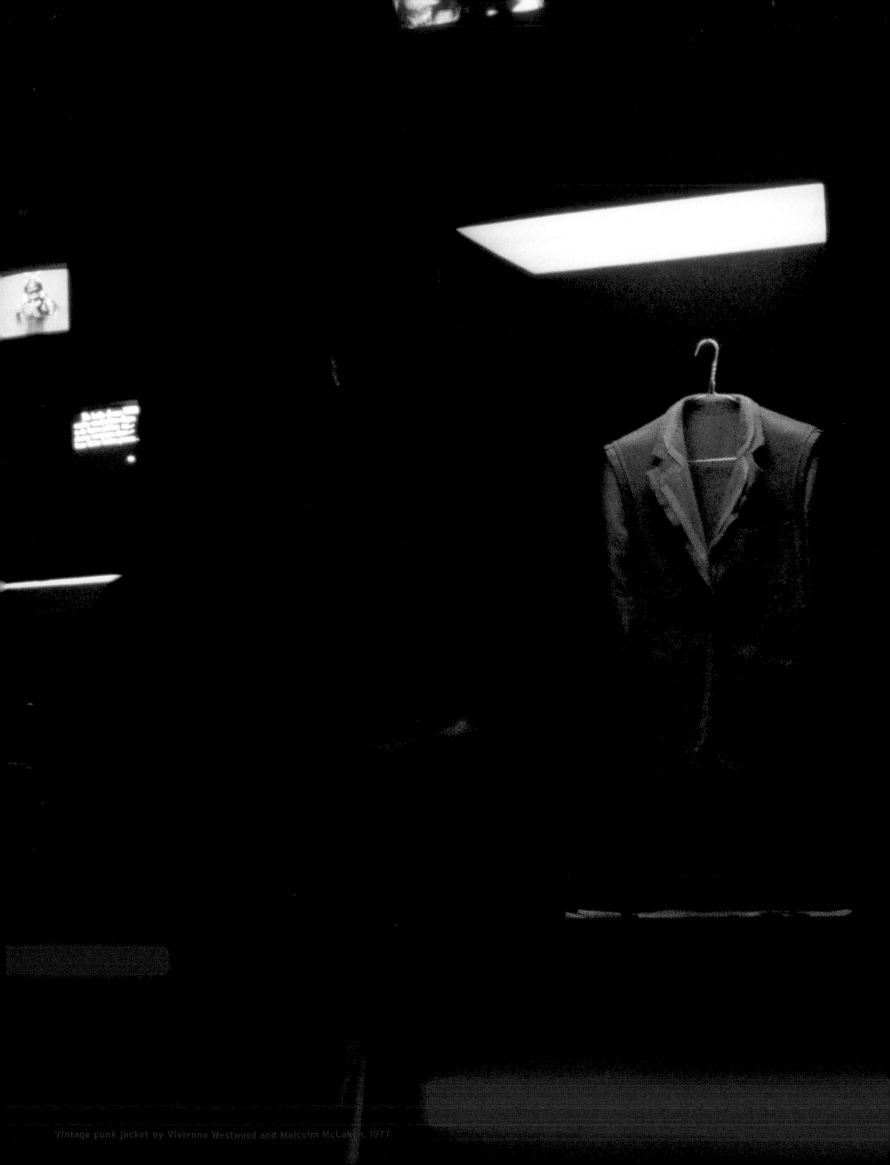

Vintage punk jacket by Vivienne Westwood and Malcolm McLaren, 1977.

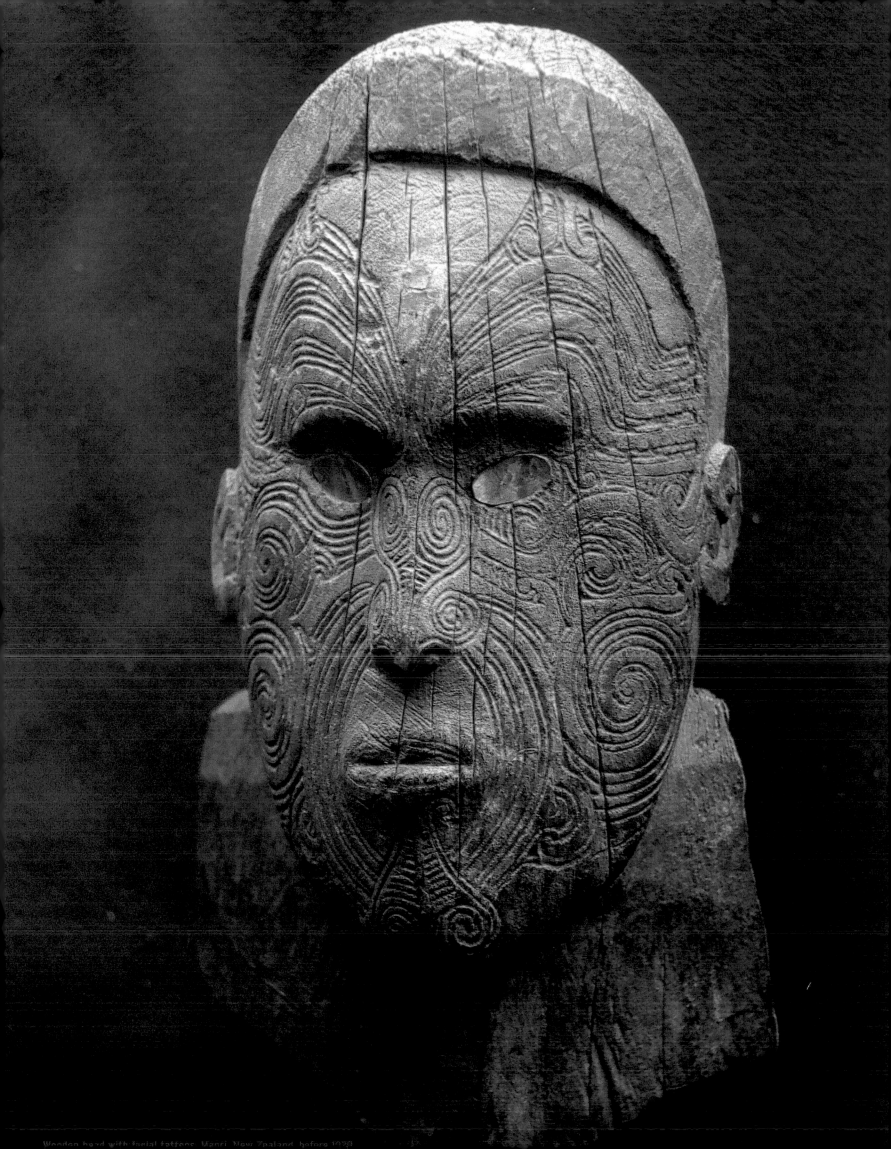

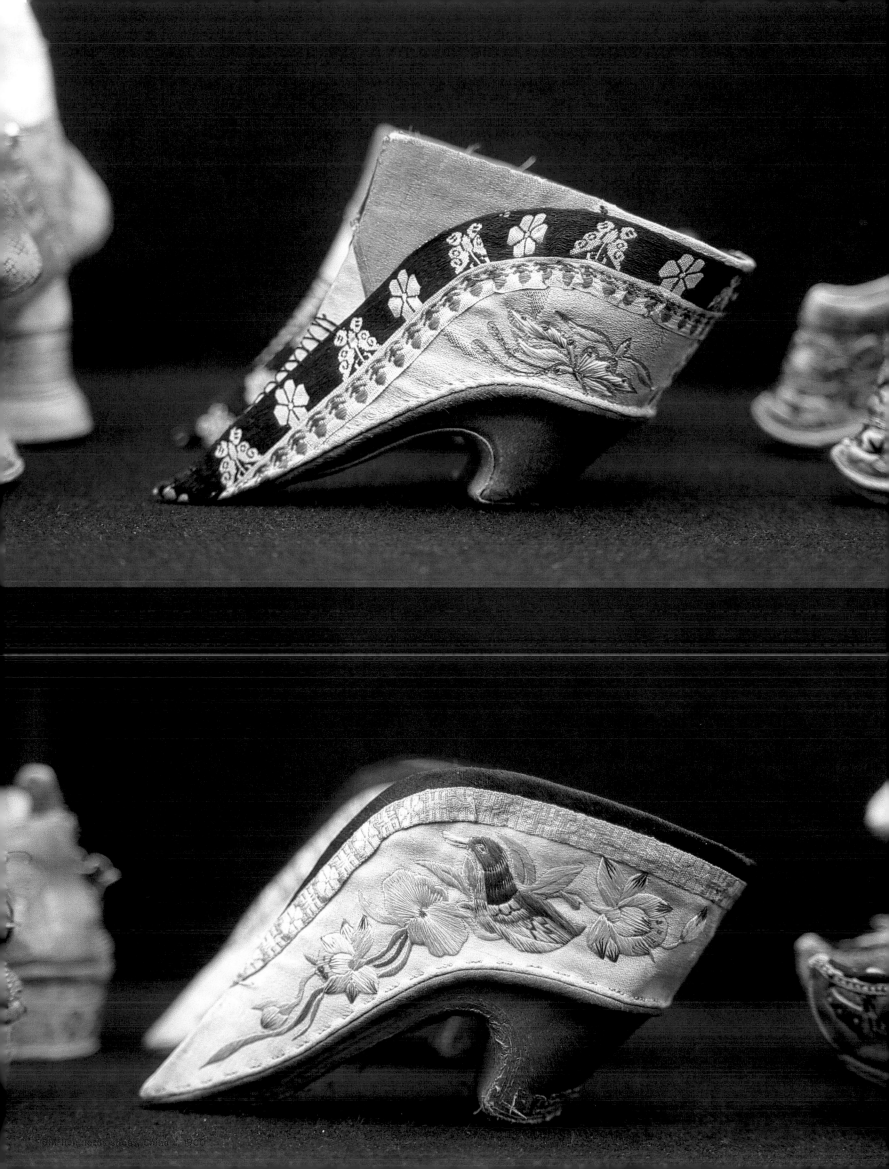

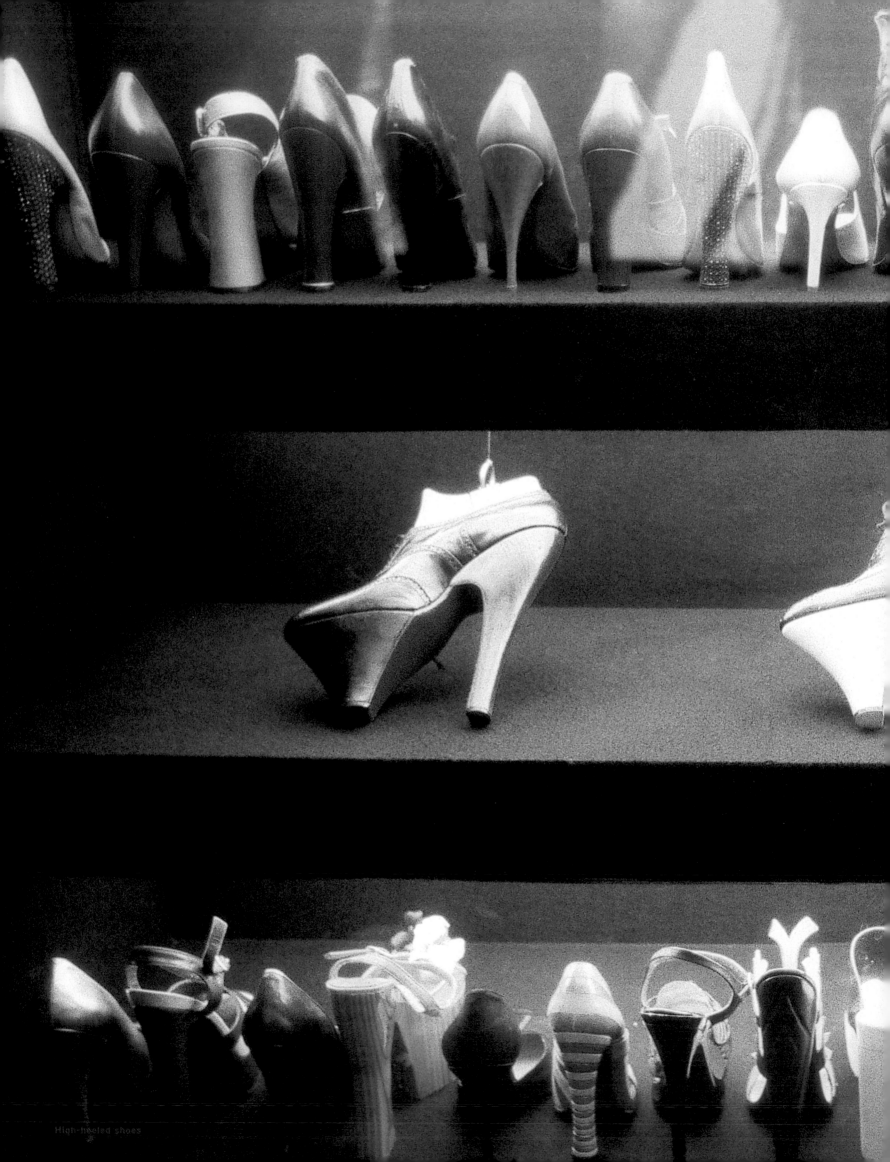

High-heeled shoes

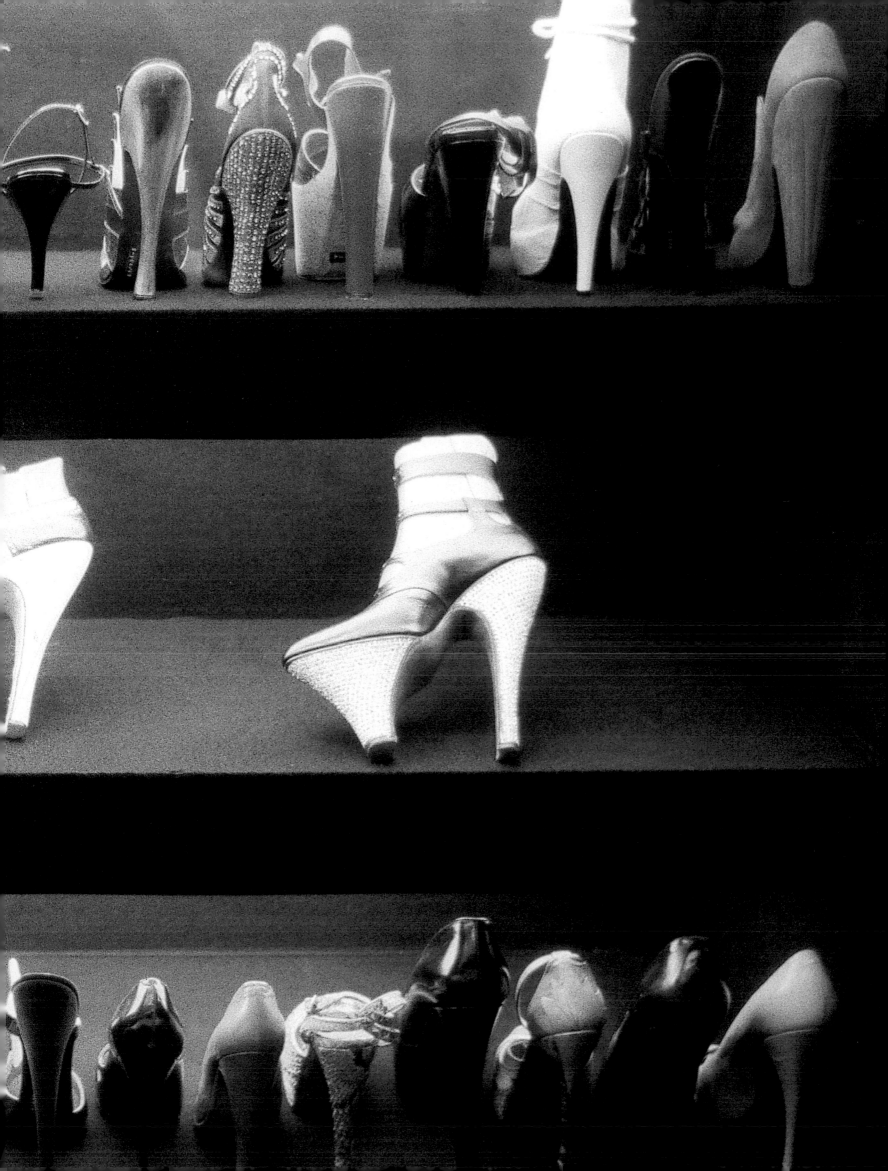

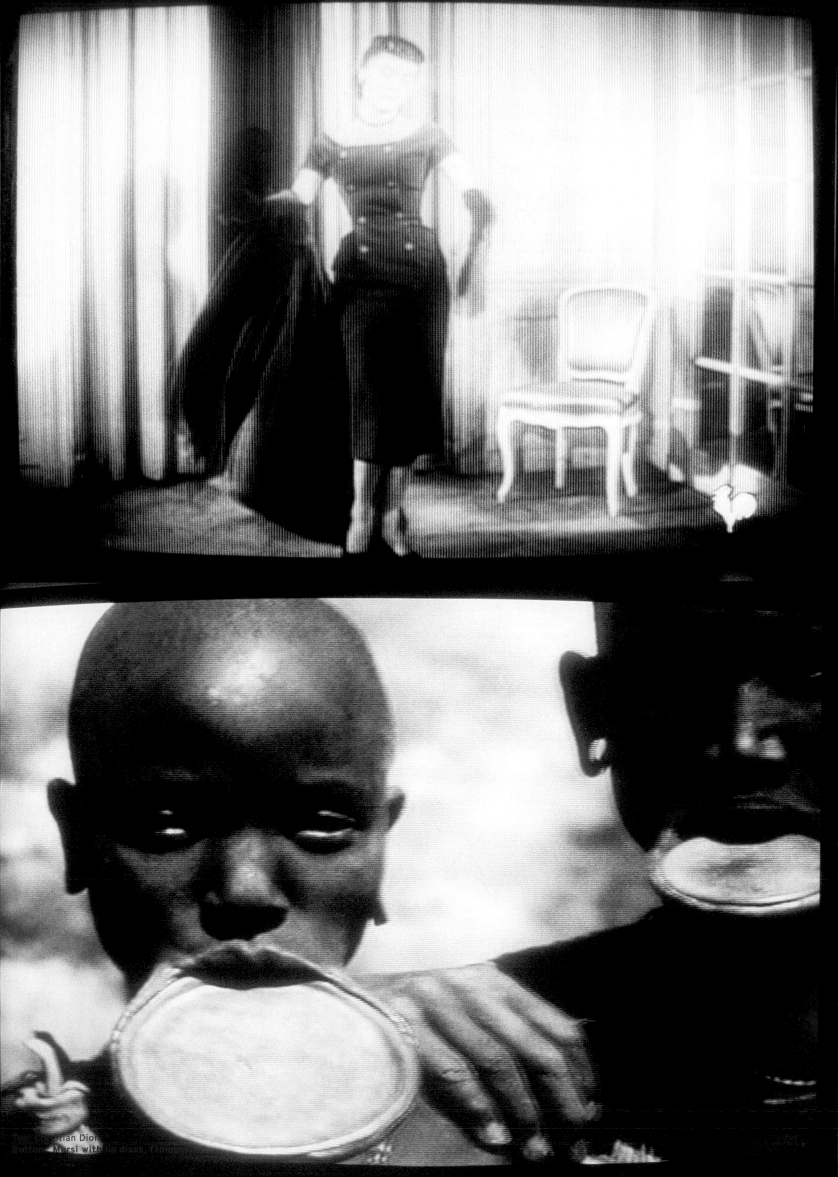

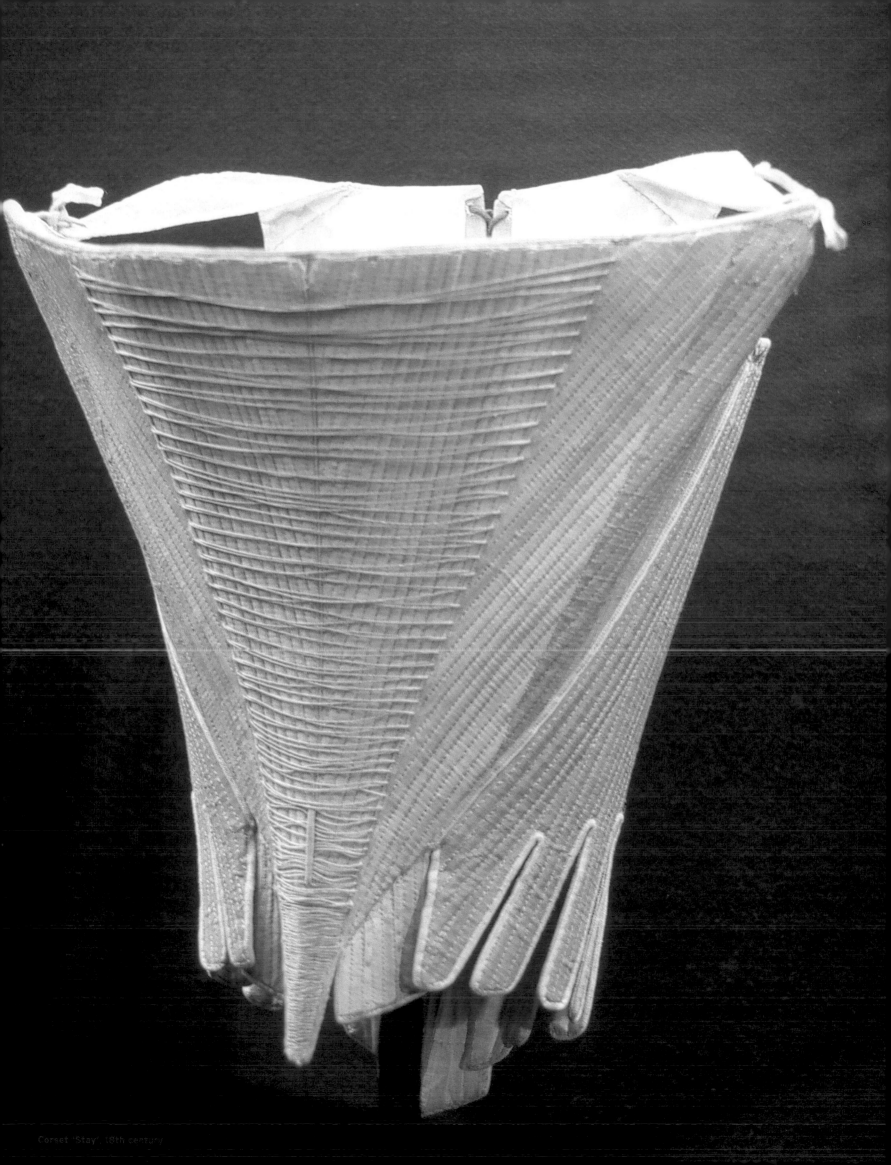

I said to them "What do you think about us taking moko. I would like to wear a moko".

Top: Maori man, New Zealand
Bottom: Padaung woman with neckrings, Burma

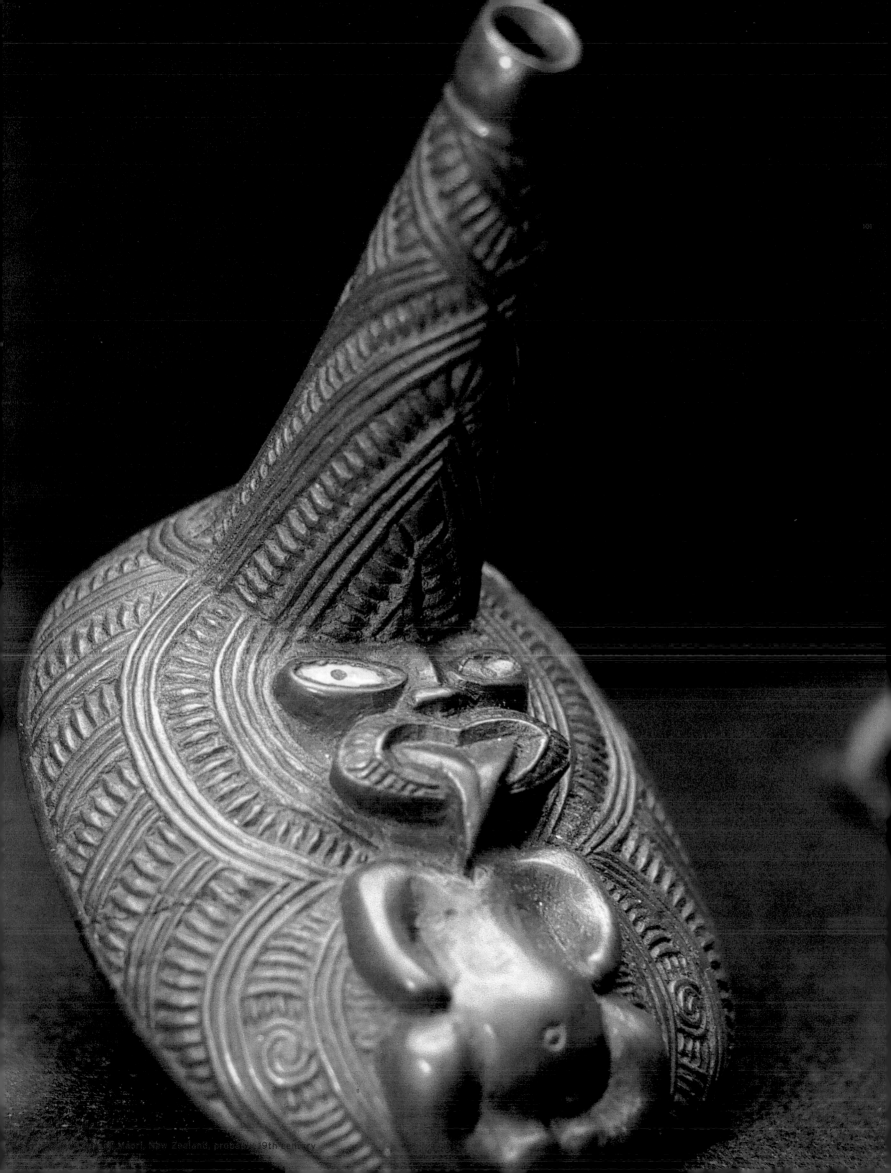

Māori, New Zealand, probably 19th century

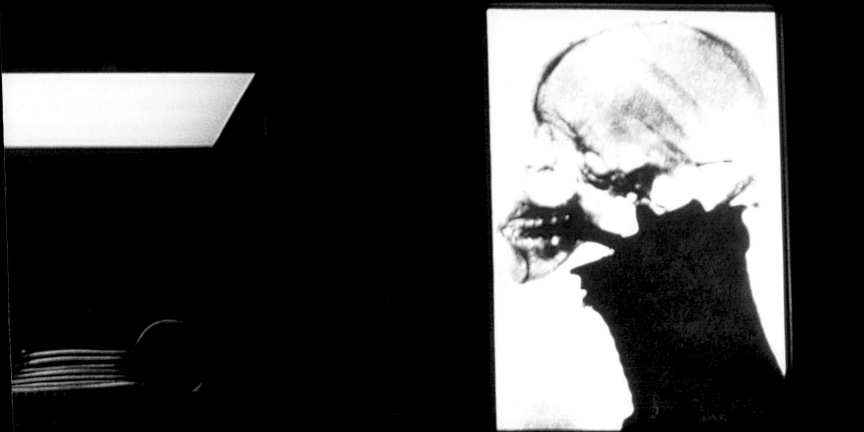

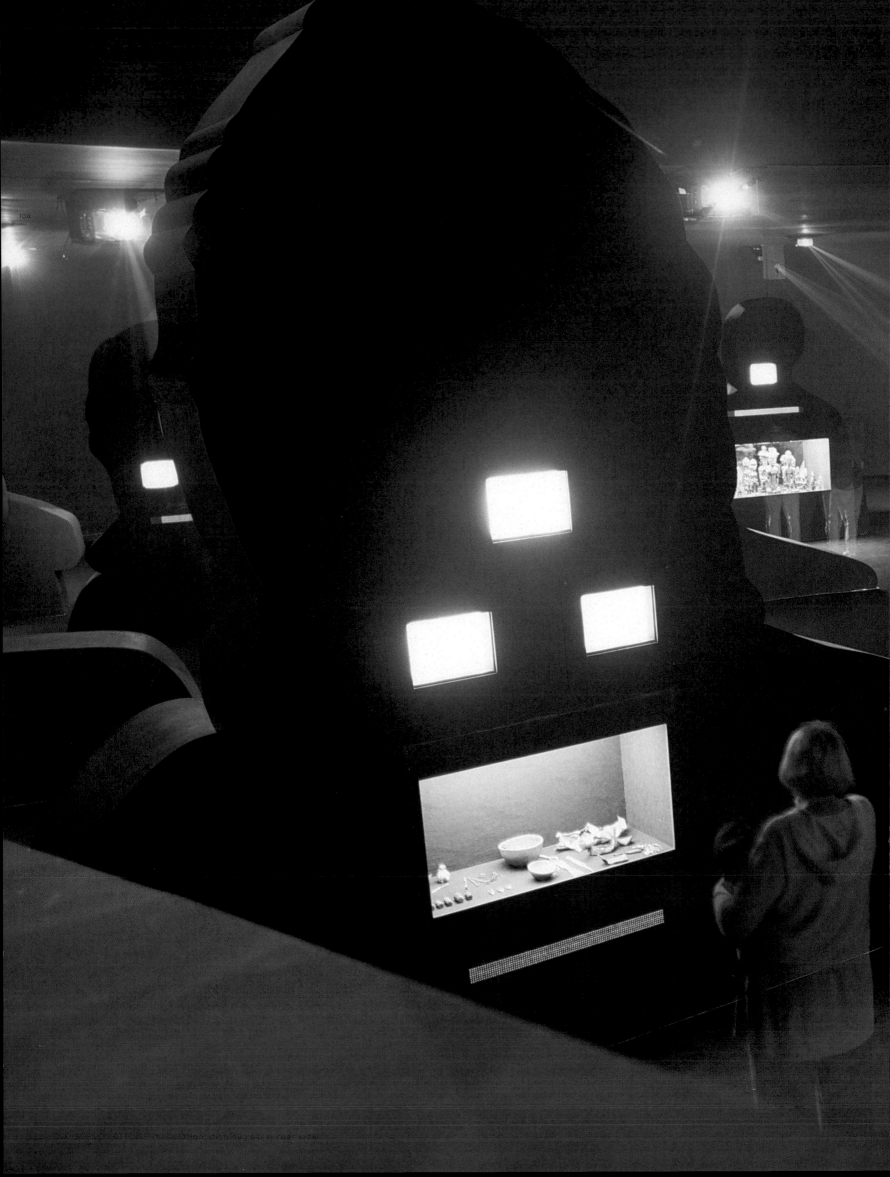

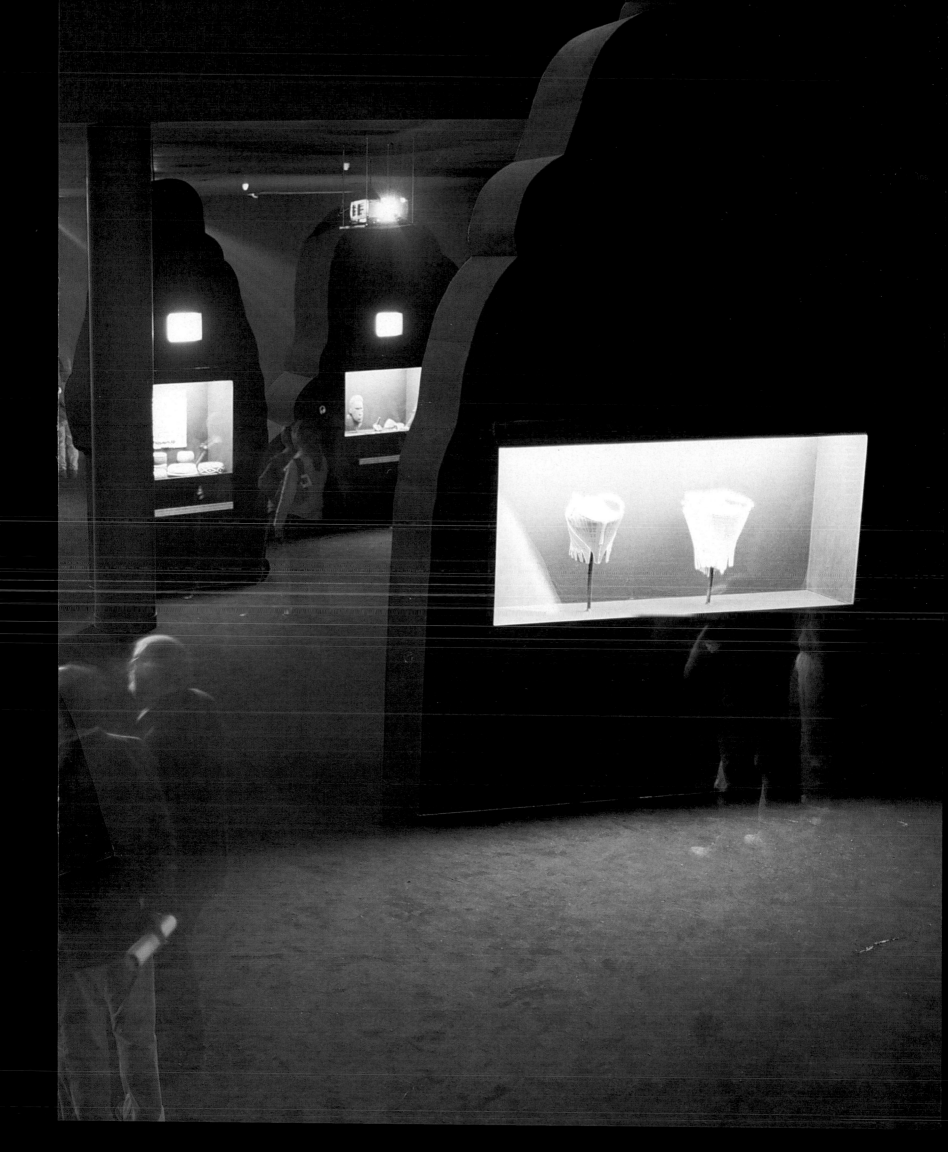

CONSTRUCTIONS

Paper Panier silhouette, *c.* 1750

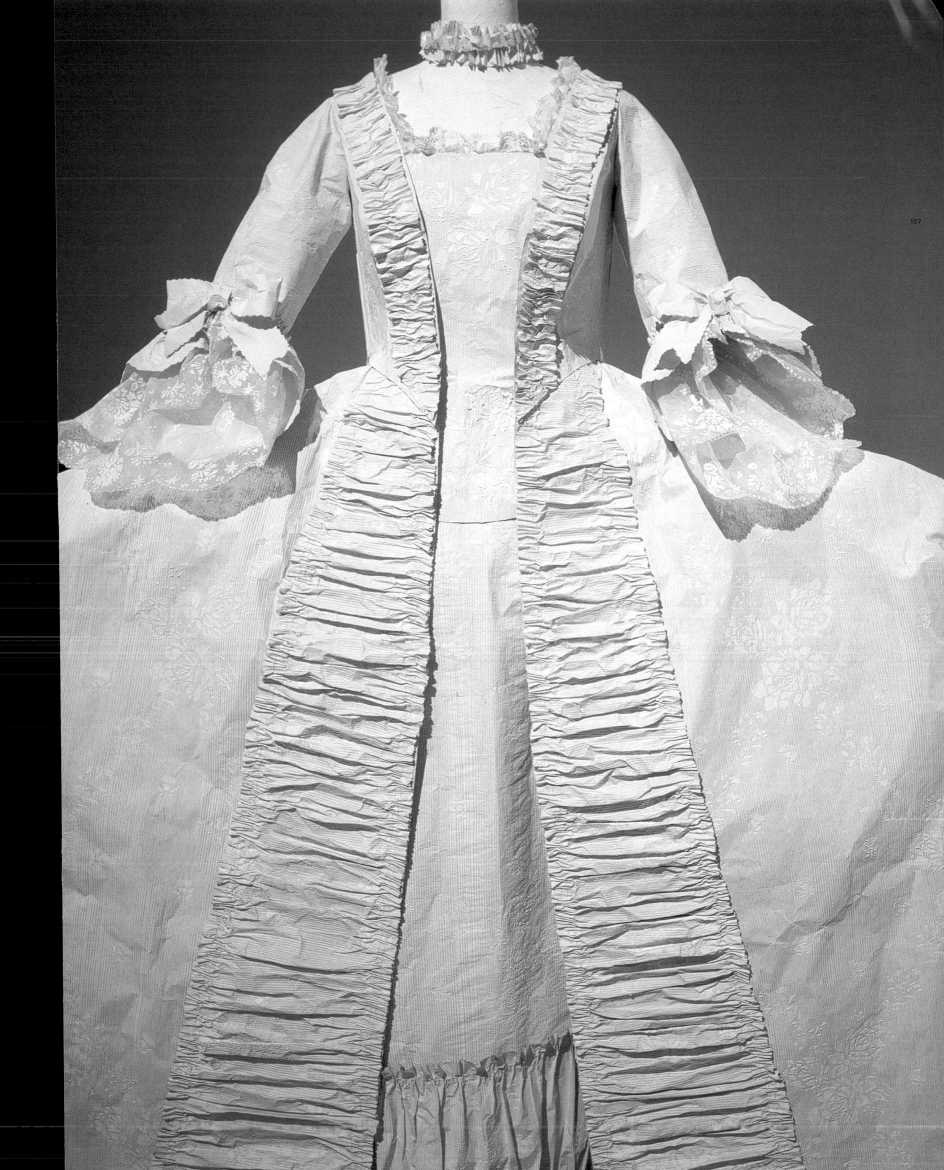

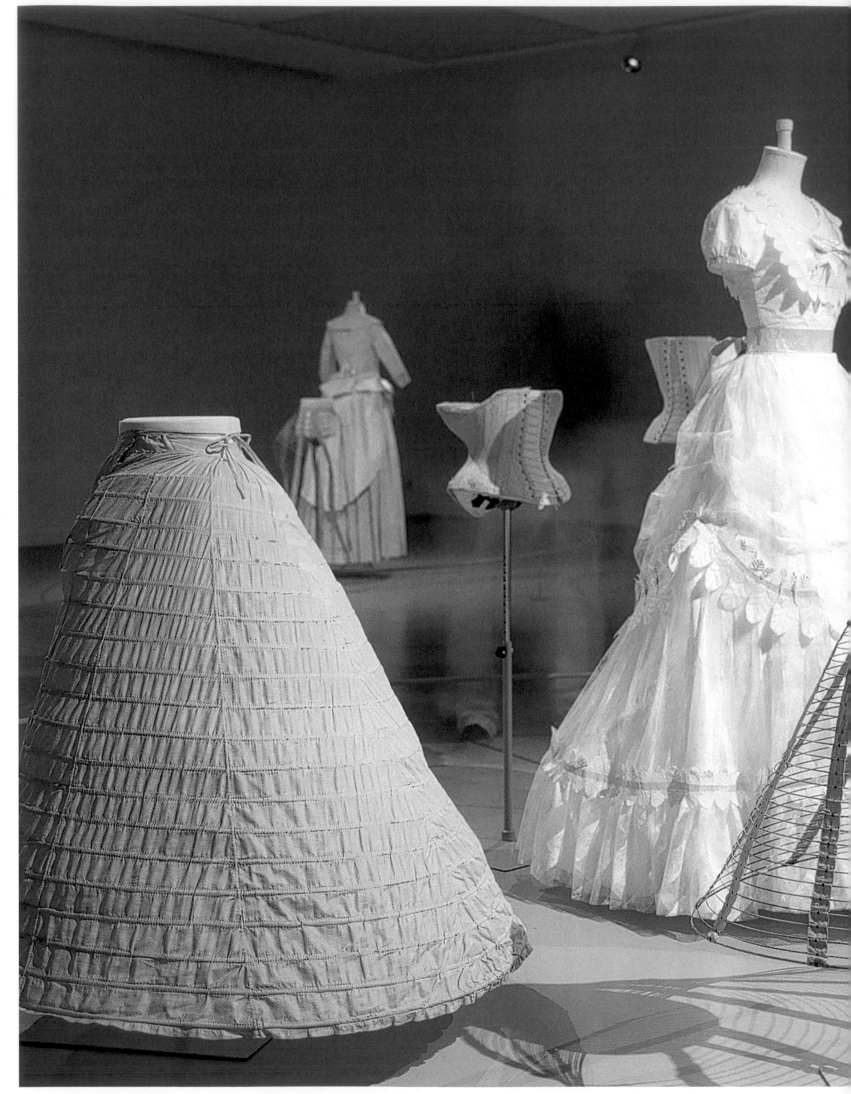

Paper Crinoline silhouette with crinolines, *c.* 1860

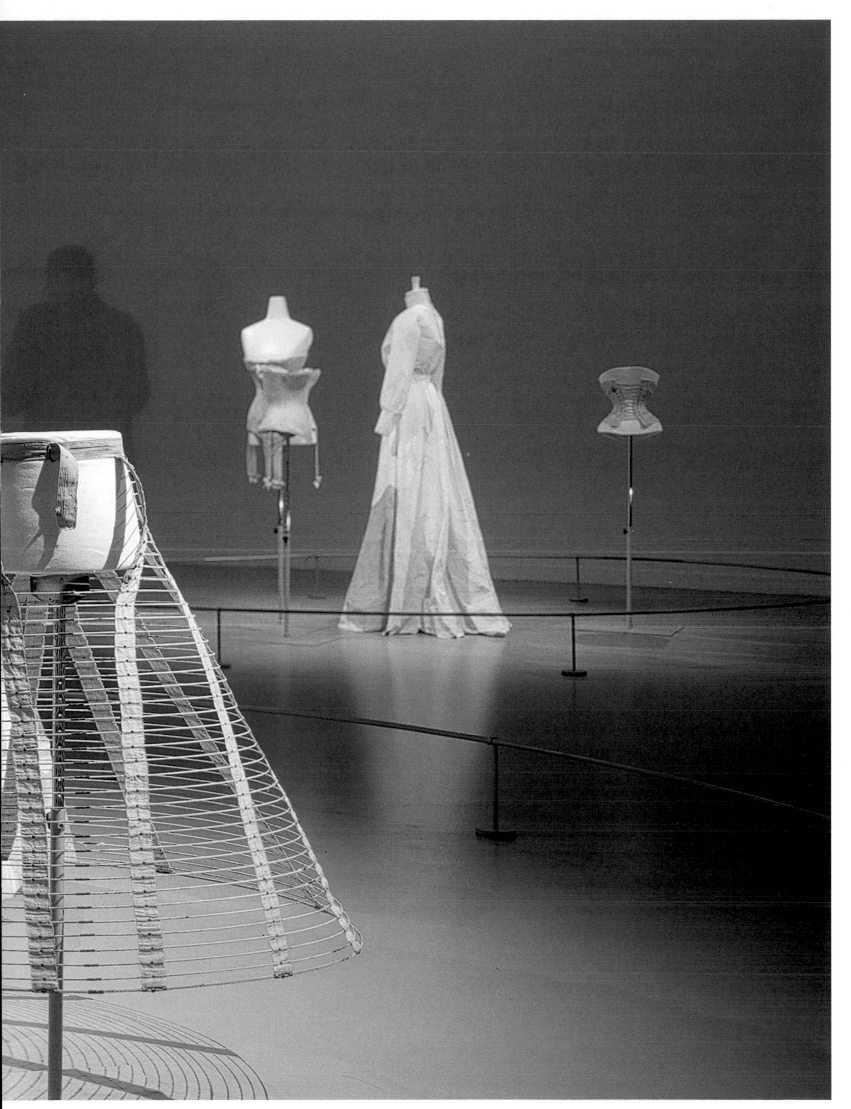

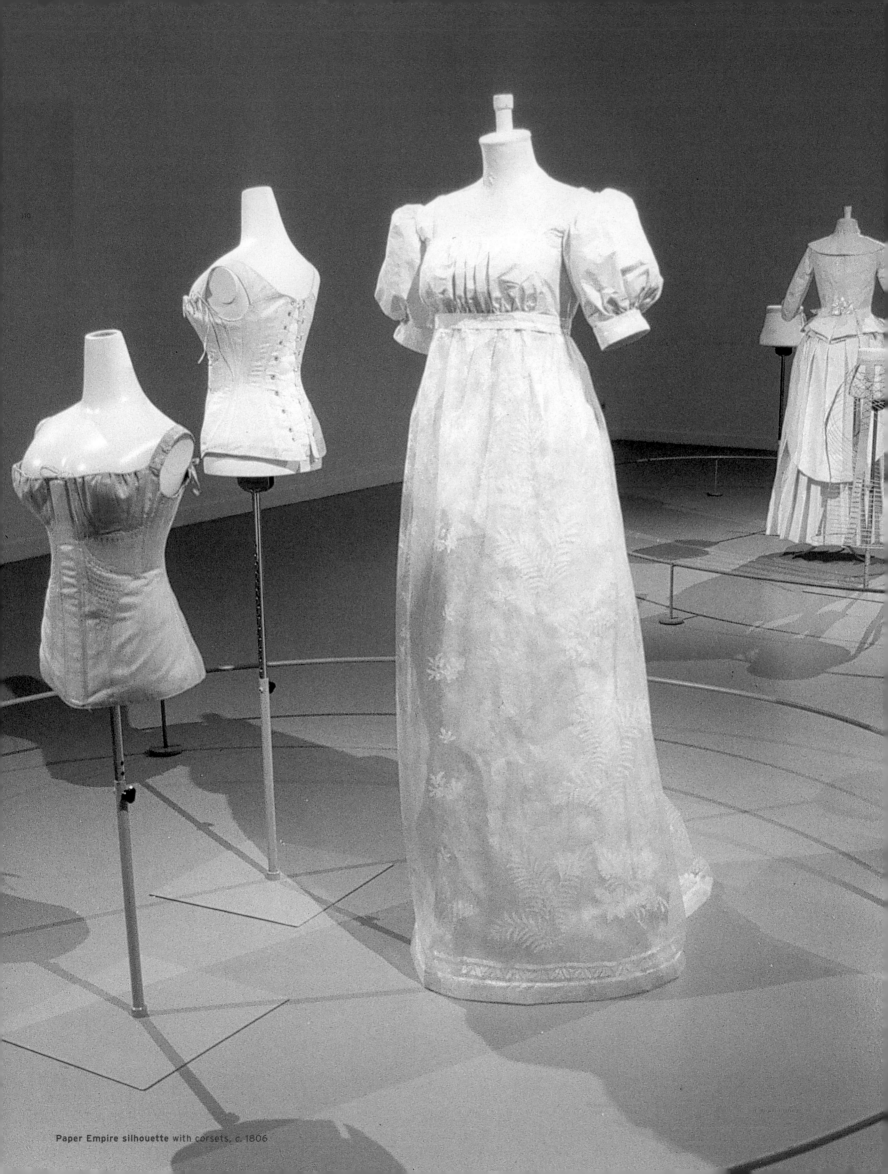

Paper Empire silhouette with corsets, c. 1806

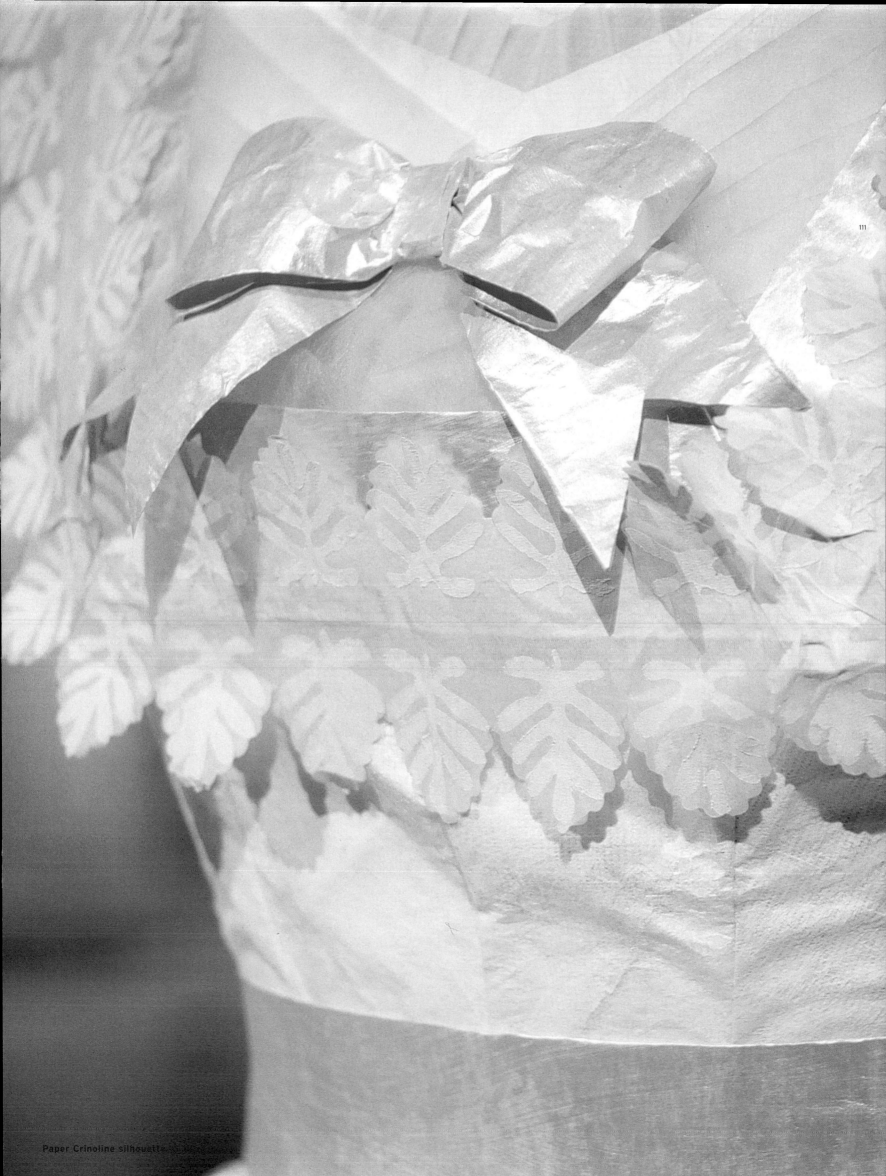

Paper Crinoline silhouette

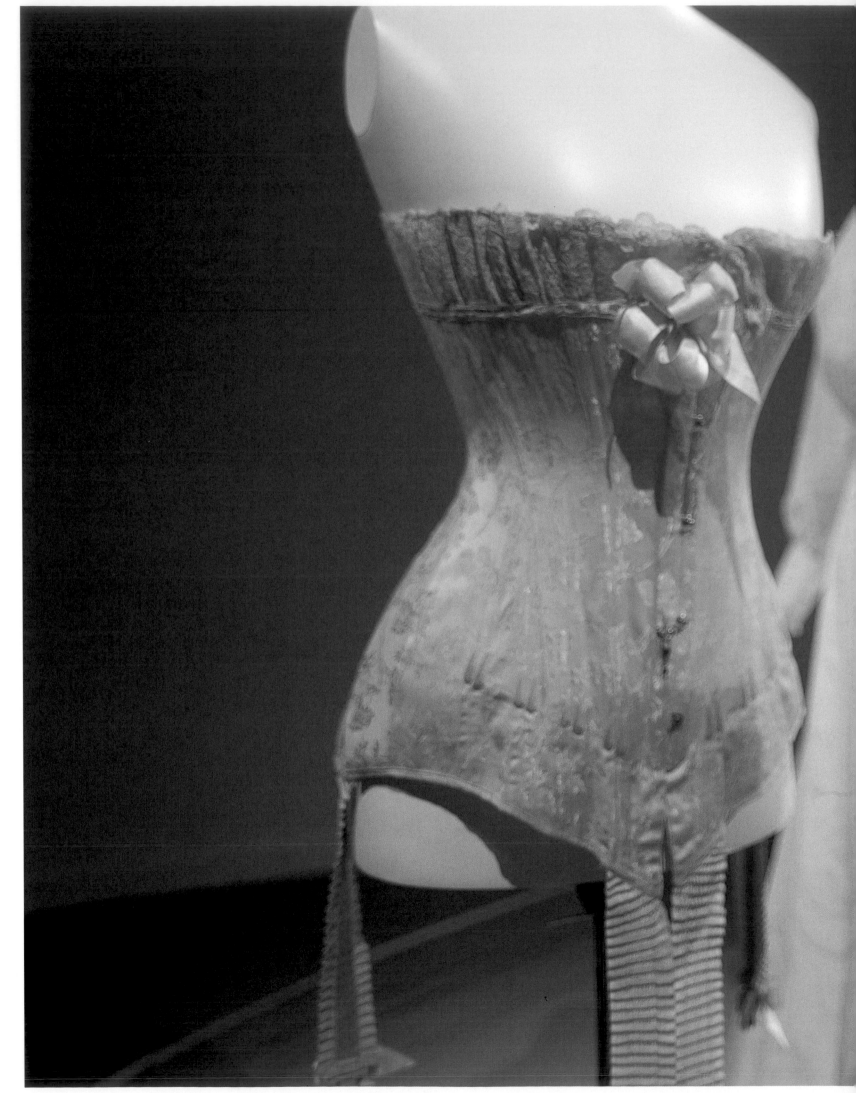

112

Paper S-silhouette with corsets, *c.* 1900

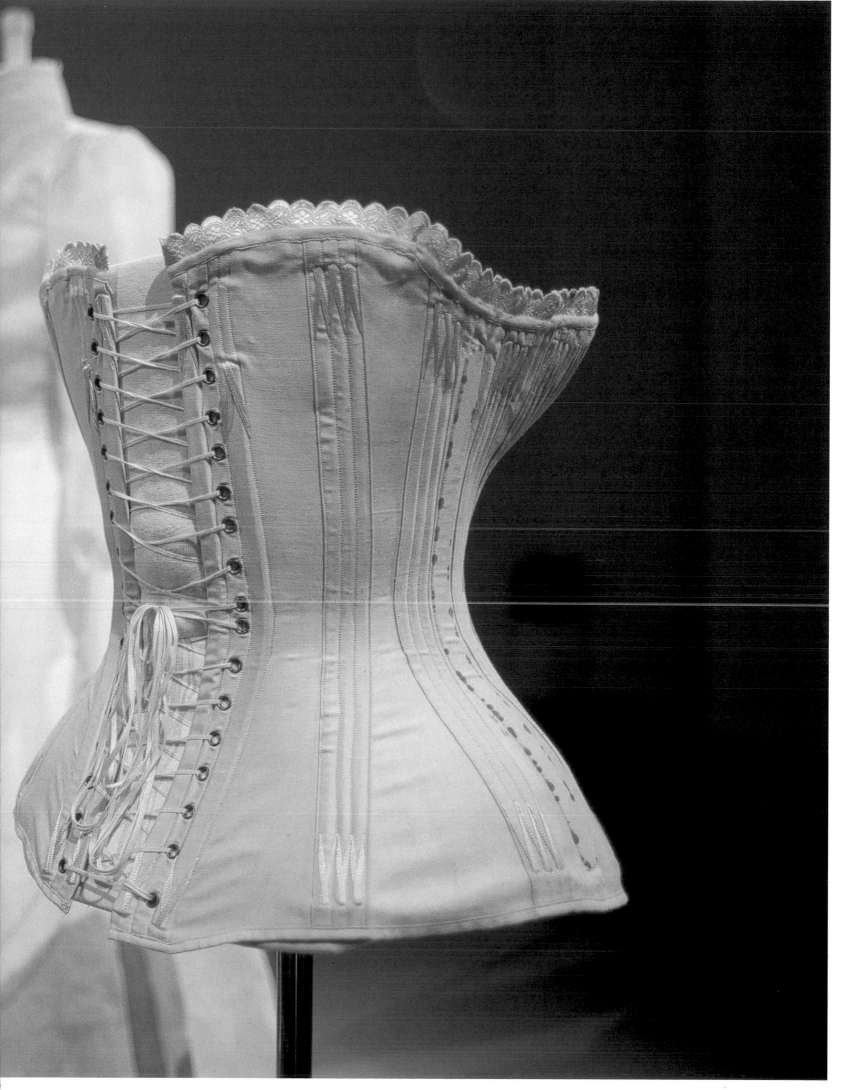

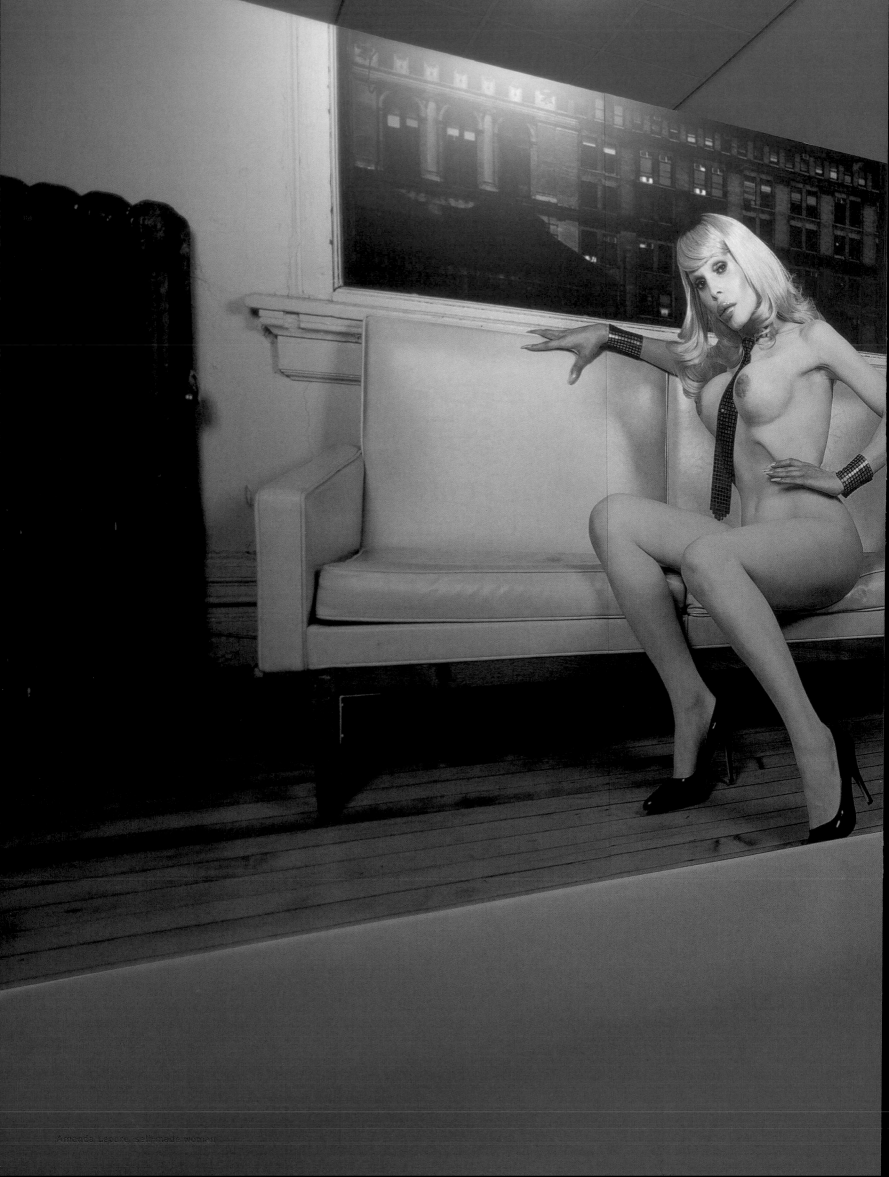

Amanda Lepore, self-made woman

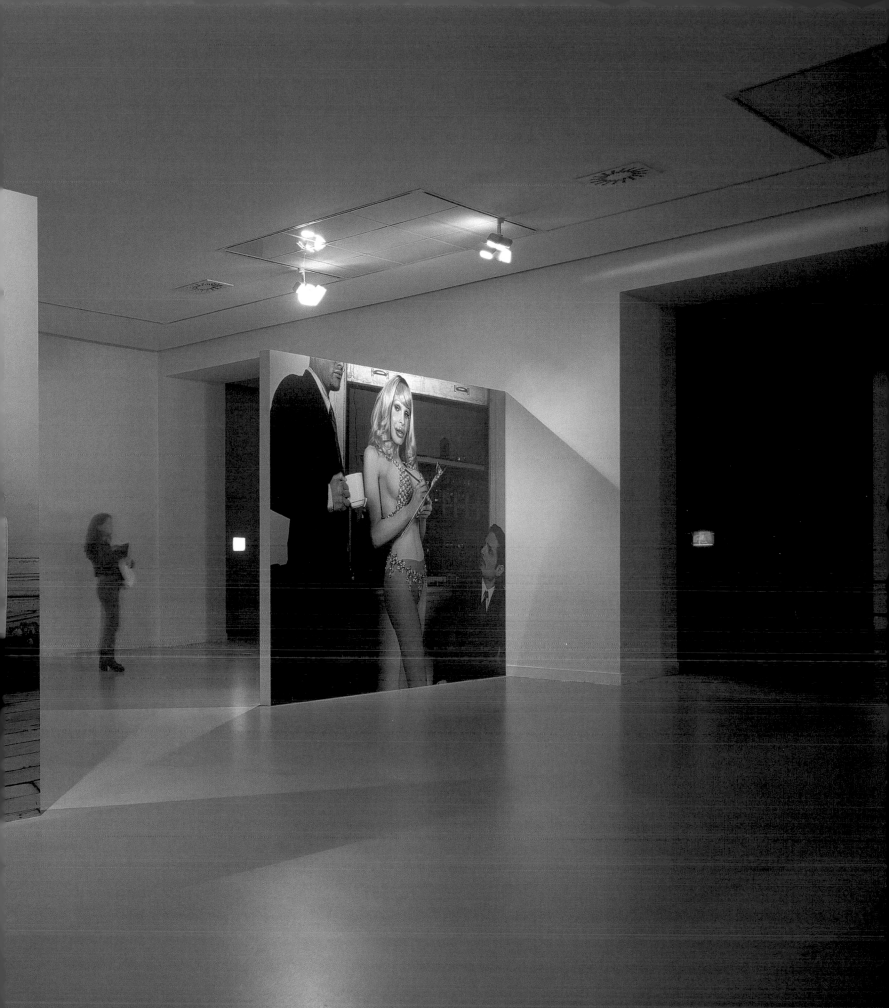

TRANSFORMATIONS

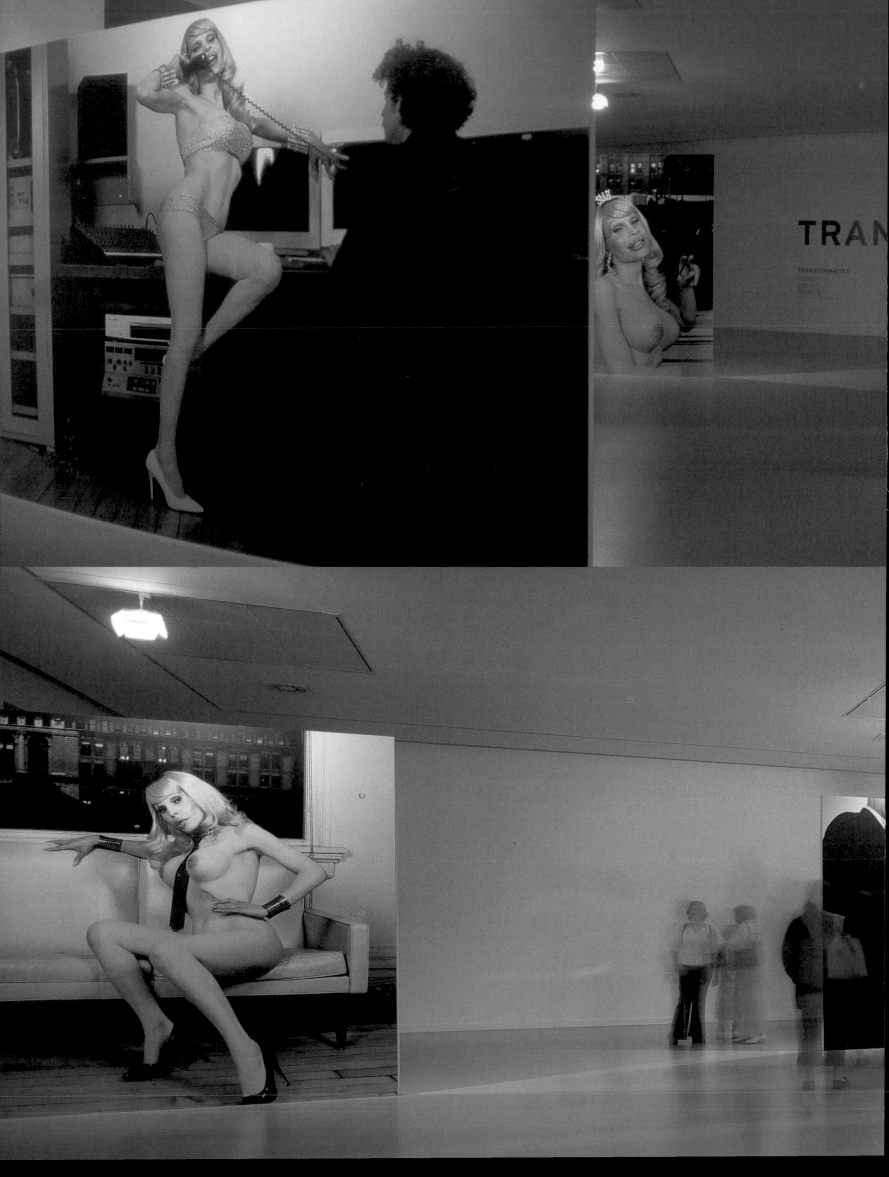

ORMATIONS

BODY ART

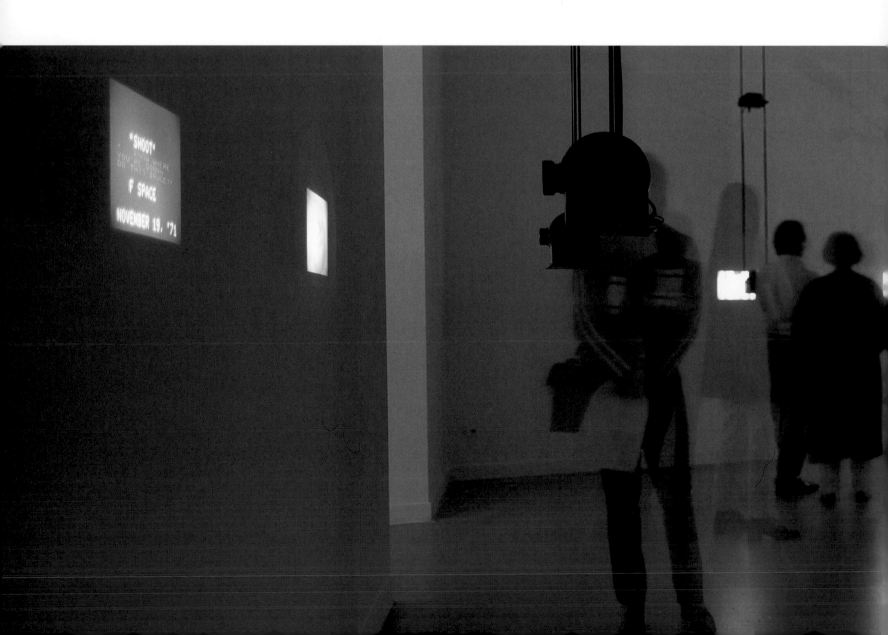

ABRAMOVIC ULAY

VITO ACCONCI

RON ATHEY

FRANKO B.

CHRIS BURDEN

GUTAI

YVES KLEIN

ELKE KRYSTUFEK

BRUCE NAUMAN

DENNIS OPPENHEIM

ORLAN

GINA PANE

ARNULF RAINER

SONJA WYSS

119

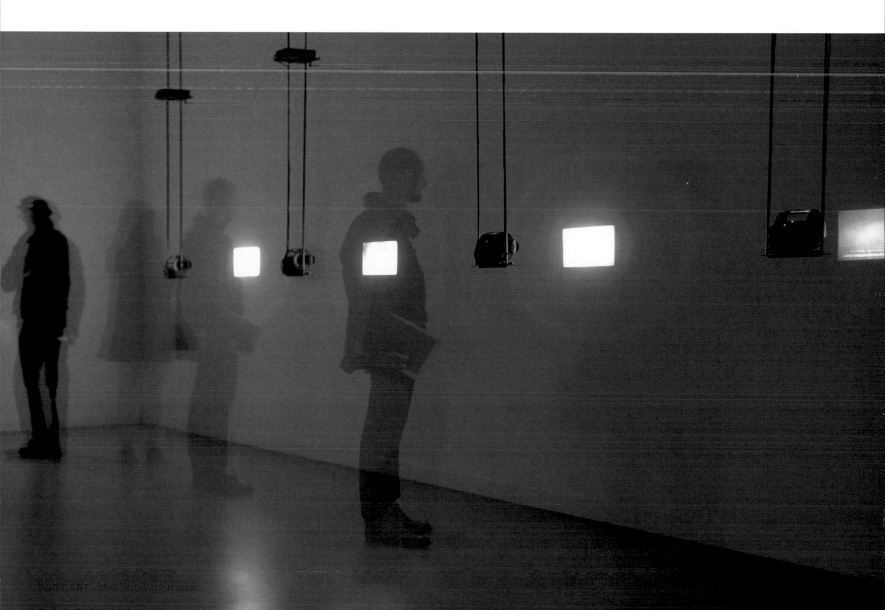

BODY ART video installation view

FASCINATION
MR PEARL'S ROOM

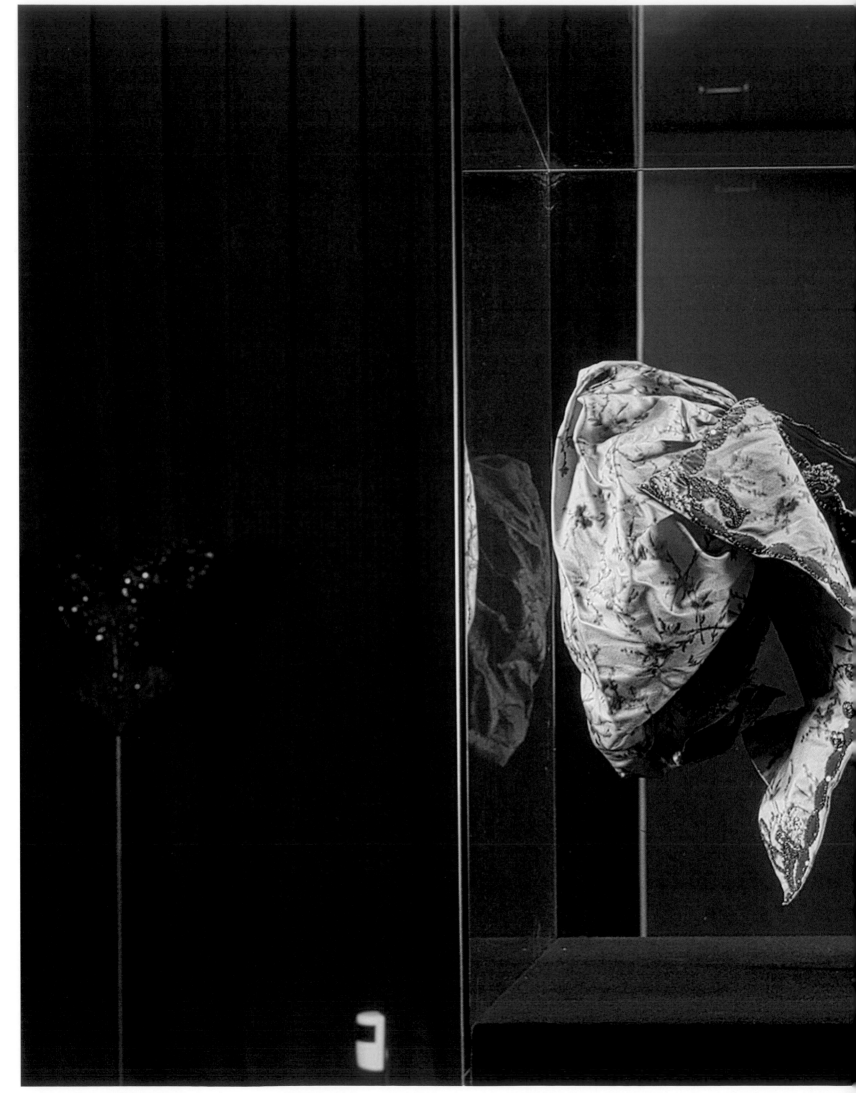

Corsage of Cleo de Mérode, 1896

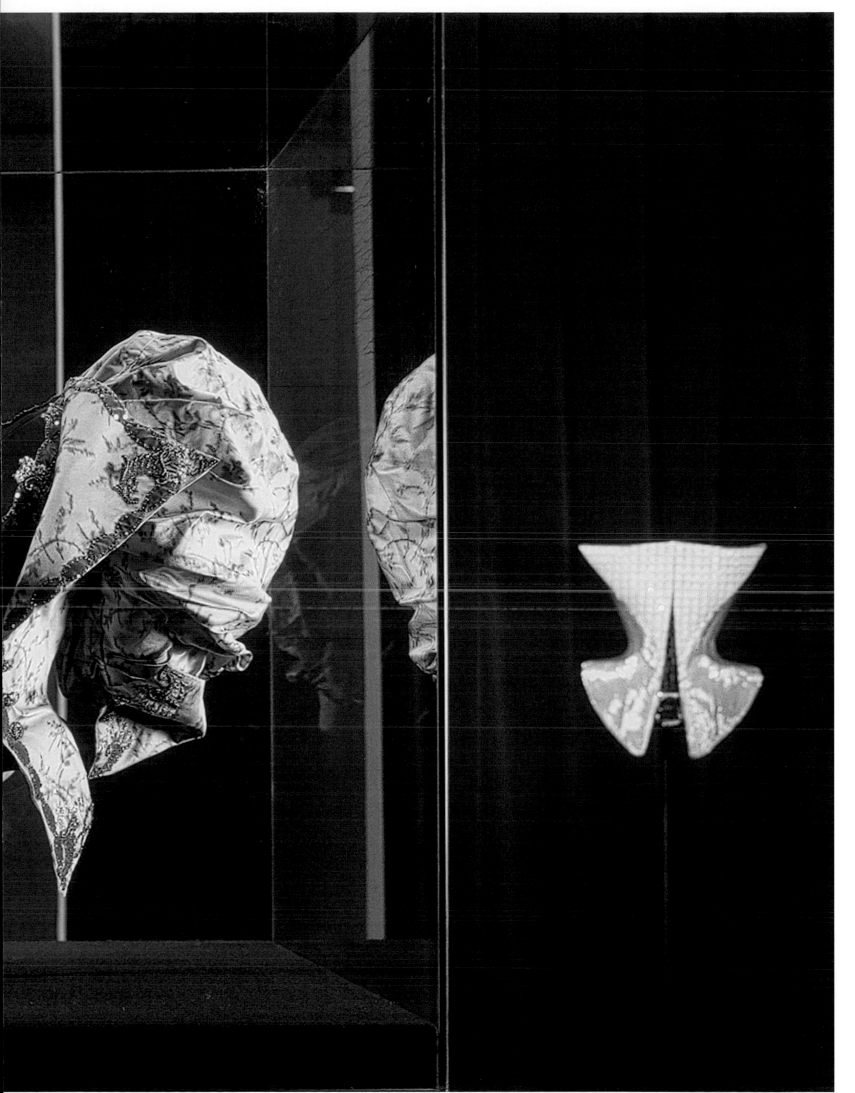

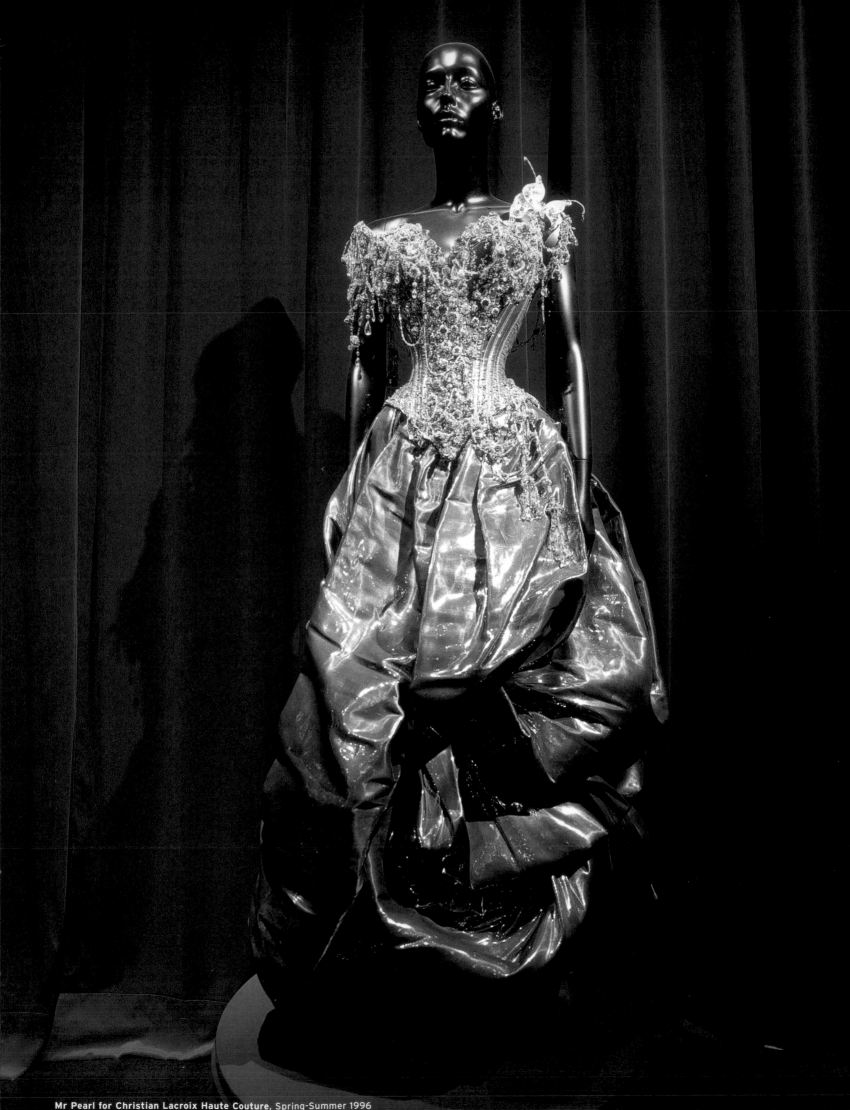

Mr Pearl for Christian Lacroix Haute Couture, Spring-Summer 1996

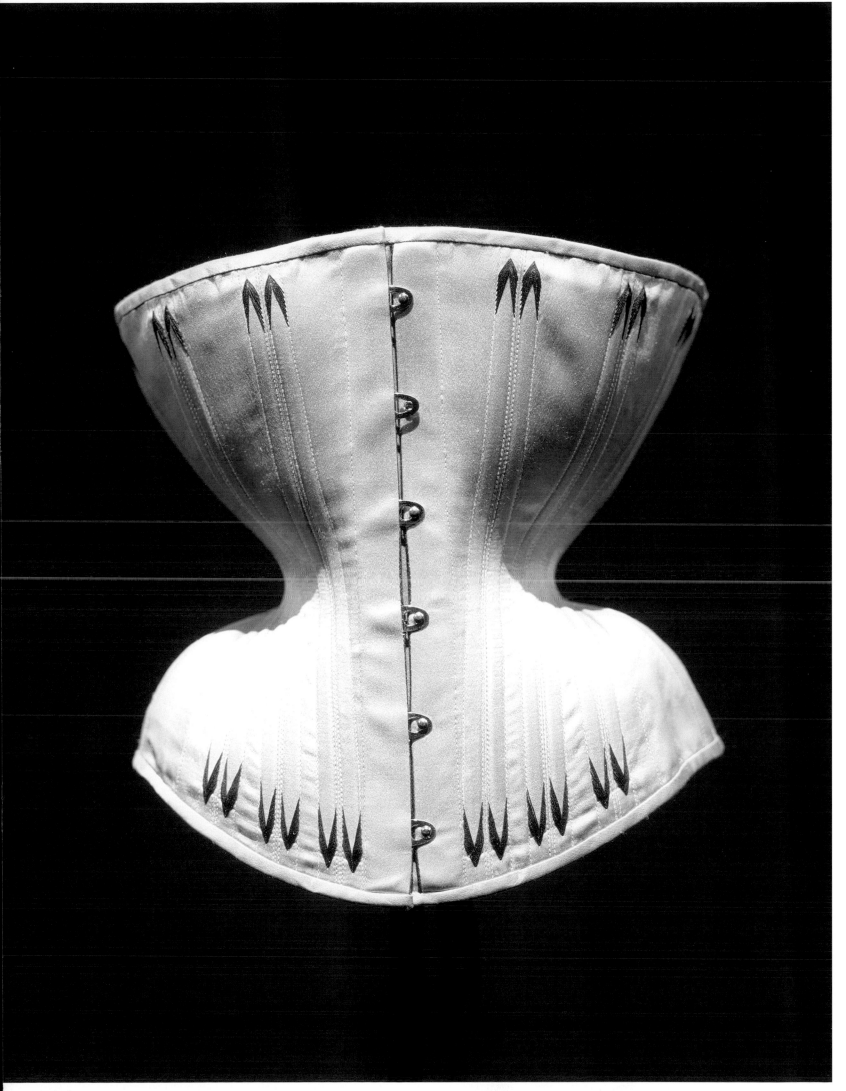

Personal corset, as worn by Mr Pearl

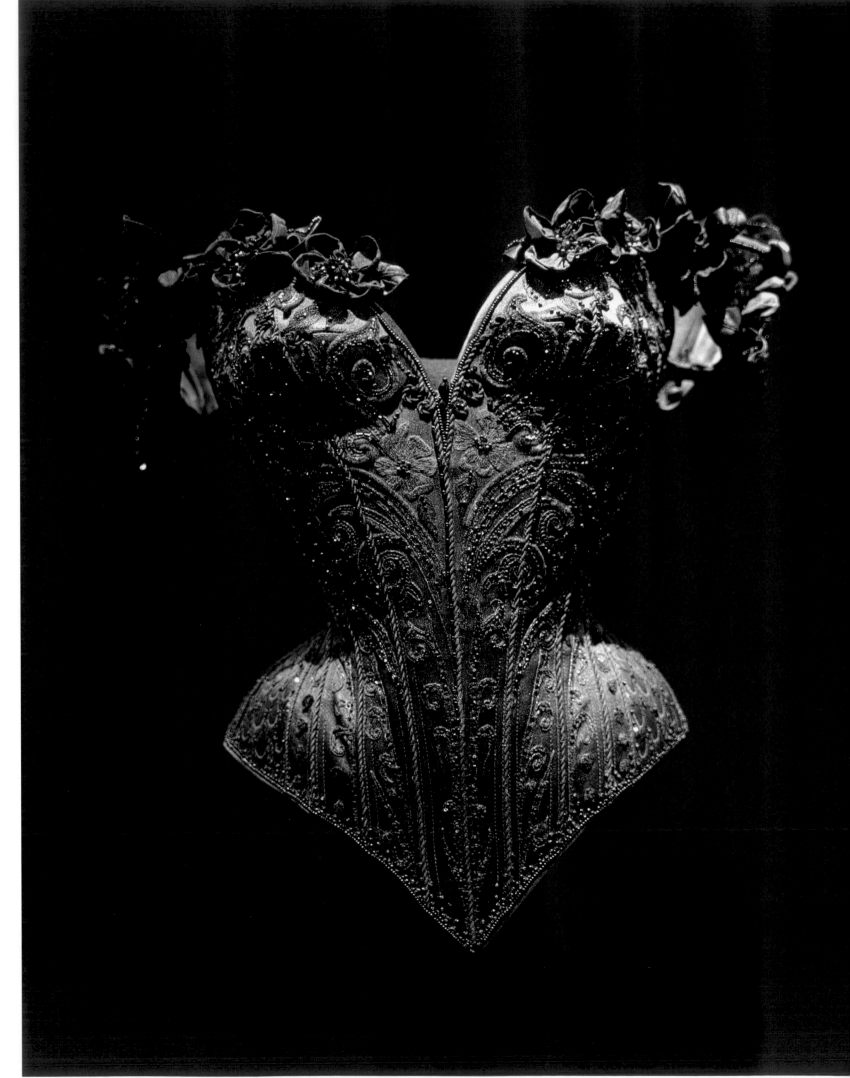

Black satin all-embroidered corset by Mr Pearl, 1996

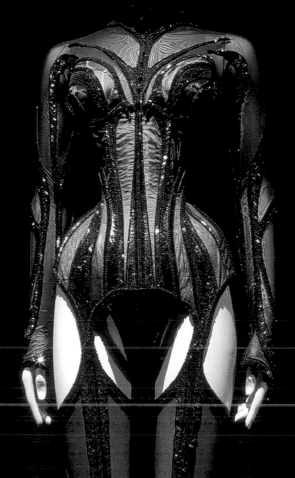

Black jet transparent corset with sleeves and stockings,
all by Mr Pearl for Thierry Mugler, 1998

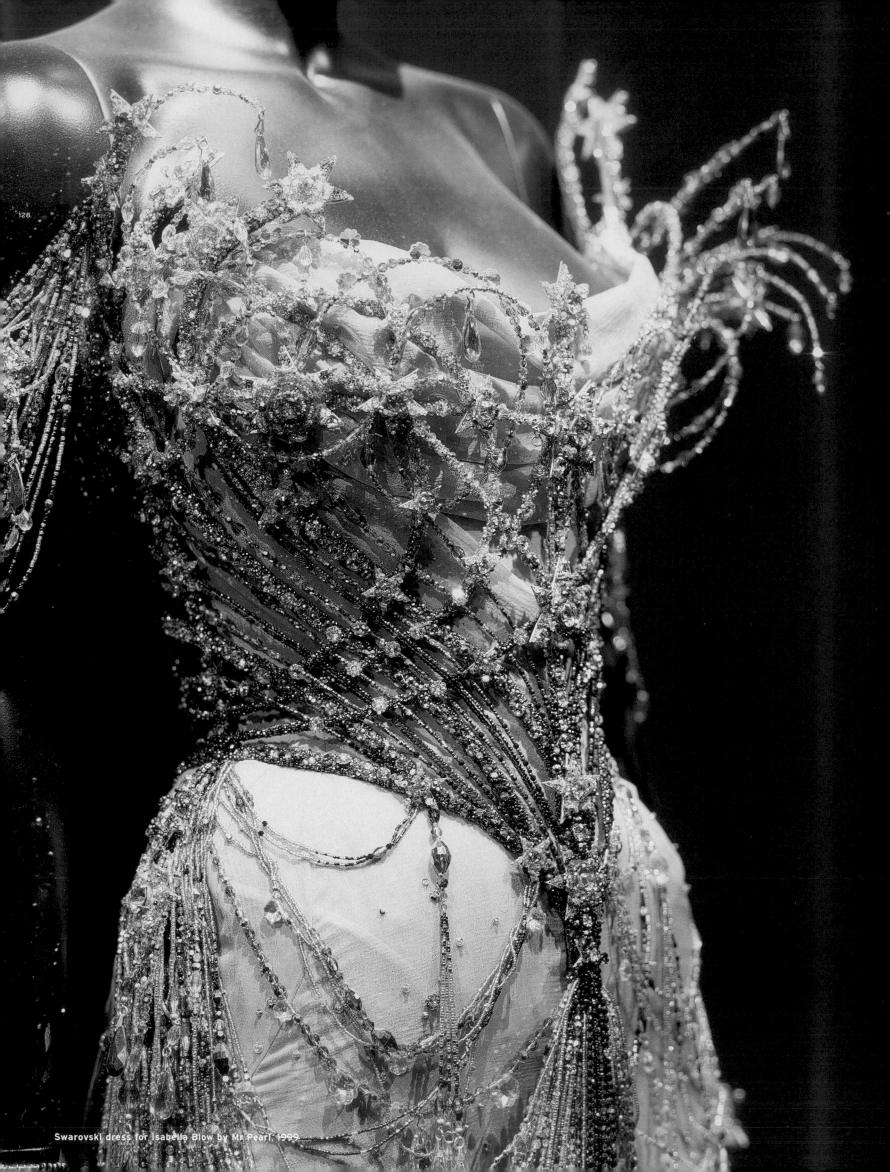

128

Swarovski dress for Isabella Blow by Mr Pearl, 1999

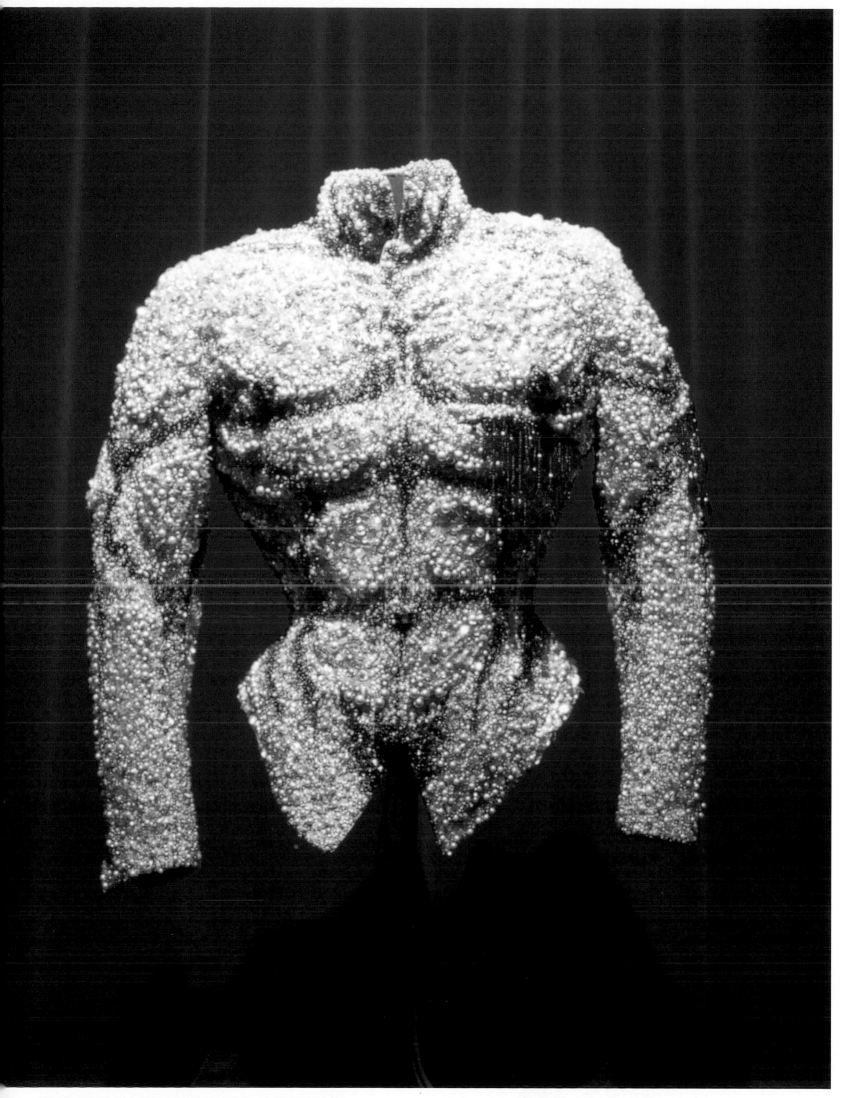

'Bleeding Torso Jacket' by Mr Pearl for Vivienne Westwood, 1996

AVATARS

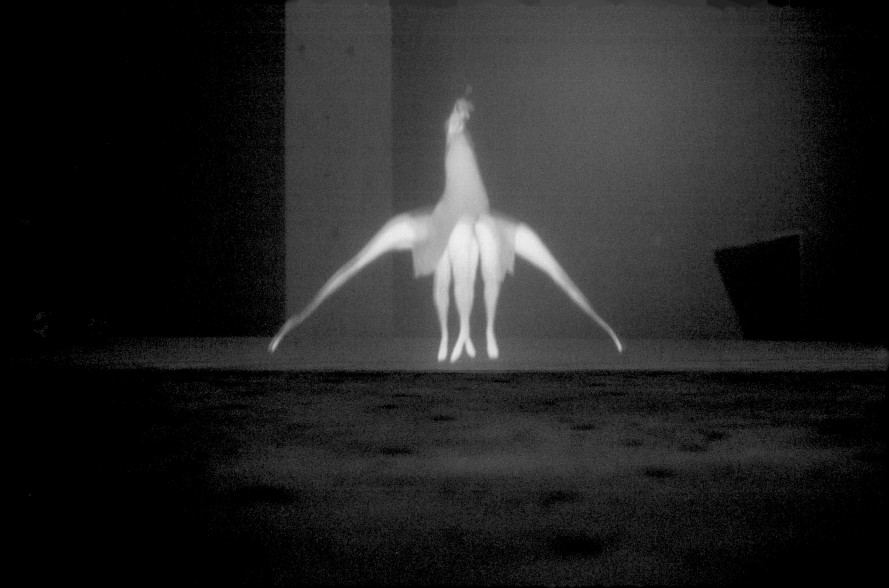

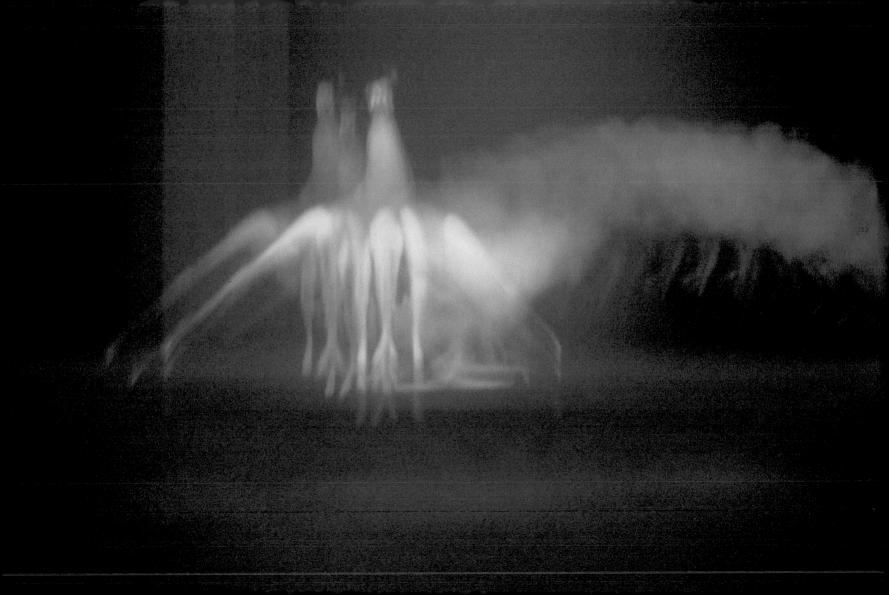

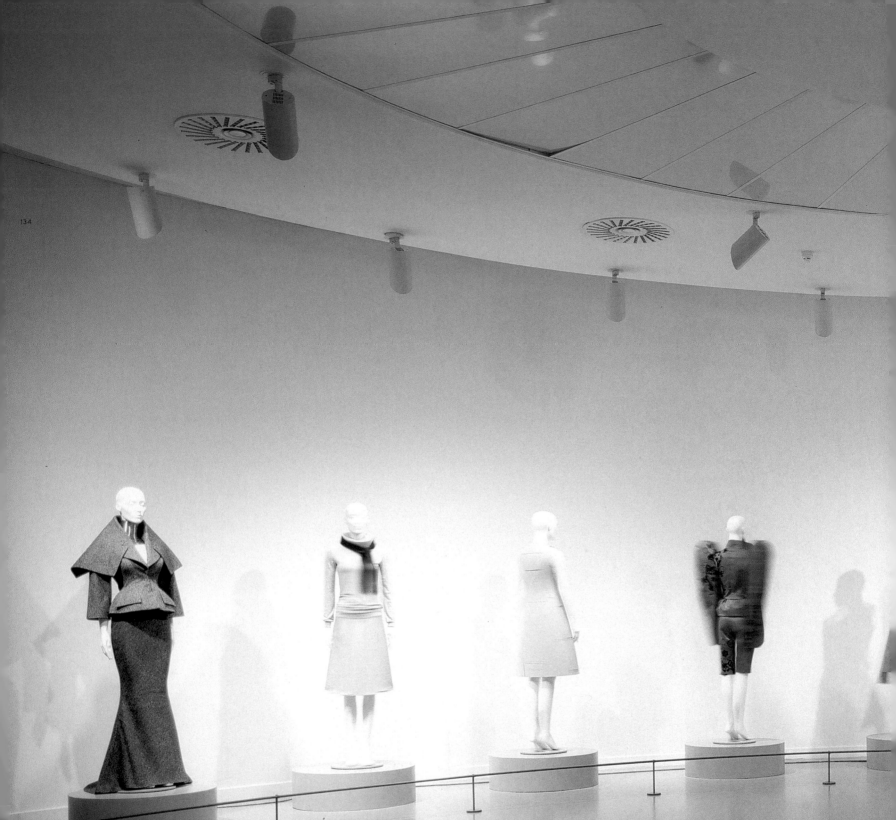

CONTEMPORARY FASHION

From left to right: Dior Couture-John Galliano, G+N, Hussein Chalayan, Keupr & van Bentm, Yohji Yamamoto

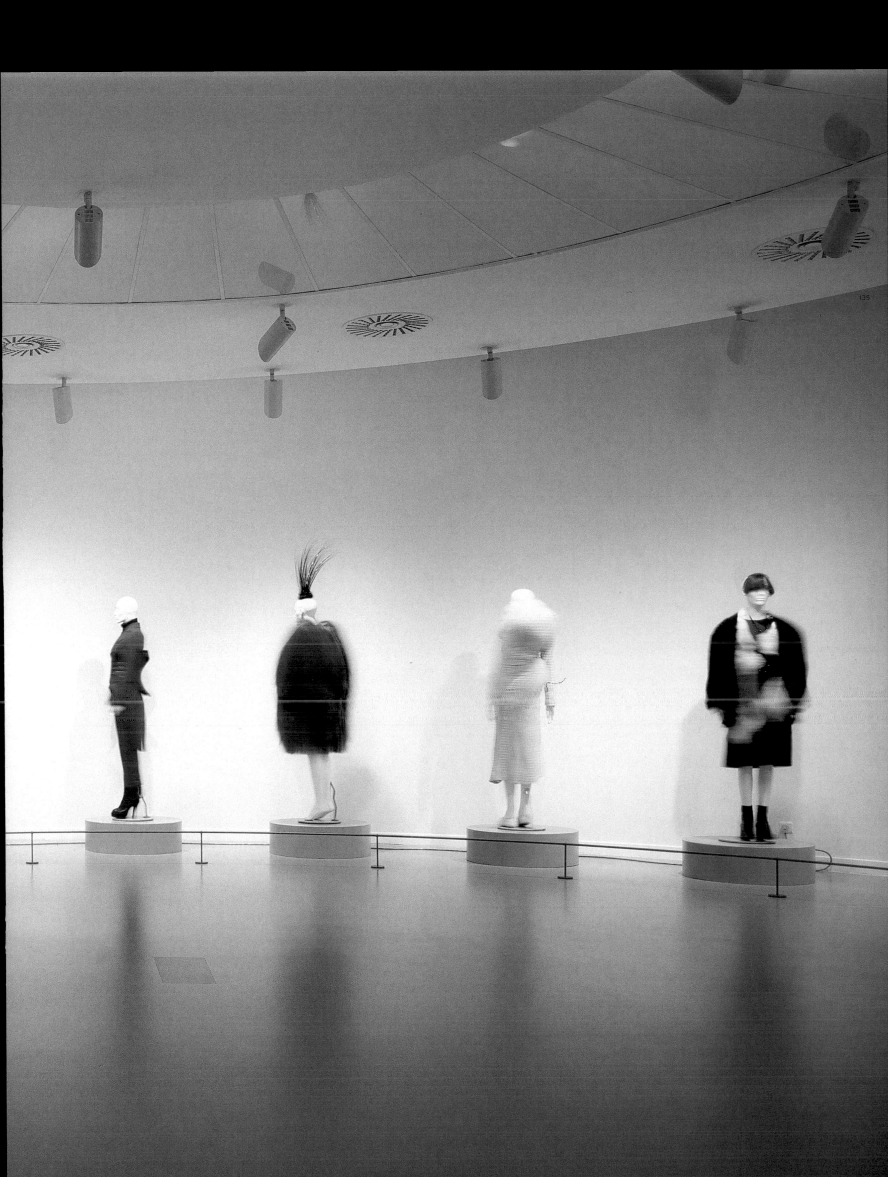

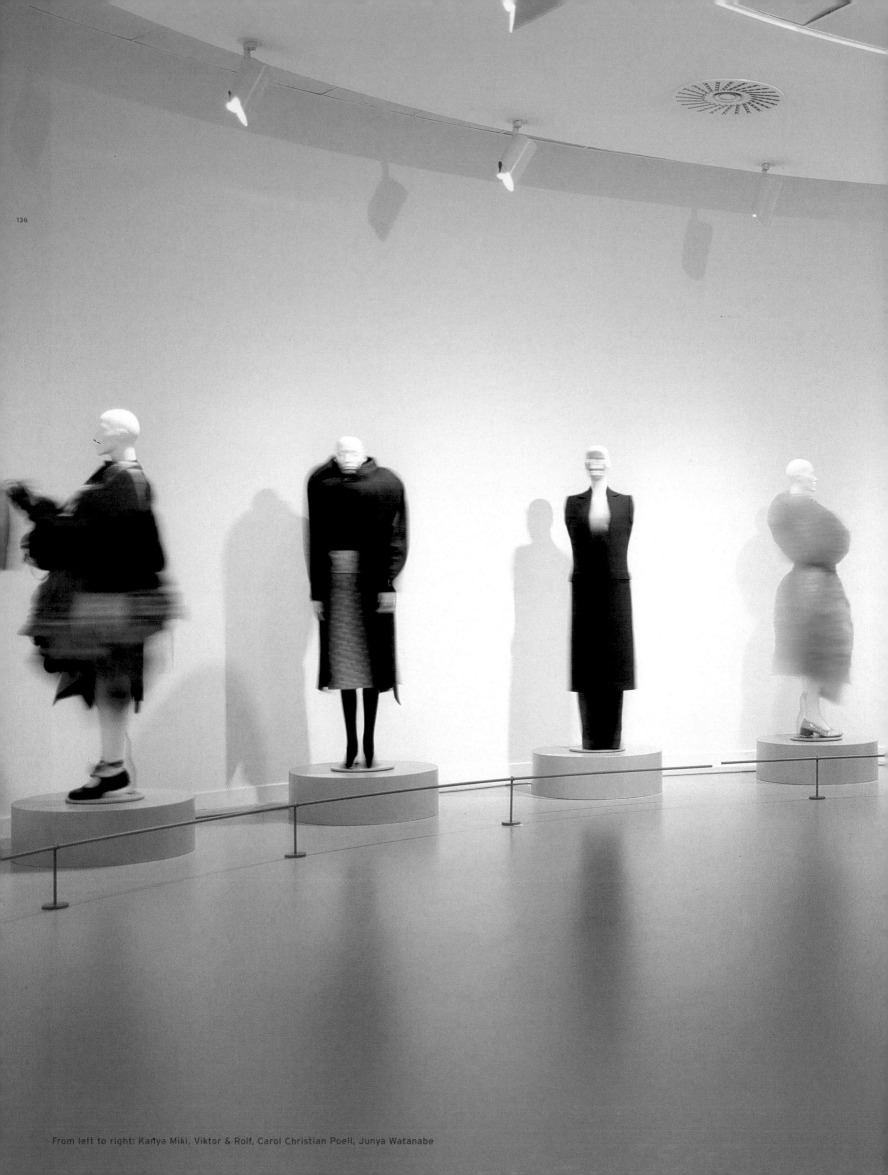

From left to right: Kanya Miki, Viktor & Rolf, Carol Christian Poell, Junya Watanabe

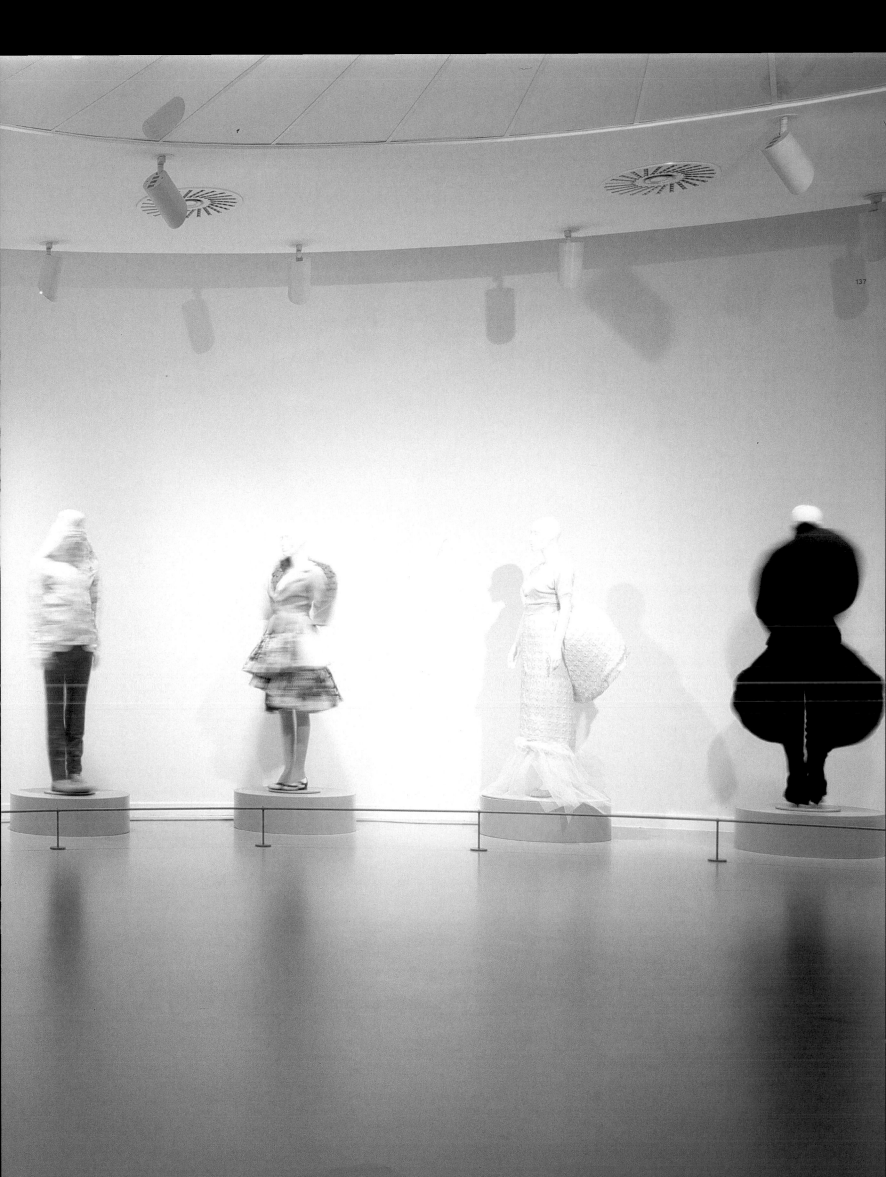

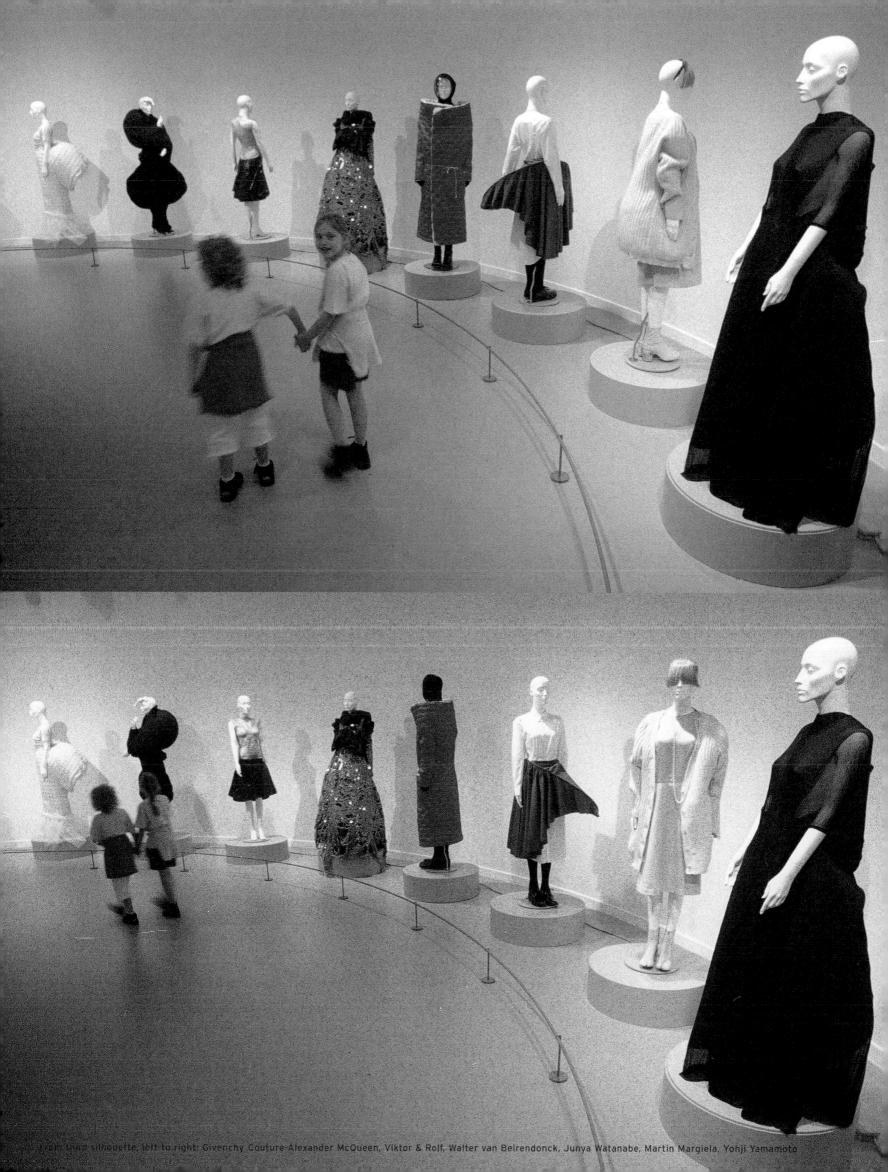

From third silhouette, left to right: Givenchy Couture-Alexander McQueen, Viktor & Rolf, Walter van Beirendonck, Junya Watanabe, Martin Margiela, Yohji Yamamoto

INFORMATION

INFORMA

information room

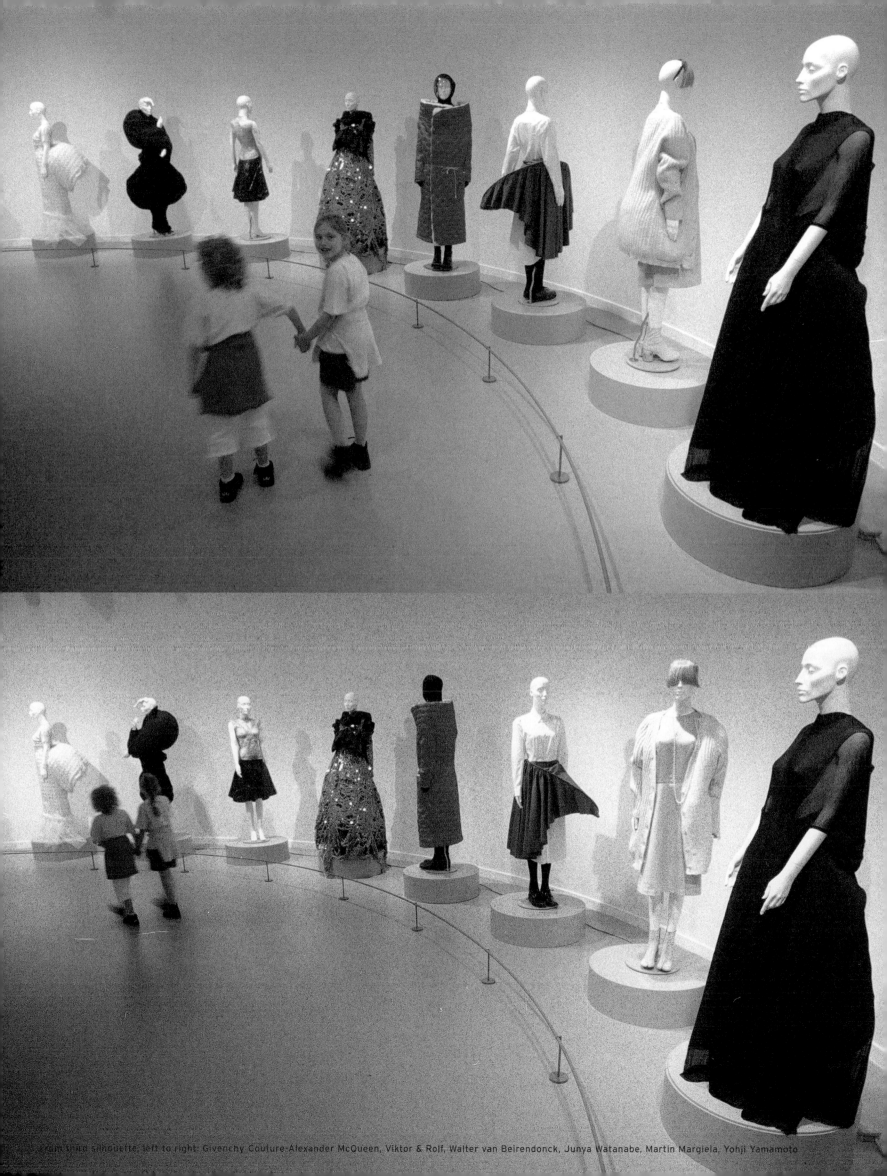

From third silhouette, left to right: Givenchy Couture-Alexander McQueen, Viktor & Rolf, Walter van Beirendonck, Junya Watanabe, Martin Margiela, Yohji Yamamoto

INFORMATION

INFORMA

information room

142

EM
OT
ION
S

EMOTIES
EMOTIONS

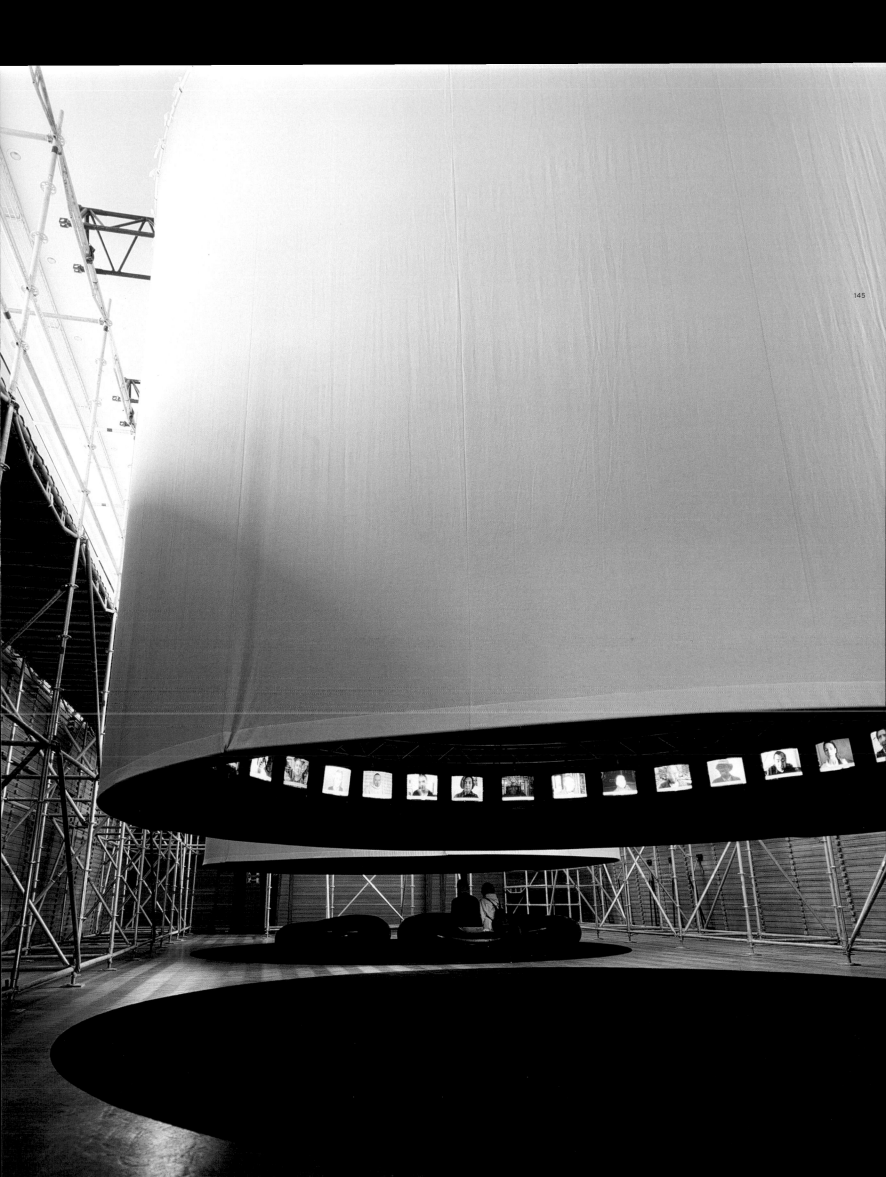

146

Interviews installation

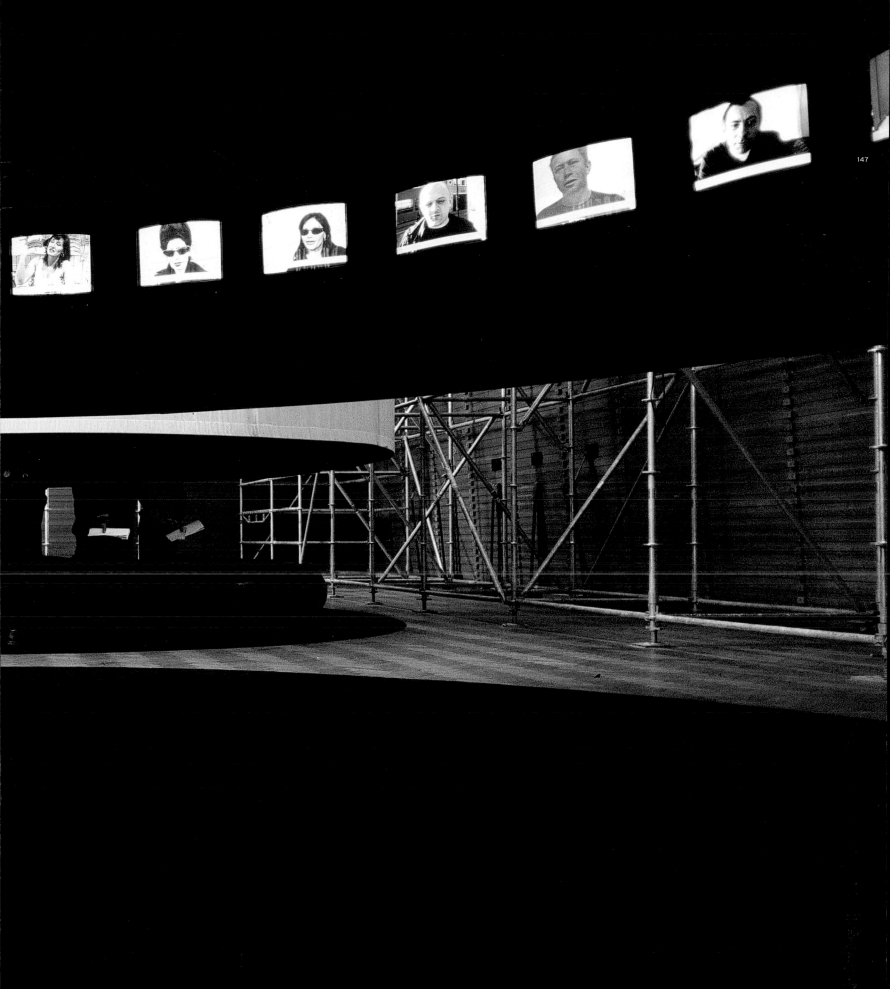

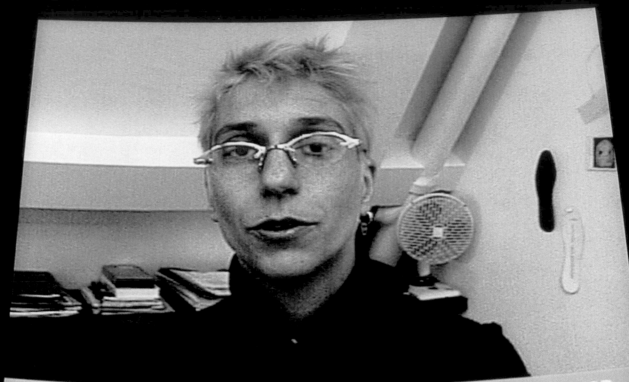

LYDIA KAMITSIS MUSEUM CURATOR
THE FIRST TIME I STARTED WORKING FOR THE MUSEUM AND

Short films installation

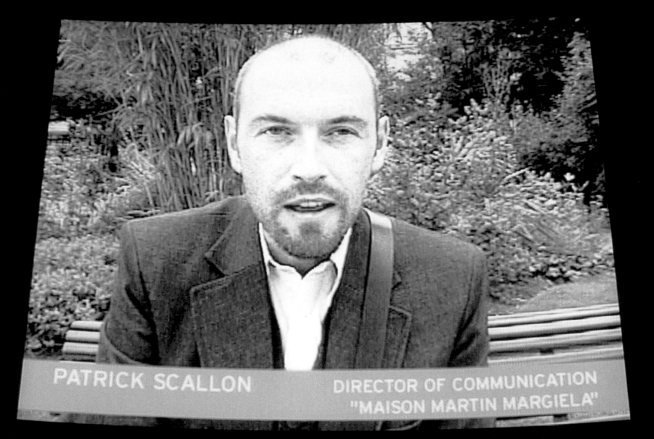

PATRICK SCALLON — DIRECTOR OF COMMUNICATION "MAISON MARTIN MARGIELA"

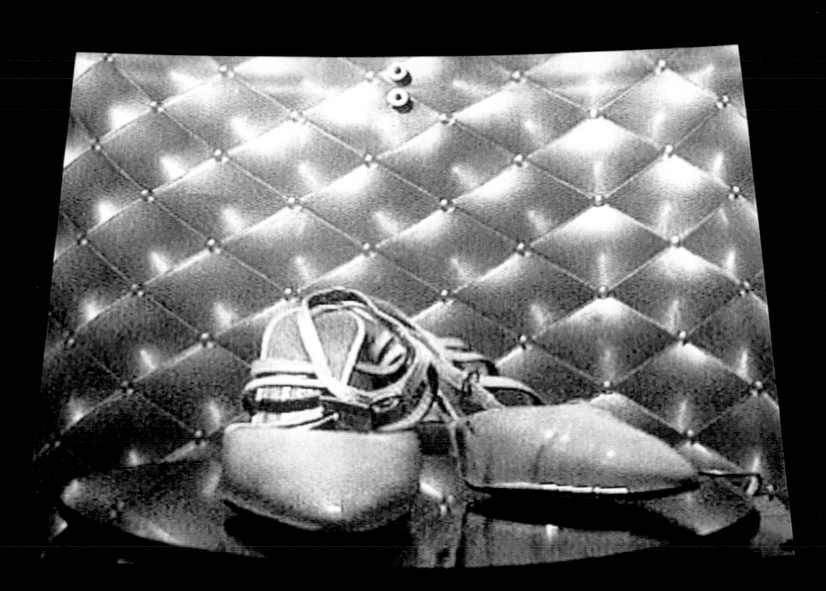

EMOTIONS installation and promenade with panoramic view

'**Brilliant**', fluorescent yellow handbag by Delvaux

Red A on top of KBC Tower, front view

154

Fluorescent yellow landmark at the ModeNatie with fluorescent yellow 'DRESSED UP!' tram

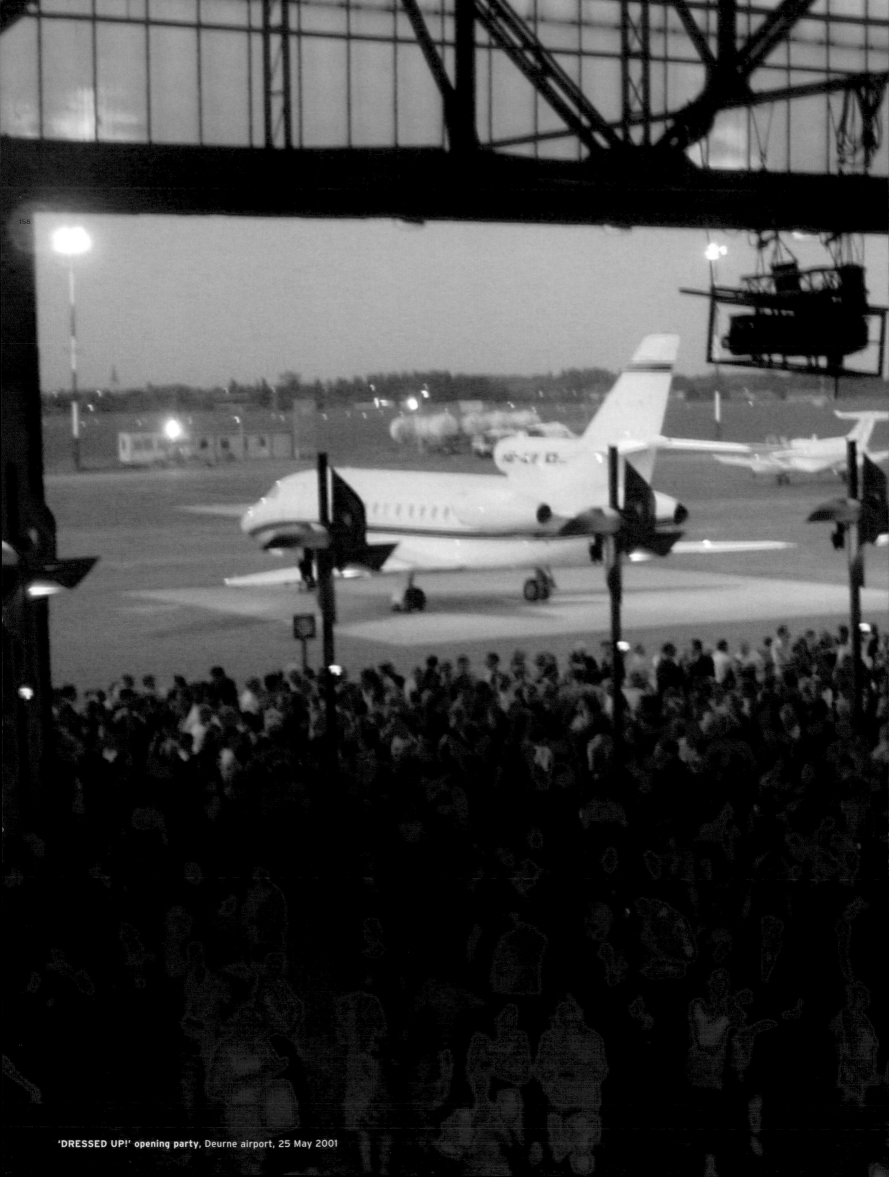

'DRESSED UP!' opening party, Deurne airport, 25 May 2001

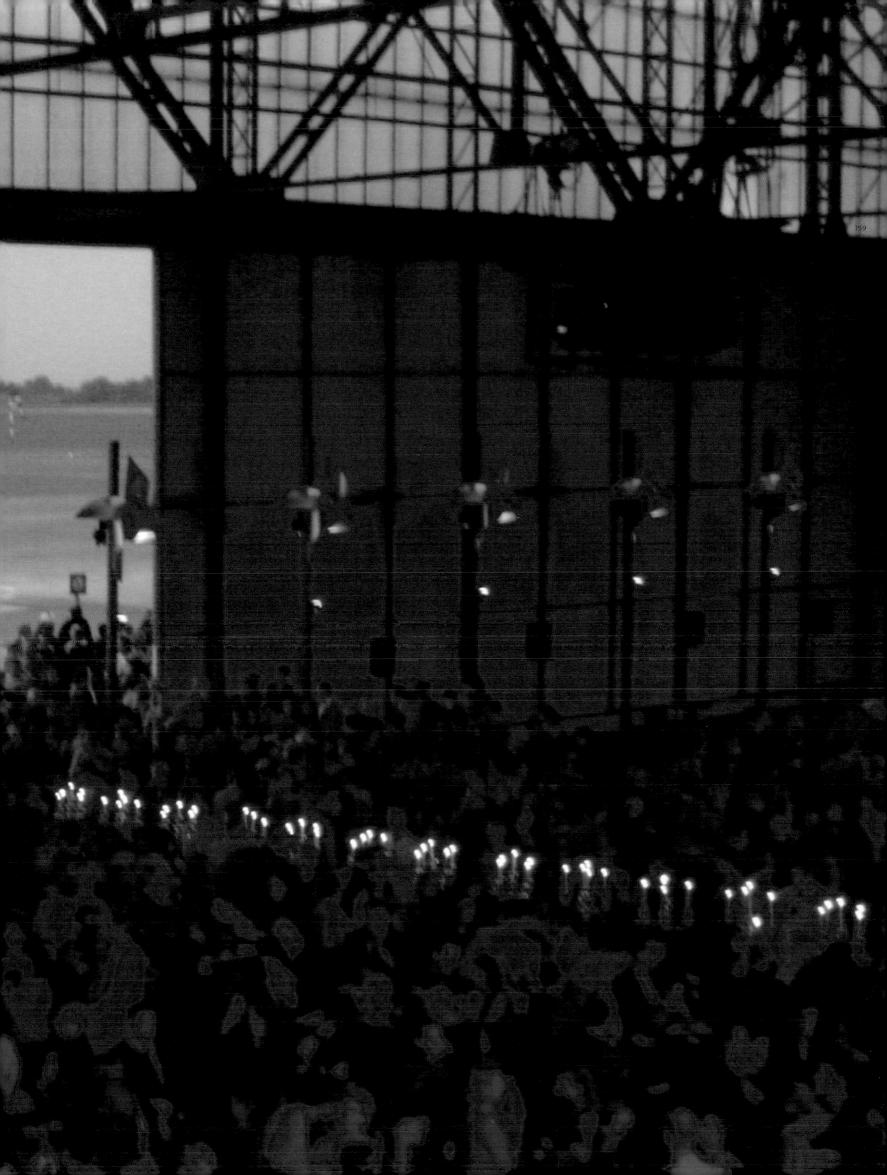

Fluorescent yellow, blue and red landmarks: view from the KBC Tower

CREDITS

RADICALS

**SLOEPENWEG, QUAYS OF THE RIVER SCHELDT
NEAR 'T EILANDJE, 2030 ANTWERP**

20 'radical' designers show 60 photographic images in an installation of 20 billboards with rotating lamellae.

BLESS (Desiree Heiss & Ines Kaag)
Photo 1 Bless N°12 team ups, 2000
'The bedsheets', a co-production with nice memories
Photo 2 'Embroidered plants 2', 2000. Courtesy of Windsor collection
Photo 3 'Naked man & porcelain/Hans', 2001

VERONIQUE BRANQUINHO
Photo 1 Willy Vanderperre, Make-up: Peter Philips, Hair: Guido Palau
Photo 2 Raf Coolen, Make-up: Peter Philips, Hair: Guido Palau
Photo 3 Corinne Day, Make-up: Ezi Wakematsu, Styling: Panos Yiapani

HUSSEIN CHALAYAN
Photos Marcus Tomlinson

SUSAN CIANCIOLO
Photo 1 Susan Cianciolo - 'Cactus garden at the Getty Museum'
Photo 2 Rosalie Knox - 'Run 8 Studio photo'
Photo 3 Anette Aurell - 'Dakota at Run store'

COMME DES GARÇONS
Photos Comme des Garçons Comme des Garçons

ANGELO FIGUS
Photos Ronald Stoops, Photo 3: Jewel: Steven Blum

G+N (Gerrit Uittenbogaard & Natasja Martens)
Photo 1 Miss Liz Wendelbo
Photo 2 Jessy Albertus & Annabel Oosteweeghel
Photo 3 Miss Liz Wendelbo

ANKE LOH
Photo 1 Frederik Hamelynck
Photo 2 Geert Samon
Photo 3 Anke Loh, Model: Susan Hengartner

JESSICA OGDEN
Photos Ellen Nolan
Photo 1 Model: Angela - August 1999
Photo 2 Model: Lotte - August 1999
Photo 3 Model: Romala - May 2001

MARJAN DJODJOV PEJOSKI
Photo 1 Mert Alas & Marcus Pigott
Photo 2 Henrik Halversson
Photo 3 Donna Troupe
Graphics Victoria Magniant

JURGI PERSOONS
Photos Ronald Stoops, Make-up: Inge Grognard

CAROL CHRISTIAN POELL
Photo 1 Graça Fisher
Photo 2 Stephan Zeisler
Photo 3 Frances Melhop

RAF SIMONS
Photo 1 Anonymous
Photo 2 Anonymous
Photo 3 Willy Vanderperre

OLIVIER THEYSKENS
Photo 1 Pascal Demeester
Photo 2 Ali Mahdavi
Photo 3 Les Cyclopes

WALTER VAN BEIRENDONCK
Photo 1 Ronald Stoops
Photo 2 Jens Boldt
Photo 3 Ronald Stoops

A.F. VANDEVORST (An Vandevorst & Filip Arickx)
Photos Ronald Stoops

DIRK VAN SAENE
Photos Ronald Stoops

VIKTOR & ROLF (Viktor Horsting & Rolf Snoeren)
Photos 'Le regard noir' - Anuschka Blommers & Niels Schumm

JUNYA WATANABE
Photos Junya Watanabe Comme des Garçons

BERNHARD WILLHELM
Photos Carmen Freudenthal & Elle Verhagen

2WOMEN GABRIELLE CHANEL

**MOMU ON LOCATION: FORMER ROYAL PALACE
5 MEIR, 2000 ANTWERP**

Hall: Chanel in the mirror © Robert Doisneau/Rapho, Paris

LA CHAMBRE DES TAILLEURS
THE SUIT ROOM

Ten suits designed by Gabrielle Chanel on display

1. Chanel-Haute Couture, Autumn-Winter 1964-5.
Suit of ivory-coloured Nattier wool, embellished with two braids, one above the other, in magenta and dark blue. Lined with ivory-coloured silk gauze with decorative stitching, giving a padded effect, edged with a gold chain. Short straight jacket with round neckline, closing edge to edge, decorated with four stitched-on pockets, trimmed. The edge of the trimmed sleeves is decorated with two gilded buttons in the form of a lion's head. Straight wrap-around skirt, trimmed along the hem.
Maison Chanel.

2. Chanel-Haute Couture, Autumn-Winter 1960-61.
Suit made of light beige Burg tweed with Brandbourg-effect, and tapered waist with dark blue trim. Lined with beige pongee, edged with a gold chain. Straight jacket with round neckline, trimmed, closing edge to edge, with four stitched-on V-shaped pockets, trimmed, with gilded button in the form of a lion's head. The edge of the trimmed sleeve is decorated with two buttons. Straight, closed skirt with a fastening on both sides.
Maison Chanel.

3. Chanel-Haute Couture, Autumn-Winter 1960-61.
Suit in Burg tweed, cream-coloured natté, finished off with a ribbed magenta braid and dark blue woollen braid. Short, straight, loose sailor jacket, unlined, with vertical ornamental stitching on the bust and horizontal ornamental stitching on the sleeves; round neckline, with a fastening that is hidden from view by the central braid. Hemmed sleeves finished off with dark blue trimming. Straight skirt composed of five panels, lined with ivory-coloured pongee. *Didier Ludot collection.*

4. Chanel-Haute Couture, Autumn-Winter 1963-4.
Suit in beige tweed trimmed with dark blue and beige. Lined with beige pongee with decorative stitching, giving a padded effect, edged with a gold chain. Straight jacket with round neckline, closing edge to edge, with four stitched-on V-shaped pockets, trimmed, with gilded button in the form of a lion's head. Turned-up cuff, trimmed, set off with buttons. Straight skirt with pockets in the side seams. *Maison Chanel.*

5. Chanel-Haute Couture, 1964.
This suit was worn by Gabrielle Chanel. Suit in dark blue woollen tweed. Jacket with a smooth, round neck, with four stitched-on pockets embellished with braid, lined with dark blue silk gauze.

The lining is stitched on to the jacket vertically with regular spaces in between, weighed down with a chain at the bottom of the seam, finished off first with a black braid to which a second dark blue and white woollen braid has been added, fastening at the centre front with four buttons and two buttons at the bottom of the sleeve (buttons gilded with eighteen-carat gold with lion's head). Straight wraparound skirt, hooked fastening on left-hand side in front, finished off first with a black braid to which a second dark blue and white woollen braid has been added. *Musée de la Mode, Marseilles.*

6. Chanel-Haute Couture, Spring-Summer 1966.
Suit in beige woollen tweed, with pongee lining. The lining is attached to the tweed by way of vertical stitching. Jacket with smooth round neck, with four stitched-on pockets decorated with braid, weighed down with a chain at the bottom of the seam. The seams were used on the front edges of the jacket or sewn on the cuffs, the neckline and the bottom of the jacket. They were duplicated using threads from the material. Fastening at the centre front, by means of three buttons and two rows of three buttons on the cuffs (gilded buttons surrounded by imitation chain). This jacket was worn by Gabrielle Chanel. Straight wraparound skirt, fastening in the front with hook and ribbed belt.
Maison Chanel.

7. Chanel-Haute Couture.
Suit trimmed with black spangles.
Didier Ludot collection.

8. Chanel-Haute Couture, Autumn-Winter 1963-4.
Suit in brown, grey and black bouclé tweed; braid in same colours. Lined with brown, grey and black silk crêpe with trompe-l'oeil tweed motifs. Short, straight jacket. Round neckline, closed edge to edge with Brandenburg loops and gilded metal buttons embellished with a star. Straight skirt with green absinthe-coloured belt, finished off at the centre with a gilded metal button, embellished with a star.
Didier Ludot collection.

9. Chanel-Haute Couture.
Suit from the wardrobe of Gabrielle Chanel.
Maison Chanel.

10. Chanel-Haute Couture, Autumn-Winter 1968.
Suit of beige tweed. This suit was originally presented in dark blue in the spring collection. Jacket with a smooth, round neckline, with dark brown and white braid in zigzag, four stitched-on pockets finished off with identical braid and the same for the cuffs. False wraparound skirt, fastening at the back with a zip fastener. Blouse of heavy-quality white crêpe de Chine, tie-up collar, long sleeves with cuffs, asymmetrically placed buttons.
Musée de la Mode, Marseilles.

Voice-over:
'Fashion changes, style remains.'
'The elegance of a garment is the freedom to be able to move.'
'Simplicity has nothing to do with poverty.'

LA CHAMBRE DES BIJOUX
THE JEWELLERY ROOM

Forty pieces of costume jewellery, *Maison Chanel.*
Diamond 'star' brooch, *Maison Chanel.*

On the voice-over we hear the following remarks repeated constantly:
'I started designing costume jewellery because I felt it was unassuming in an age when ostentation was all too easy..., I chose diamonds because of their density, through which they represent the greatest value in a small volume.'

LA CHAMBRE PARLANTE
THE CONVERSATION ROOM

Video projection: '5 colonnes à la Une',
5 February 1959, French,
INA ref. 13-04-1901 04130747 (11 mins., 15 secs.)
Interview with Gabrielle Chanel

LA CHAMBRE DU COMMENTAIRE
THE COMMENTARY ROOM

Outspoken comments from Gabrielle Chanel
projected on contemporary film material from
the Pathé Archives, Paris

LA CHAMBRE DES SECRETS
THE ROOM OF SECRETS

1. THE SUIT
On display: *Suit, Maison Chanel.*
The basic idea of the suit is that it is an extension
of the human body. The difficulty is to design the
material in such a way that it cannot lose its shape:
the secrets are all discoveries that contribute
towards a natural appearance and therefore towards
elegance, as seen by Gabrielle Chanel.

2. THE GARÇONNE-LOOK
On display: *One pair of scissors, a lock of hair.*
Miss Chanel made short work of the codes and
duties that had dominated women's lives from the
beginning of the last century: corsets, long hair
and hats, all of which were regarded as 'mainstays'.
In 1917 she cut her long hair short because 'it was
a nuisance'.

3. SHOES
On display: *Two-tone sandals from 1957,
Maison Chanel.*
Miss Chanel devised shoes to go with any outfit.
She designed a two-tone shoe with a strap and a
small heel in 1957: she used black for the graphic
effect and the practical aspects of the colour -
black makes the foot look smaller and shows less
dirt - and beige to make the leg look slimmer.

4. THE HANDBAG
On display: *Two padded Chanel handbags,
Maison Chanel.*
Miss Chanel: 'I was tired of carrying my bag in my
hand and losing it. So I attached a strap to it and
wore it on my shoulder.' In order to give the leather
or jersey more volume and greater sturdiness, she
had the bag stitched in diamond shapes. She chose
a red lining because it made it easier to see the
contents of the bag.

5. BEAUTY ACCORDING TO CHANEL
On display: *Make-up, powder and lipstick, make-up
removal tissues, weekend beauty cream, lotion with
fruit, powder and oil 'Tan pour l'Eté', Maison Chanel.*
Miss Chanel: 'The face is a mirror that reflects the
movements of the inner life: therefore take very
good care of it'. From 1924 Gabrielle Chanel began
to show an interest in beauty products and make-
up. She came up with the idea of making them
essential accessories, objects which after a while
you could not do without, functional, and in luxury
boxes that one could easily take anywhere.

LA CHAMBRE N°5
THE CHANEL N°5 ROOM

Bottles of perfume, Maison Chanel.

Voice-over:
'Perfume Is the most important thing there is. Paul
Valéry once said: "A badly perfumed woman has no
future."'

LA CHAMBRE MADEMOISELLE
THE 'MADEMOISELLE' ROOM

Music: **Le sacre du Printemps by Igor Stravinsky,**
the performance of which Chanel helped to finance
in 1919.

Photos
Wladimir Rehbinder, 1923
© British Vogue-The Condé Nast Publications Ltd.
© Bettman Newsphotos England-Van Parys Media
Hulton Getty © Fotogram-Stone images
Hulton Getty © Van Parys Media
Man Ray © Man Ray Trust-ADAGP-Telimage
Philippe Ledru © Van Parys Media
Cecil Beaton © Sotheby's London
Douglas Kirkland © Van Parys Media
P. Horst © Van Parys Media
Kammerman © Rapho, Paris
© Société des Bains de Mer, Monte Carlo
Roger Shall © Jean-Frédéric Schall
François Kollar © Ministère de la culture - France
Cecil Beaton © Van Parys Media
Lipnitzki-Viollet © Roger-Viollet

LA CHAMBRE DU STYLE
THE STYLE ROOM

3 video projections showing montage of various
recent fashion shows by Chanel designed by Karl
Lagerfeld (from left to right):

Haute Couture collection, Spring-Summer 2001
Haute Couture collection, Spring-Summer 1998
Haute Couture collection, Spring-Summer 1996

2WOMEN REI KAWAKUBO

5 STATEMENTS
First presentation of the Comme des Garçons
Autumn-Winter 2001-2 collection at the
Royal Athenaeum, Antwerp.

The Rei Kawakubo project consists of five present-
ations: from 26 May to 29 September this fashion
designer is showing several interpretations of her
Autumn-Winter 2001-2 collection.
The presentations take place at the following
locations: the Royal Athenaeum (26 May),
the Royal Museum of Fine Art (22 June),
the Church of St Augustine (27 July),
the Commodity Exchange (24 August) and the
Winter Garden at the Antwerp Zoo (29 September).

Of the five statements, the one in the Commodity
Exchange at 9 p.m. on 24 August, is open to the
public. Because of limited space, admission to the
other four venues is by invitation only.
All the statements are being filmed and shown
throughout the project at the **2WOMEN** exhibition.

MUTILATE?

MUHKA
MUSEUM OF CONTEMPORARY ART ANTWERP
11 LEUVENSTRAAT, 2000 ANTWERP

CONFRONTATIONS

Display cases with video projections on front;
objects displayed in cases, video at the back.
Each display case has a different theme.

1. WIGS & DECORATION
Front: video projection Huli warrior,
Papua New Guinea, photo Malcolm Kirk.
Back: video 'Voices in the Forest', Papua New
Guinea, *ABC, Australia.*

2. TAILLEUR BAR
Front: video projection model wearing the
Tailleur Bar, Dior Haute Couture collection,
Spring-Summer 1947.
Back: video, fragments from 'The Death of Dior',
Pathé Archives, Paris.
Video, documentary 'Monsieur Dior',
Canal +, Paris.

3. HEAD-SHAPING
Front: video projection Mangbetu woman,
photo C. Zagourski (1930).
Back: objects in glass cases,

A. ANTHROPOMORPHIC FIGURES
– from left to right:

1. Anthropomorphic figure, Mangbetu, Democratic
Republic of Congo, early 20th century, 42.7 cm,
Royal Museum for Central Africa, Tervuren;

2. Anthropomorphic figure, Mangbetu,
Democratic Republic of Congo, early 20th century,
37.1 cm, *Royal Museum for Central Africa, Tervuren;*

3. Anthropomorphic figure, Mangbetu, Democratic
Republic of Congo, early 20th century, 68.3 cm,
Royal Museum for Central Africa, Tervuren;

4. Anthropomorphic figure, Mangbetu, Democratic
Republic of Congo, early 20th century, 49 cm,
Royal Museum for Central Africa, Tervuren;

5. Anthropomorphic figure, Mangbetu, Democratic
Republic of Congo, early 20th century, 50.5 cm,
Royal Museum for Central Africa, Tervuren;

6. Spool used for head-binding, Mangbetu,
Democratic Republic of Congo, late 19th century,
55 x 8.2 cm, *American Museum of Natural History,
New York;*

B. HAIRPINS - from left to right:

7. Hairpin, Mangbetu, Democratic
Republic of Congo, early 20th century, 51.1 x 6.4 cm,
Royal Museum for Central Africa, Tervuren;

8. Hairpin, Mangbetu, Democratic
Republic of Congo, early 20th century, 22.6 cm,
Royal Museum for Central Africa, Tervuren;

9. Hairpin, Mangbetu, Democratic
Republic of Congo, mid- or late 19th century,
6.5 x 5.1 cm,
Royal Museum for Central Africa, Tervuren;

10. Hairpin, Kuba, Democratic Republic
of Congo, mid- or end 19th century, 27.7 cm,
Royal Museum for Central Africa, Tervuren;

11. Hairpin, Mangbetu, Democratic Republic
of Congo, early 20th century, 36 cm,
Royal Museum for Central Africa, Tervuren;

12. Hairpin, Mangbetu, Democratic Republic
of Congo, early 20th century, 13.7 cm,
Royal Museum for Central Africa, Tervuren;

13. Hairpin, Mangbetu, Democratic Republic
of Congo, 19.8 x 2.4 cm,
Ethnographic Museum, Antwerp;

14. Hairpin, Mangbetu-Zande, Democratic Republic
of Congo, 31.2 cm,
Ethnographic Museum, Antwerp;

15. Hairpin, Mangbetu, Democratic Republic
of Congo, early 20th century, 24 cm,
Royal Museum for Central Africa, Tervuren;

16. Hairpin, Mangbetu-Zande, Democratic Republic
of Congo, 33.8 cm,
Ethnographic Museum, Antwerp;

17. Hairpin, Mangbetu-Zande, Democratic Republic
of Congo, 27.8 x 6 cm,
Ethnographic Museum, Antwerp;

18. Hairpin, Mangbetu-Zande, Democratic Republic
of Congo, 27.7 x 3.9 cm,
Ethnographic Museum, Antwerp;

19. Hairpin, Mangbetu-Zande, Democratic Republic
of Congo, 31.3 x 4.7 cm,
Ethnographic Museum, Antwerp.

Video, 'Mangbetu',
Democratic Republic of Congo, *Gérard de Boe.*

4. SCARIFICATION
Front: video projection of girl with scarifications.
Back: objects in glass case,

From left to right:

1. Anthropomorphic figure, Yombe,
Democratic Republic of Congo, late 19th century,
33 cm, *Royal Museum for Central Africa, Tervuren;*

2. Anthropomorphic figure, Yombe,
Democratic Republic of Congo, late 19th century,
22.5 cm, *Royal Museum for Central Africa, Tervuren;*

3. Anthropomorphic figure, Yombe,
Democratic Republic of Congo, late 19th century,
34 cm, *Royal Museum for Central Africa, Tervuren;*

4. Anthropomorphic figure, Lumbo,
Gabon, early 20th century, 24.9 x 6.8 cm,
Royal Museum for Central Africa, Tervuren;

5. Anthropomorphic figure, Teke, Democratic
Republic of Congo, early 20th century, 29.3 cm,
Royal Museum for Central Africa, Tervuren;

6. Anthropomorphic figure, Luluwa,
Democratic Republic of Congo,
mid- or late 19th century, 34 cm,
Royal Museum for Central Africa, Tervuren;

7. Anthropomorphic figure, Luluwa,
Democratic Republic of Congo,
mid- or late 19th century, 46.5 x 9.3 cm,
Royal Museum for Central Africa, Tervuren;

8. Anthropomorphic figure, Luluwa, Democratic
Republic of Congo, mid- or late 19th century, 41 cm,
Royal Museum for Central Africa, Tervuren;

9. Anthropomorphic figure, Ndengese,
Democratic Republic of Congo,
mid- or late 19th century, 57.5 cm,
Royal Museum for Central Africa, Tervuren;

10. Anthropomorphic figure, Ndengese,
Democratic Republic of Congo,
mid- or late 19th century, 54 cm,
Royal Museum for Central Africa, Tervuren;

11. Anthropomorphic figure, Baule, Ivory Coast,
late 19th or early 20th century, 45.6 cm,
Royal Museum for Central Africa, Tervuren;

12. Anthropomorphic figure, Yoruba, Nigeria,
mid-20th century, 24.6 cm,
Royal Museum for Central Africa, Tervuren;

13. Anthropomorphic figure, Yoruba, Nigeria,
early 20th century, 29.2 cm,
Royal Museum for Central Africa, Tervuren;

14. Anthropomorphic figure, Beembe,
Democratic Republic of Congo,
mid-20th century, 18.4 cm,
Royal Museum for Central Africa, Tervuren;

15. Anthropomorphic figure, Beembe,
Democratic Republic of Congo,
mid-20th century, 24.6 cm,
Royal Museum for Central Africa, Tervuren;

16. Anthropomorphic figure, Beembe,
Democratic Republic of Congo,
early 20th century, 18.5 cm,
Royal Museum for Central Africa, Tervuren.

Video, 'Masakin. The Application of Scarifications',
Sudan, 1963, *Institut für den Wissenschaftlichen
Film, Göttingen.*

5. LOTUS FEET
Front: video projection of woman on a bed
wearing lotus shoes.
Back: objects in glass case,

Row 1 - from left to right:

1. Lotus shoes, China, *c.* 1900,
7.5 x 4 x 14 cm, *Collection Bertholet;*

2. Lotus shoes, China, *c.* 1900,
8 x 5.5 x 13 cm,
Deutsches Ledermuseum-Schuhmuseum, Offenbach;

3. Lotus shoes, China, 19th century,
7 x 4 x 17 cm,
Royal Museum of Art and History, Brussels;

4. Lotus shoes, China, *c.* 1900,
6 x 4 x 10.5 cm,
Collection Bertholet;

5. Lotus shoes, China, 19th century,
7.5 x 5.2 x 12.6 cm,
*Musée Internationale de la Chaussure,
Romans-sur-Isère;*

6. Lotus shoes, China, 1910-30,
13 x 5 x 10 cm,
Nederlands Leder- en Schoenenmuseum, Waalwijk;

7. Lotus shoes, China, 19th century,
7.8 x 5 x 10 cm,
*Musée Internationale de la Chaussure,
Romans-sur-Isère;*

8. Lotus shoes, China, 19th century,
10 x 13 cm,
Royal Museum of Art and History, Brussels;

9. Lotus shoes, China, 19th century,
4.5 x 4.8 x 11.7 cm,
*Musée Internationale de la Chaussure,
Romans-sur-Isère;*

10. Lotus shoes, China, *c.* 1900,
8 x 5 x 11 cm,
Nationaal Schoeiselmuseum, Izegem;

11. Lotus shoes, China, *c.* 1900,
18 x 4 x 12.5 cm,
Deutsches Ledermuseum-Schuhmuseum, Offenbach;

ROW 2 - from left to right:

12. Lotus shoes, China, 19th century,
6 x 4 x 15 cm,
Royal Museum of Art and History, Brussels;

13. Lotus shoes, China, *c.* 1900,
6.5 x 4.5 x 13.5 cm,
Nationaal Schoeiselmuseum, Izegem;

14. Lotus shoes, China, 1920-28,
6 x 4 x 16.5 cm,
Ethnographic Museum, Antwerp;

15. Lotus shoes, China, 19th century,
11.8 x 4.7 x 16.9 cm,
*Musée Internationale de la Chaussure,
Romans-sur-Isère;*

16. Lotus shoes, China, *c.* 1900,
11 x 4 x 12 cm,
Nationaal Schoeiselmuseum, Izegem;

17. Lotus shoes, China, *c.* 1900,
7 x 3.7 x 11.5 cm,
Collection Bertholet;

18. Lotus shoes, China, *c.* 1900,
6 x 4 x 13 cm,
Nationaal Schoeiselmuseum, Izegem;

19. Lotus shoes, China, 1920-28,
8 x 4 x 18 cm,
Ethnographic Museum, Antwerp;

20. Lotus shoes, China, *c.* 1900,
16.5 x 4.5 x 10 cm,
Collection Bertholet;

21. Lotus shoes, China, *c.* 1900,
11.5 x 4 x 12 cm,
Deutsches Ledermuseum-Schuhmuseum, Offenbach;

22. Röntgen photo of a lotus foot,
40 x 30 cm,
German Röntgen Museum, Remscheid.

6. YOUTH CULT
Front: video projection portrait Twiggy, 1965.
Back: videos 'One Pair of Eyes', Norman Parkinson,
Filmimages, Paris; 'Catwalks - Kate Moss', *BBC,
London;* 'Garçonne-look in the Twenties',
Pathé Archives, Paris.

7. LIP DISCS
Front: video projection Kaiapo warrior,
photo Hibiki Kobayashi.
Back: objects in glass case,

KAIAPO - WOODEN OVAL-SHAPED LIP DISCS
- from top to bottom:

1. Lip disc, Kaiapo, Brazil,
10.3 x 7.7 x 1.9 cm,
Ethnographic Museum, Antwerp;

2. Lip disc, Kaiapo, Brazil,
1.5 x 10.5 x 7.5 cm,
Museum der Kulturen, Basel;

3. Lip disc, Kaiapo, Brazil,
1.5 x 12 x 8 cm,
Museum der Kulturen, Basel;

4. Lip disc, Kaiapo, Brazil,
late 20th century, 12 x 9.5 cm,
Royal Museum for Central Africa, Tervuren;

5. Lip disc, Kaiapo, Brazil,
late 20th century, 5.7 x 4.5 cm,
Royal Museum for Central Africa, Tervuren;

6. Lip disc, Kaiapo, Brazil,
late 20th century, 10.3 x 8.2 cm,
Royal Museum for Central Africa, Tervuren;

7. Lip disc, Kaiapo, Brazil,
late 20th century, 9.8 x 8 cm,
*Royal Museum for Central Africa, Tervure*n;

AFRICA - from top to bottom:

8. Lip disc, Mursi, Ethiopia, 1990-95,
2 x 10 x 15 cm,
Collection Houben, Belgium;

9. Lip disc, Baale, Sudan, late 20th century,
Royal Museum for Central Africa, Tervuren;

10. Earplug, Mursi, Ethiopia,
late 20th century, 1.7 x 6.2 cm,
Royal Museum for Central Africa, Tervuren;

11. Lip disc, Mursi, Ethiopia, 1990-95,
2 x 13.5 x 21 cm,
Collection Houben, Belgium;

12. Lip disc, Mursi, Ethiopia, 1990-95,
2 x 6.5 cm,
Collection Houben, Belgium;

13. Lip disc, Mursi, Ethiopia, 1990-95,
2 x 17.2 cm,
Collection Houben, Belgium;

14. Lip disc, Mursi, Ethiopia,
late 20th century, 2 x 10 cm,
Royal Museum for Central Africa, Tervuren;

15. Lip disc, Mursi, Ethiopia,
late 20th century, 2 x 10 cm,
Royal Museum for Central Africa, Tervuren;

16. Lip disc, Mursi, Ethiopia,
late 20th century, 2 x 12 cm,
Royal Museum for Central Africa, Tervuren;

NORTH AMERICA - from top to bottom:

17. Labret Tsimshian, Canada, 19th century,
2 x 10.2 cm,
Canadian Museum of Civilisation, Hull;

18. Labret, Haida, Canada, 19th century,
2.1 x 4.5 cm,
Canadian Museum of Civilisation, Hull;

19. Labret, Tlingit, Canada, 19th century,
2.3 x 5.5 x 3.5cm,
American Museum of Natural History, New York;

20. Labret, north-west coast Alaska-Canada,
19th century, 2.4 x 6.7 cm,
Canadian Museum of Civilisation, Hull;

21. Labret, Haida, Canada, 19th century,
2.3 x 5.6 cm,
Canadian Museum of Civilisation, Hull;

22. Labret, Inuit, Canada, 19th century,
3.4 x 5.7 cm,
Canadian Museum of Civilisation, Hull;

23. Labret, Tlingit, Canada, 19th century,
2 x 3.2 cm,
Canadian Museum of Civilisation, Hull;

24. Labret, Haida, Canada, 19th century,
3.1 x 7 cm,
Canadian Museum of Civilisation, Hull.

Videos, 'Cradle of Humanity, The Valley of the Ages',
Ethiopia, *Télé-images International, Boulogne*;
'Secrets of the Black Continent. The Women of the
Saras-Djingé', Sudan, *Filmmuseum Amsterdam.*
Compilation: 'Carving a Lip Disc', Brazil, 1960,
Institut für den Wissenschaftlichen Film, Göttingen;
'Eating, Drinking and Smoking with a Lip Disc',
Brazil, 1960, *Institut für den Wissenschaftlichen
Film, Göttingen.*

8. HIGH HEELS
Front: video projection high-heeled shoe.
Back: objects in glass case,

Top shelf:

1. Pink high-heeled shoe,
designer Julienne, France, 1920-28,
18.5 x 6.5 x 20.5 cm,
*Musée Internationale de la Chaussure,
Romans-sur-Isère*;

2. Red high-heeled shoe,
designer Ernest, France, *c.* 1950,
17.5 x 7.5 x 18.7 cm,
*Musée Internationale de la Chaussure,
Romans-sur-Isère*;

3. Sandal with high heel, Italy, 1967-75,
21 x 8 x 17 cm,
Nederlands Leder- en Schoenenmuseum, Waalwijk;

4. Red high-heeled shoe,
designer Julienne, France, 1920-28,
19.8 x 6.5 x 18.8 cm,
*Musée Internationale de la Chaussure,
Romans-sur-Isère*;

5. Black high-heeled shoe,
designer Julienne, France, 1920-28,
18.6 x 6.9 x 20.1 cm,
*Musée Internationale de la Chaussure,
Romans-sur-Isère*;

6. Green high-heeled shoe,
designer Brunis, Italy, *c.* 1960,
17.3 x 7.3 x 22.5 cm,
*Musée Internationale de la Chaussure,
Romans-sur-Isère*;

7. Brown high-heeled shoe, 1975,
17.5 x 7.5 x 22 cm,
Nationaal Schoeiselmuseum, Izegem;

8. Green high-heeled shoe,
designer Julienne, France, 1920-28,
19 x 6.4 x 19.7 cm,
*Musée Internationale de la Chaussure,
Romans-sur-Isère*;

9. White high-heeled shoe,
Michel Perry, Italy, 25 x 6 x 14 cm,
Coccodrillo, Antwerp;

10. High-heeled shoe in red and gold,
designer Julienne, France, *c.* 1930,
22 x 6.9 x 20 cm,
*Musée Internationale de la Chaussure,
Romans-sur-Isère*;

11. Black fetish heel,
6 x 5 x 14 cm,
Private collection;

12. High-heeled shoe in black, red and gold,
designer Leslie Dupont, Belgium,
1950-60, 19 x 7 x 16 cm,
Nationaal Schoeiselmuseum, Izegem;

13. Black high-heeled shoe,
designer Julienne, France, 1920-28,
19 x 7 x 19.9 cm,
*Musée Internationale de la Chaussure,
Romans-sur-Isère*;

14. Orange pump with high heel, 19 x 8 x 20 cm,
Nederlands Leder- en Schoenenmuseum, Waalwijk;

15. Black high-heeled shoe,
designer Mahmout,
United Kingdom, 1940-45,
21 x 8 x 17 cm,
*Musée Internationale de la Chaussure,
Romans-sur-Isère*;

16. White high-heeled boot,
A.F. Vandevorst, Belgium,
25 x 6 x 18 cm,
Coccodrillo, Antwerp;

17. High-heeled shoe in red and black,
designer Leslie Dupont, Belgium,
1950-60, 18 x 7.5 x 17 cm,
Nationaal Schoeiselmuseum, Izegem;

18. Red high-heeled shoe,
designer Leslie Dupont, Belgium,
1950-60, 21 x 7.5 x 17 cm,
Nationaal Schoeiselmuseum, Izegem;

Middle shelf:

19. Fetish high-heeled shoe in red and black,
designer Hellstern, France, *c.* 1950,
25 x 7.5 x 22.5 cm,
*Musée Internationale de la Chaussure,
Romans-sur-Isère*;

20. Fetish high-heeled shoe in black and white,
designer Hellstern, France, *c.* 1950,
29 x 7.5 x 24 cm,
*Musée Internationale de la Chaussure,
Romans-sur-Isère*;

21. Fetish high-heeled shoe in black with strass heel,
designer Hellstern, France, *c.* 1950,
3.5 x 7.5 x 23.5 cm,
*Musée Internationale de la Chaussure,
Romans-sur-Isère*;

Bottom shelf:

22. Silver high-heeled shoe,
Italy, c. 1960,
17.8 x 7.3 x 22.1 cm,
*Musée Internationale de la Chaussure,
Romans-sur-Isère;*

23. Sandal with high heel,
Italy, 1975,
14 x 6 x 22 cm,
Nederlands Leder- en Schoenenmuseum, Waalwijk;

24. High-heeled shoe in red and black,
designer Brunis, Italy,
c. 1960, 16.5 x 7.9 x 23 cm,
*Musée Internationale de la Chaussure,
Romans-sur-Isère;*

25. Green sandal with high-heeled shoe,
1976, 16 x 6 x 23 cm,
Nederlands Leder- en Schoenenmuseum, Waalwijk;

26. Black high-heeled shoe,
designer Rudolphe Menudier, Italy,
15 x 5 x 25 cm,
Coccodrillo, Antwerp;

27. High-heeled shoe,
designer Eperon d'Or (Vandommele), 1935,
18 x 7 x 19 cm,
Nationaal Schoeiselmuseum, Izegem;

28. Black high-heeled shoe,
Italy, 1950-60,
15 x 6 x 18 cm,
Nationaal Schoeiselmuseum, Izegem;

29. High-heeled shoe,
15 x 7 x 25 cm,
Coccodrillo, Antwerp;

30. High-heeled shoe,
designer Leslie Dupont, Belgium, 1950-60,
17 x 7.5 x 17 cm,
Nationaal Schoeiselmuseum, Izegem;

31. High-heeled shoe,
designer Leslie Dupont, Belgium, 1950-60,
18.5 x 8 x 16 cm,
Nationaal Schoeiselmuseum, Izegem;

32. Black high-heeled shoe,
designer Brunis, Italy c. 1960,
17.3 x 7.2 x 22.3 cm,
*Musée Internationale de la Chaussure,
Romans-sur-Isère;*

33. Grey high-heeled shoe,
1942, 15 x 5 x 16 cm,
Deutsches Ledermuseum-Schuhmuseum, Offenbach;

34. Serpent high-heeled shoe,
1953, 22 x 6 x 21 cm,
Deutsches Ledermuseum-Schuhmuseum, Offenbach;

35. Black high-heeled shoe,
1953, 21.3 x 6 x 21.5 cm,
Deutsches Ledermuseum-Schuhmuseum, Offenbach;

36. High-heeled shoe in white, yellow and green,
1950, 22 x 6 x 18 cm,
Deutsches Ledermuseum-Schuhmuseum, Offenbach;

37. Black high-heeled shoe,
Italy, 1960, 20 x 6 x 20 cm,
Deutsches Ledermuseum-Schuhmuseum, Offenbach;

38. Yellow high-heeled shoe,
Italy, 1960, 18 x 20.1 cm,
Deutsches Ledermuseum-Schuhmuseum, Offenbach.

9. POLYNESIAN TATTOO
Front: video projection of a Maori man.
Back: objects in glass case,

1. Anthropomorphic figure, Maori, New Zealand,
accomplished in 1956, 24.9 cm,
Ethnographic Museum, Antwerp;

2. Wooden head with facial tattoos,
Maori, New Zealand, before 1929, 60 cm,
Koninklijk Instituut voor de Tropen, Amsterdam;

3-6. Tattooing tools, Maori, New Zealand,
probably 19th century;

7. Feeding funnel, Maori, New Zealand,
probably 19th century, 19 x 13 x 12.2 cm,
American Museum of Natural History, New York;

8. Pigment bowl in lava stone, New Zealand,
Tattoo Museum, Amsterdam;

9. Kokui nuts, New Zealand,
Tattoo Museum, Amsterdam;

10. Resin of the Kauri tree, New Zealand,
Tattoo Museum, Amsterdam.

Video, 'About Face', *Singapore Airlines.*

10. NDEBELE
Front: video projection of a Ndebele woman.
Back: objects in glass case,

From left to right:

1. Golwani with pins, South Africa,
28 x 8.5 cm,
Private collection;

2. Pair of two superimposed red izigolwani,
South Africa, 30 x 10 cm,
Private collection;

3. Golwani with ring inside,
South Africa, 28 x 10.5 cm,
Private collection;

4. Pair of two superimposed blue izigolwani,
South Africa, 22 x 14 cm,
Private collection;

5. Iphoto,
South Africa, 35 x 40 cm,
Private collection.

Video, 'Ndebele Women',
South Africa, *TV De Wereld, Leuven.*

11. PUNK
Front: video projection portrait Cat Woman.
Back: videos, compilation:
'Interview Malcolm McLaren, Punk Clothes,
the Sex Pistols and Anarchy in the UK',
BBC, United Kingdom;
compilation:
'Punk, the Sex Pistols, God Save the Queen',
BBC, United Kingdom;
Vintage punk jacket by Vivienne Westwood
and Malcolm McLaren, 1975.
Resurrection, Los Angeles.

12. BODY-PAINTING
Front: video projection of a Wodaabe man.
Back: objects in glass case,

Foreground – from left to right:

1-5. Cylindrical stamps, Mangbetu,
Democratic Republic of Congo, 1890-1910,
American Museum of Natural History, New York;

6-8. Zigzag formed stamps, Mangbetu,
Democratic Republic of Congo, 1890-1910,
American Museum of Natural History, New York;

9. Calabash, Kaiapo,
Brazil, late 20th century, 5 x 10.8 cm,
Royal Museum for Central Africa, Tervuren;

10. Instrument used for body-painting, Kaiapo,
Brazil, late 20th century, 20.3 x 4 cm,
Royal Museum for Central Africa, Tervuren;

11. Instrument used for body-painting, Kaiapo,
Brazil, late 20th century, 23 x 1.5 cm,
Museum der Kulturen, Basel;

12. Make-up stick with small leather sack
and blue pigment, Niger, 9 cm,
Collection Van Nieuwerburgh;

13. Leather make-up bottle, Wodaabe,
Niger, *Collection 't Jolle;*

Background – from left to right:

14. Kalabas, Mangbetu,
Democratic Republic of Congo, 1890-1910,
11.5 x 8.8 cm,
American Museum of Natural History, New York;

15. Leather container with pigment, Mangbetu,
Democratic Republic of Congo, 1890-1910,
7.4 x 5.4 cm,
American Museum of Natural History, New York;

16. Instrument used for body-painting, Mangbetu,
Democratic Republic of Congo, 1890-1910,
9.3 x 1.7 cm,
American Museum of Natural History, New York;

17. Kalabas, Kaiapo, Brazil, late 20th century,
9.5 x 18.5 cm,
Royal Museum for Central Africa, Tervuren;

18-20.
Pigments used for body-painting, Wodaabe,
Niger, *Collection Van Nieuwerburgh;*

21. Part of a kalabas with yellow pigment, Wodaabe,
Niger, *Collection Van Nieuwerburgh.*

Videos, 'Waura, Body-painting', Brazil, 1964,
Institut für den Wissenschaftlichen Film, Göttingen;
'Wodaabe – Facial Make-up for the 'dance of beauty'
'Yaake', Niger, *Dominique 't Jolle, Antwerp;*
'Mangbetu', Democratic Republic of Congo,
Gérard de Boe.

13. PANIER
Front: video projection of woman with panier.
Back: objects in glass case,

1. Corset,
18th century,
Museum voor het Kostuum en de Kant, Brussels;

2. Corset,
18th century,
Historisch Museum Rotterdam.

14. PADAUNG
Front: video projection Padaung woman.
Back: objects in glass case,

1. Neckring, Padaung, Thailand,
20th century, 13 x 11 cm,
American Museum of Natural History, New York;

2. Neckring, Padaung, Thailand,
20th century, 24 x 8 cm,
American Museum of Natural History, New York;

3. Röntgen photo of the head and the neck of
a Padaung woman with neckrings,
German Röntgen Museum, Remscheid.

Videos,
compilation: 'The Secret Worlds of Asia.
The Legend of the Golden Spiral', Thailand,
Télé-images International, Boulogne;
'Padaung, Long-necked Woman',
Filmimages, Paris.

Credits:
Realization of installation: SET bvba, Aartselaar;
Videoprojection: Vidi-Square nv, Zandhoven.

CONSTRUCTIONS

In this room ten historical silhouettes have been
set up. Around these paper silhouettes the original
constructions, which give the silhouettes their
shape, are shown.

1. **'S'-silhouette**: *c.* 1900,
S-corset, *c.* 1892, *Kyoto Costume Institute*;
S-corset, 1891, *Kyoto Costume Institute*;
S-corset, *c.* 1901, *Kyoto Costume Institute*;

2. **'Tournure' silhouette**: *c.* 1885,
Bustle, c. 1870, *Kyoto Costume Institute*;
Bustle, c. 1871, *Kyoto Costume Institute*;

3. **'Empire' silhouette**: *c.* 1806,
Empire corset, 1801, *Kyoto Costume Institute*;
Empire corset, 1831, *Kyoto Costume Institute*;

4. **'Crinoline' silhouette**: *c.* 1860,
Corset, 1865-70, *Kyoto Costume Institute*;
Corset, 1881, *Kyoto Costume Institute*;
Crinoline, 1863, *Kyoto Costume Institute*;
Crinoline, 1865-70, *Kyoto Costume Institute*;

5. The **'New Look' silhouette** by Dior, 1947;

6. **Silhouette**: *c.* 1750;
Stay, 1781, *Kyoto Costume Institute*;

7. **Silhouette**: *c.* 1900;
S-corset, *c.* 1908, *Kyoto Costume Institute*;

8. **'Panier' silhouette**: *c.* 1750;
Stay, late 18th century, *Kyoto Costume Institute*;

9. **'Tournure' silhouette**: *c.* 1880;
Tournure, 1870, *Kyoto Costume Institute*;
Corset, *c.* 1892, *Kyoto Costume Institute*;

10. **'20s' silhouette**:
Three-in-one corset, *c.* 1925,
Kyoto Costume Institute;
Corset, 1920, *Kyoto Costume Institute*.

Credits:
Paper silhouettes by Isabelle de Borchgraeve
and Rita Brown, Brussels;
arrangement of historical pieces by Dirk van Saene,
Erwina Sleutel and Kyoto Costume Institute.

TRANSFORMATIONS

6 photographic prints on wall.

Photographer: Michael Williams
at Walter Schupfer Management, New York
Model: Amanda Lepore
1st Assistant: Siege Fotowork
2nd Assistant: Edwin Steinitz
Hair & Make-up Stylist: Donald Simrock
Fashion Stylist: Leslie Lessin
Films & Processing: Color Edge, New York
Equipment: Adorama, New York
Location: Consulate, New York
Prints: Claes Tradigital Photolab, Antwerp

BODY ART

Fifteen videos projected on wall.

1. **Franko B.**,
'I Miss You 1', 1999 (13 mins.)

2. **Bruce Nauman**,
'Art Make-up', 1967-8, (40 mins.)

3. **Vito Acconci**,
'Light, Reflection, Self-control', 1971 (90 mins.)

4. **Chris Burden**,
'Shoot', 1971 (2 mins.)

5. **Ron Athey**,
'Ronnie Lee', 2001 (7 mins.)

6. **Abramovic Ulay**,
'Art Must be Beautiful, Artist Must be Beautiful',
1975 (12 mins.)
Talking about 'Similarity', 1971 (9 mins.),
'Imponderabilia', 1971 (9 mins.),
'Relation in Time', 1971 (10 mins.)

7. **Sonja Wyss**,
'To Date', 1998 (7 mins.)

8. **Arnulf Rainer**,
'Confrontation with My Video Image', 1975
(18 mins.)

9. **Dennis Oppenheim**,
'Extended Armour', 1970 (2 mins.),
'Gingerbread Man', 1970 (2 mins.)

10. **Yves Klein**,
'Yves Klein réalisant une peinture de feu', 1961

11. **Gutai** on the stage Art exhibition, 1957 (4 min.)

12. **Yves Klein**,
'Antropometrie de l'époque Blue', 1960 (11 mins.)

13. **Gina Pane**,
'Psyche', 1974 (25 mins.)

14. **Elke Krystufek**,
'Aktion', 1990 (26 mins.)

15. **Orlan**,
'Omniprésence', New York, 1993 (34 mins.)

Video projections by Vidi-Square nv, Zandhoven.

FASCINATION - MR PEARL'S ROOM

Corsets and silhouettes by Mr Pearl, London.

1. Corsage of Cleo de Mérode, 1896,
Musée de la Mode, Palais Galliera, Paris;

2. Personal corset as worn by Mr Pearl;

3. Swarovski dress by Mr Pearl, 1999,
Black satin corset with velvet belt by Mr Pearl for
Christian Lacroix Skirt by Atelier Lacroix-Haute
Couture, Paris, Spring-Summer 1997;

4. Beaded 'Bleeding Torso Jacket' with undercorset
– embroidery and corset by Mr Pearl for Vivienne
Westwood – Men's Collection, Milan, 1996;

5. Red satin black metallic beaded corset with
velvet sleeves by Mr Pearl for Christian Lacroix;

6. Skirt and gold sleeves by Atelier Lacroix-
Haute Couture, Autumn-Winter 1995;

7. Hand-woven green metallic silk corset with
black sleeves by Mr Pearl for Christian Lacroix;

8. Skirt by Atelier Lacroix-Haute Couture,
Spring-Summer, 1997;

9. Black satin all-embroidered corset by Mr Pearl,
1996;

10. Bugle beaded and sequined corset
'Future Officer' by Mr Pearl for Thierry Mugler-
Haute Couture, Spring-Summer 1997-8;

11. Black jet embroidered transparant corset
with sleeves and stockings all by Mr Pearl
for Thierry Mugler-Haute Couture, Paris,
Autumn-Winter 1998-9;

12. Metallic butterfly beaded corset all by
Mr Pearl for Christian Lacroix Skirt by Atelier
Lacroix-Haute Couture, Spring-Summer 1996;

13. Gentleman's corset, 1907,
Kyoto Costume Institute;

14. Silk chiffon and beaded lace corseted dress
with stockings all by Mr Pearl for Thierry Mugler-
Haute Couture, Paris, Spring-Summer 1999-2000;

15. Sequined corseted dress 'Butterfly' all by
Mr Pearl for Thierry Mugler-Haute Couture, Paris,
Spring-Summer 1997-8;

16. 'Surgical corset' by Mr Pearl for Hussein
Chalayan-Prêt-à-porter, London, 1995.

Installations:
Twin Design, Temse & Pandora, Antwerp.

AVATARS

An installation by Frank Theys.

Interactive development: Magic Media
Software engeneering: Emmanuel Lestienne
Motion tracking design & development,
technical mangement: Yves Bernard
Scenography & realization of installation:
Central Omgevingen, Dries De Jonghe, Bert Leysen
Sound design: Missfit
(Arnoud Jacobs @ FYKE facilities)
Video realization: VOTNIK
Camera & editing: Frank Theys
Recording assistants: Hans van Nuffel,
Niels van Tomme

Editing assistants: Edit Kaldor, Sabine Vanderlinden
Hat design: Anke Tacq
Production assistant: Hai-chay Jiang

With the cooperation of:
BRONKS,
Departement werktuigkunde KUL,
deSingel,
Polar Video,
Provinciaal Domein Kessel-Lo,
STUC Leuven,
Toneelgroep Amsterdam,
Dierenkliniek Kerberos
Thanks to: Nina Beulens, Freek Boei, Erik Dehaes,
Danny Elsen, Pieter Hollants, Nana Jans, Diederik
Peeters, Guy Peeters, Ilonka Rozenbeek, Hans
Sonneveld

CONTEMPORARY FASHION

A selection of twenty-three contemporary fashion
designs.

1. **Dior Couture - John Galliano,**
Autumn-Winter 1997-8,
Kyoto Costume Institute.

2. **G+N - Gerrit Uittenbogaard & Natasja Martens,**
Spring-Summer 2000,
Centraal Museum Utrecht;

3. **Hussein Chalayan,**
Airship dress - Millennium Dome 2000,
Costume Gallery, Mme Judith Clark;

4. **Keupr-van Bentm,**
Frost-Parade 1999,
Centraal Museum Utrecht;

5. **Yohji Yamamoto,**
Autumn-Winter 1991-2,
Harry Houben - Yohji Yamamoto shop, Antwerp;

6. **A.F. Vandevorst,**
Autumn-Winter 1998-9,
A. F. Vandevorst;

7. **Givenchy Couture-Alexander McQueen,**
Autumn-Winter 1997-8,
Givenchy, Paris;

8. **Comme des Garçons,**
Spring-Summer 1997,
Comme des Garçons - Japan;

9. **Martin Margiela,**
Autumn-Winter 2000-2001,
Maison Martin Margiela;

10. **Kanya Miki,**
Collection 1st master's degree - Politically incorrect,
*Kanya Miki - student Koninklijke Academie
voor Schone Kunsten, Antwerp;*

11. **Viktor & Rolf,**
Autumn-Winter 1998-9,
Centraal Museum Utrecht;

12. **Carol Christian Poell,**
Jacket: Winter 2000-2001,
Top in glass: Winter 2000-2001,
Skirt: Winter 1999-2000,
Shoes: Winter 1999,
Mask: Summer 2000,
Carol Christian Poell;

13. **Junya Watanabe,**
Autumn-Winter 1998-9,
Junya Watanabe Comme des Garçons;

14. **Ysuke Okabe,**
Collection 1st master's degree -
The past of which I am part,
*Ysuke Okabe - student Koninklijke Academie
voor Schone Kunsten, Antwerpen;*

15. **Comme des Garçons,**
Autumn-Winter 1995-6,
Comme des Garçons - Japan;

16. **Angelo Figus,**
Autumn-Winter 2000-2001,
Angelo Figus;

17. **Givenchy Couture - Alexander McQueen,**
Spring-Summer 2001,
Givenchy Paris;

18. **Viktor & Rolf,** 1993,
Centraal Museum Utrecht;

19. **Walter van Beirendonck,**
'Gender' collection, Spring-Summer 2000,
Walter van Beirendonck;

20. **Junya Watanabe,**
Autumn-Winter 2000-2001,
Junya Watanabe Comme des Garçons;

21. **Walter van Beirendonck,**
'No References' collection,
Autumn-Winter 1999-2000,
Walter van Beirendonck;

22. **Martin Margiela,**
Autumn-Winter 2000-2001,
Maison Martin Margiela;

23. **Yohji Yamamoto,**
Autumn-Winter 1996-7,
Yohji Yamamoto, Paris.

INFORMATION

Books made available by
Copyright Art and Architecture Bookshop,
Ghent & Antwerp.
Xeroxed files on the exhibition's content
from various sources.
Videos available for viewing.
Internet access, website guide.

EMOTIONS

An 'interviews' installation mounted on thirty-six
screens. Hundreds of figures from the worlds of
fashion, art and design were asked to describe their
most emotional memory to do with clothing or
fashion. All their recollections were related in front
of the camera.

A 'short films' installation with video projection.
In addition to this, a number of film-makers were
asked to illustrate a selection of these interviews
in short films.

The former gymnasium of the Police Tower is being
used as a lounge for the duration of the exhibition,
as well as an observation post from where visitors
can view the city and its different-coloured
sections.

INTERVIEWS INSTALLATION

Interviewees:
AARICH JESPERS, ZITA SWOON, ANTWERP
ADELINE ANDRE, FASHION DESIGNER, PARIS
ADRIAAN RAEMDONCK, OWNER OF ZWARTE PANTER
GALLERY, ANTWERP
AGNES GOYVAERTS, JOURNALIST, GHENT
ALEKSANDER KOVACEVIC, FASHION STUDENT, ANTWERP
ALESSANDRO MENDINI, ARCHITECT, MILAN
ALEXANDRE MORGADO, FASHION DESIGNER, ALEXANDRE
MATTHIEU, PARIS
ALEXANDRE PAUL, PARIS
ALEXIS GEORGACOPOULOS, DESIGNER, LAUSANNE
ALINE WALTHER, FASHION DESIGNER, ANTWERP
AMANDA LEPORE, ARTIST
AN AVONDS, ART DIRECTOR, ANTWERP
AN D'HUYS, COSTUME DESIGNER, ANTWERP
AN PIERLE, SINGER, BRUSSELS
AN VANDEVORST, FASHION DESIGNER, ANTWERP
ANA KARINA VILLARROE I MORENO, FASHION STUDENT,
VIENNA
ANDERS EDSTROM, PHOTOGRAPHER, LONDON
ANDREA FERREOL, ACTRESS, PARIS
ANDREAS BERGBAUR, FASHION SCHOOL TEACHER, VIENNA
ANDREAS KOKKINO, WRITER/DIRECTOR, LONDON
ANDREAS SEMERAD, FASHION STUDENT, VIENNA
ANGELO FIGUS, FASHION DESIGNER, ANTWERP
ANGELO PENAZZATO, SHOE MANUFACTURER, ITALY
ANITA MOSES, SOCIAL WORKER, NEW YORK
ANJELIKA SAGAR, PRODUCER, LONDON
ANKE LOH, FASHION DESIGNER, PARIS
ANKE VAN BERENDONCKS, PHOTOGRAPHER, ANTWERP
ANN VERONICA JANSSENS, ARTIST, BRUSSELS
ANNA HEYLEN, FASHION DESIGNER, ANTWERP
ANNE KURRIS, GRAPHIC DESIGNER, ANTWERP
ANNE ZAZZO, CURATOR, MUSEE GALLIERA, PARIS
ANNEMARIE ULEMAN, STYLIST, PARIS
ANNE-MIE VAN KERCKHOVEN, ARTIST, ANTWERP
ANNEMIE VERBEKE, FASHION DESIGNER, BRUSSELS
ANNETTE DE KEYSER, GALLERY OWNER, ANTWERP
ANTIGONE SCHILLING, JOURNALIST, PARIS
ARJEN LUCAS, SILVERSMITH, ANTWERP
ARLETTE VERMEIREN, ART DIRECTOR,
TEXTILE FOUNDATION, BRUSSELS
ARTHUR AILLAUD, ARTIST, PARIS
AUDE BUTTAZZONI, GRAPHIC DESIGNER, PARIS
AUDRY BARTIS, RESEARCHER IN SEMIOTICS, PARIS
AURELIE MATHIGOT, DOCUMENTARY MAKER, PARIS
BACHE JESPERS, PHOTOGRAPHER, ANTWERP
BART VANDEBOSCH, FASHION STUDENT, KASKA, ANTWERP
BEATRICE SALMON, CURATOR, PARIS
BENJAMIN CHO, DESIGNER, NEW YORK
BENJAMIN GALOPIN, STYLIST, PARIS
BENOIT GELEZ, MANAGEMENT ASSISTANT, JEAN-PAUL
GAULTIER, PARIS
BENOIT MELEARD, SHOE DESIGNER, PARIS
BEPPE CATUREGLI, ARCHITECT, MILAN
BERNARD PERRIS, COUTURIER, PARIS
BERNHARD WILLHELM, FASHION DESIGNER, ANTWERP
BEVERLY CANIN, SOCIAL SERVICE ADM., NEW YORK

BLESS, FASHION DESIGNER, PARIS
BO COOLSAET, URO-AUDROLOGIST, ANTWERP
bOb VAN REETH, ARCHITECT, ANTWERP
BOY KORTEKAAS, STUDENT, ANTWERP
BRIAN HARRIS, DESIGNER, LONDON
BRIGITTE TELLIER, FREELANCE STYLIST, THE HAGUE
BURNADAIR LIPSEOMB HUNT, ACTRESS/MODEL, NEW YORK
CARENE MICHAUD, FASHION STUDENT, ANTWERP
CARL DE CANADA, WRITER, PARIS
CARLA AROCHA, ARTIST, ANTWERP
CARLA BOI, PARIS
CARMEN LUCINI, ARTIST/ART HISTORIAN, PARIS
CAROLINE CORNU, JOURNALIST, PARIS
CAROLINE KROUWELT, FASHION DESIGNER, AMSTERDAM
CEL CRABEELS, ARTIST
CHARLOTTE GRAPHITO, PARIS
CHINA, SINGER, PARIS
CHRIS FRANSEN, LECTURER,
FASHION DEPT, KASKA, ANTWERP
CHRIS PROOST, OWNER OF DE GROENE WOLK SHOP,
ANTWERP
CHRISTINE BLANC, PR, PARIS
CHRISTINE WALTER-BONINI, SALON DIRECTOR, PARIS
CHRISTOPH RUTIMANN, ARTIST
CHRISTOPHE CHARON, FASHION DESIGNER, PARIS
CHRISTOPHE COPPENS, DESIGNER, BRUSSELS
CHRISTOPHE LUCIEN, ART DIRECTOR, PARIS
CHRISTOPHE MOLLET, MAISON MARTIN MARGIELA, PARIS
CLAIRE HALLEREAU, EVENT PLANNING, NEW YORK
CLAIRE ROBERTSON, FASHION STUDENT, CSM, LONDON
CRISTINA DE LA MUELA, ASSISTANT, JED ROOD, PARIS
CYD JOUNY, SHOE DESIGNER, MARSEILLES
DAMIAAN DE SCHRIJVER, ACTOR, ANTWERP
DANA INTERNATIONAL, SINGER
DANIELLE POLLET, PR, PARIS
DANILO DANKOWORLD, HAIRDRESSER, VIENNA
DARJA RICHTER, FASHION DESIGNER, PARIS
DAVID WALTER MACDERMOTT, ARTIST, NYC
DEBRA SOTO, MODEL, VIENNA
DEJAN, PHOTOGRAPHER, PARIS
DEMETRE SAYALA, HAIRDRESSER, VIENNA
DEMIS MARIN, DESIGNER, PARIS
DEMIS SULEYMAN, FASHION DESIGNER,
OSCAR SULEYMAN, AMSTERDAM
DESMOND, DESIGNER, COOKED IN MARSEILLE, MARSEILLES
DIANE PERNET, JOURNALIST/DESIGNER, PARIS
DIRK ENGELEN, ARCHITECT, ANTWERP
DIRK VAN DOOREN, CREATIVE DIRECTOR, TOMATO, LONDON
DIRK VAN SAENE, FASHION DESIGNER, ANTWERP
DIRK VANDERDONCKT, MANAGER, GHENT
DRIES VAN NOTEN, FASHION DESIGNER, ANTWERP
E. D'HAUTEVILLE, MERCHANDISING DIRECTOR,
TINTIN, PARIS
ELISABETH PAILLIE, JOURNALIST, PARIS
ELKE HOSTE, PATTERN DESIGNER, ANTWERP
ELLENA BERENICE, DESIGNER, DELHI
ELVIS POMPILIO, HAT DESIGNER, BRUSSELS
EMMANUELLE GAULTHIER, PHOTOGRAPHER, NEW YORK
ENIE VAN DE MEIKLOKJES, TV PRESENTER, VIENNA
ERIK FRENKEN, FASHION STUDENT, THE HAGUE
ETTORE SOTTSASS, ARCHITECT, MILAN
EVA GRONBACH, STYLIST, PARIS
EVELINE SCHRODER, EMPLOYEE, ANTWERP
EVERT CROLS, ARCHITECT, ANTWERP
EYAL, PRODUCT DESIGNER, NEW YORK
F. WERNER, STUDENT, VIENNA
FAZE SGHAIER, SINGER, PARIS
FILIP ARICKX, FASHION DESIGNER, ANTWERP
FLORENCE, FASHION DESIGNER, VIENNA
FOUZIA CHERMAL, PARIS
FRANCESCA SORRENTI, PHOTOGRAPHER, NEW YORK
FRANCINE DE MEULDER, OWNER OF APC SHOP, ANTWERP
FRANCINE PAIRON, DIRECTOR, IFM, PARIS
FRANCOIS LESAGE, PDG LESAGE, PARIS
FRANCOISE BUSSIERES, FASHION EDITOR, BLVD,
THE HAGUE
FRANK SCHAFFER, HAIRDRESSER, VIENNA
FRANK VERVOORT, HAIRDRESSER, ANTWERP
FRED BONN, GRAPHIC DESIGNER, NEW YORK
FRED RIEFFEL, DESIGNER, PARIS
FREDERIC COUPET, ARTIST/ACTOR, MARSEILLES

FREDERIC GUELAFF, ARTIST, PARIS
FREDERIQUE DURAND, ASSISTANT, MARC LE BIHAN, PARIS
FRIEDA SORBER, HEAD OF MOMU, ANTWERP
FRIEDA VAN DUN, ARTIST, ANTWERP
GABRIEL MARTIN, STUDENT, VIENNA
GAMILIARI HARRIS, INTERIOR DESIGNER, MILAN
GASPARD YURKIEVICH, FASHION DESIGNER, PARIS
GEERT BRULOOT, OWNER, LOUIS, ANTWERP
GENEVIEVE SANGARE, MODEL, MALI
GENEVIEVE SEVIN-DOERING,
'PLASTICIEN DE VETEMENTS', MARSEILLES
GEORGESCU GREGORY, FASHION STUDENT, ANTWERP
GERALD DAUPHIN, PHOTOGRAPHER, ANTWERP
GERDI ESCH, FLANDERS FASHION INSTITUTE, ANTWERP
GERT CUYPERS, ARCHITECT, ANTWERP
GERY KESZLER, ORGANIZER, LIFE BALL, VIENNA
GHISLAINE NUYTTEN, JOURNALIST, ANTWERP
GILBERT & GEORGE, ARTISTS, LONDON
GIORGIO ARMANI, FASHION DESIGNER, MILAN
GIORGIO BLASI, ASSISTANT, DANIEL TEDESCHI, PARIS
GIOVANNELLA FORMICA, ARCHITECT, MILAN
GIULIO CAPPELLINI, DIRECTOR,
CAPPELLINI COMPANY, MILAN
GLENN SESTIG, ARCHITECT, GHENT
GREGORY LEWIS, STYLIST, NEW YORK
GUIDO NUSSBAUM, ARTIST
GUILLAUME CHALLET, PRESS AGENT,
SOCIETE PRESSING, PARIS
HALVOR HAUEN, TAILOR, LONDON
HAMAN ALIMARDANI, GRAPHIC DESIGNER/
FASHION STUDENT, LONDON
HANNES WIEDER, STUDENT, VIENNA
HANS DE FOER, FASHION DESIGNER, PARIS
HARRY HOUBEN, OWNER OF YOHJI YAMAMOTO/
JUNYA WATANABE SHOP, ANTWERP
HEIDI BROECKAERT, STUDENT, ANTWERP
HIDETAKA FUKOZONO, FASHION STUDENT, ANTWERP
HINRICH SACHS, PROJECT MANAGER, MILAN
HIRO IWATO, FASHION DESIGNER, PARIS
HORTENSIA DE HUTTEN, ORGANIZER, WORKSHOP, PARIS
HOWARD TANGYE, TUTOR/ARTIST/DESIGNER, LONDON
HUSSEIN CHALAYAN, FASHION DESIGNER, LONDON
HYE-JIN YOUN, DESIGNER, KOREA
ILZE QUAEYHAEGENS, ARCHITECT, ANTWERP
INAGAKI, COMMERCIAL DIRECTOR, TOKYO
INGE GROGNARD AND RONALD STOOPS, MAKE-UP
ARTIST/PHOTOGRAPHER, ANTWERP
INGRID, NO PROFESSION, PARIS
ITALO MOSCA, DIRECTOR/BUYER, 2 LINK, MILAN
IVAN CHAPELLE, COLETTE, PARIS
IVAN TERESTCHENKO, PHOTOGRAPHER, PARIS
J. C. DE CASTELBAJAC, FASHION DESIGNER, PARIS
J. J. PICART, CONSULTANT, PARIS
JADE TUNG, INVESTMENT BANKING ANALYST, NEW YORK
JAN DECLAIR, ACTOR, ANTWERP
JAN LEYERS, MUSICIAN, ANTWERP
JAN VANRIET, ARTIST, ANTWERP
JAN VERHULSEL, TRANSLATOR, ANTWERP
JASON CAMPBELL, CREATIVE DIRECTOR, SURFACE, PARIS
JEAN BOSCO SAFARI, MUSICIAN, ANTWERP
JEAN COLONNA, FASHION DESIGNER, PARIS
JEAN DOSSE, FILM DIRECTOR, PARIS
JEAN ROUZAUD, AUTHOR, PARIS
JEAN ULRICK DESERT, ARTIST, PARIS
JEFF, NO PROFESSION, PARIS
JELLE SPRUYT, FASHION STUDENT, KASKA, ANTWERP
JEROEN HENNEMAN, ARTIST, AMSTERDAM
JEROME de NOIRMONT, GALLERY OWNER, PARIS
JEROME DREYFUSS, FASHION DESIGNER, PARIS
JIGGY, INTERIOR DESIGNER, PARIS
JO CREPAIN, ARCHITECT, ANTWERP
JOB KOELEWIJN, ARTIST
JOEL BAUMANN, NEW MEDIA, TOMATO, LONDON
JOHAN MICHIELSENS, MANAGER, ANTWERP
JOHN WARWICKER, CREATIVE DIRECTOR, TOMATO, LONDON
JONATHAN BERNARD, FASHION DESIGNER, BRUSSELS
JOOST JOOSSEN, PHOTOGRAPHER, ANTWERP
JOSHUA MOJJIS, SALES ASSOCIATE, NEW YORK
JOSJE JANSE, PHOTOGRAPHER, AMSTERDAM
JULIE DE TAEYE, FASHION STUDENT, KASKA, ANTWERP
JULIE SCHOUVEY, FASHION DESIGNER, PARIS

JULIE SKARLAND, FASHION DESIGNER, PARIS
JULIEN DONADA, DIRECTOR, PARIS
JUNE, STYLIST, PARIS
JUNIOR, AMSTERDAM
JURGEN SCHABES, STYLIST, VIENNA
KAREL VINGERHOETS, ACTOR, ANTWERP
KAREN HENDRIX, JUWEL DESIGNER, ANTWERP
KAREN LANGLEY, FASHION STUDENT, CSM, LONDON
KARIN DILLEN, DOCTOR, ANTWERP
KARLHEINZ HACKL, ACTOR, BURGTEATER, VIENNA
KATRIN WOUTERS, JEWELLERY DESIGNER, ANTWERP
KEITH HIOCO, FASHION STUDENT, KASKA, ANTWERP
KEN KRUGER, STYLIST, VIENNA
KEZIAH JONES, MUSICIAN, NIGERIA
KIRSTEN PIETERS, MODEL, ANTWERP
KITTY BOOTS, DESIGNER, NEW YORK
KOEN DE CEULENEER, ARTIST, ANTWERP
KRIS FIERENS, ARTIST, ANTWERP
KRIS VAN ZEEBROECK, ARCHITECT, ANTWERP
KRISTIEN HEMMERECHTS, AUTHOR, ANTWERP
KURINO HIROFUMI, UNITED ARROWS, TOKYO
KURT VAN EEGHEM, NERU, ANTWERP
KYOKO WAINAI, DESIGNER, MILAN
LAETITIA CRAHAY, FASHION DESIGNER, PARIS
LARA MAGNUS, STYLIST, VIENNA
LAURENT GOUMARRE, JOURNALIST, PARIS
LEO KERTES, ART DIRECTOR, VIENNA
LIEVE ULBURGHS, ARTIST, ANTWERP
LIEVE VAN GORP, FASHION DESIGNER, ANTWERP
LINDA LOPPA, DIRECTOR, FASHION DEPT, KASKA,
ANTWERP
LOESJE MAIEU, MUSICIAN, ANTWERP
LORENZ FELHOFER, MUSICIAN, VIENNA
LUC TUYMANS, ARTIST, ANTWERP
LUCA DE OVIDIIS, FASHION DESIGNER, MILAN
LUDOVICUS, ARTIST, ANTWERP
LUK MESTDAGH, GRAPHIC DESIGNER, ANTWERP
LYDIA KAMITSIS, MUSEUM CURATOR, PARIS
LYNDELL MANSFIELD, HAIR STYLIST, VIENNA
MAARTEN SPRUYT, PHOTOSTYLIST, AMSTERDAM
MAGLOIRE DELCROS-VARAUD, JOURNALIST, PARIS
MAIA ADAMS, FASHION STUDENT, CSM, LONDON
MARA MCLOUGHTON, FASHION DESIGNER, NYC
MARC LE BIHAN, FASHION DESIGNER, PARIS
MARC SCHILS, FASHION DESIGNER, SHIRTOLOGIE, PARIS
MARI EIJIMA, NON-PROFIT ADVISER, TOKYO/NEW YORK
MARI OTBERG, FASHION DESIGNER, LONDON
MARIA INTSCHER, FASHION DESIGNER, ANTWERP
MARIAN MCEVOY, EDITOR, NYC
MARIANNE RUTTEN, SECRETARY, ANTWERP
MARIE VAN GENECHTEN, HEAD OF MAIN
DRIES VAN NOTEN SHOP, ANTWERP
MARIE CLAUDE BEAUD, ARTISTIC DIRECTOR, PARIS
MARIELOU PHILLIPS, ASSISTANT, KARL LAGERFELD/
SHOES CHANEL, PARIS
MARISE PEYRE, DESIGNER, COOKED IN MARSEILLE,
MARSEILLES
MARJAN EGGERS, INUSTRIAL DESIGNER, ANTWERP
MARK BRAZIER-JONES, FURNITURE DESIGNER
MARKO GALOVIC, FASHION STUDENT, ANTWERP
MARKO PODREKO, STUDENT, VIENNA
MARTANNE KOHN, OWNER, LOOS BAR, VIENNA
MASHA CALLOWAY, ARTIST, NEW YORK
MASSIMO CAIAZZO, GRAPHIC DESIGNER, MILAN
MATT LAIDLAW, FASHION STUDENT, CSM, LONDON
MATT MULLICAN, ARTIST
MATTHIEU BUREAU, FASHION DESIGNER, ALEXANDRE
MATTHIEU, PARIS
MATTHIEU FOSS, PARIS
MAURIZIO GALANTE, FASHION DESIGNER, PARIS
MAXENCE DINANT, FASHION STUDENT, ANTWERP
MAYA, MODEL, VIENNA
MELKY LONGETUDE, PICNIC SURGEON, NEW YORK
MELLE MEI, FASHION STYLIST, NEW YORK
MENDY ADRIEN, SPORTS TEACHER, PARIS
MICHAEL HORSHAM, TOMATO, LONDON
MICHAEL PAS, ACTOR, ANTWERP
MICHELLE LOWE-HOLDER, FASHION DESIGNER, LONDON
MICHELLE SYLVANDER, ARTIST, MARSEILLES
MIDORI KOBAYASHI, JOURNALIST, PARIS/TOKYO
MIEKE DE GROOTE, ACTRESS, ANTWERP

Bottom shelf:

22. Silver high-heeled shoe,
Italy, c. 1960,
17.8 x 7.3 x 22.1 cm,
Musée Internationale de la Chaussure,
Romans-sur-Isère;

23. Sandal with high heel,
Italy, 1975,
14 x 6 x 22 cm,
Nederlands Leder- en Schoenenmuseum, Waalwijk;

24. High-heeled shoe in red and black,
designer Brunis, Italy,
c. 1960, 16.5 x 7.9 x 23 cm,
Musée Internationale de la Chaussure,
Romans-sur-Isère;

25. Green sandal with high-heeled shoe,
1976, 16 x 6 x 23 cm,
Nederlands Leder- en Schoenenmuseum, Waalwijk;

26. Black high-heeled shoe,
designer Rudolphe Menudier, Italy,
15 x 5 x 25 cm,
Coccodrillo, Antwerp;

27. High-heeled shoe,
designer Eperon d'Or (Vandommele), 1935,
18 x 7 x 19 cm,
Nationaal Schoeiselmuseum, Izegem;

28. Black high-heeled shoe,
Italy, 1950-60,
15 x 6 x 18 cm,
Nationaal Schoeiselmuseum, Izegem;

29. High-heeled shoe,
15 x 7 x 25 cm,
Coccodrillo, Antwerp;

30. High-heeled shoe,
designer Leslie Dupont, Belgium, 1950-60,
17 x 7.5 x 17 cm,
Nationaal Schoeiselmuseum, Izegem;

31. High-heeled shoe,
designer Leslie Dupont, Belgium, 1950-60,
18.5 x 8 x 16 cm,
Nationaal Schoeiselmuseum, Izegem;

32. Black high-heeled shoe,
designer Brunis, Italy c. 1960,
17.3 x 7.2 x 22.3 cm,
Musée Internationale de la Chaussure,
Romans-sur-Isère;

33. Grey high-heeled shoe,
1942, 15 x 5 x 16 cm,
Deutsches Ledermuseum-Schuhmuseum, Offenbach;

34. Serpent high-heeled shoe,
1953, 22 x 6 x 21 cm,
Deutsches Ledermuseum-Schuhmuseum, Offenbach;

35. Black high-heeled shoe,
1953, 21.3 x 6 x 21.5 cm,
Deutsches Ledermuseum-Schuhmuseum, Offenbach;

36. High-heeled shoe in white, yellow and green,
1950, 22 x 6 x 18 cm,
Deutsches Ledermuseum-Schuhmuseum, Offenbach;

37. Black high-heeled shoe,
Italy, 1960, 20 x 6 x 20 cm,
Deutsches Ledermuseum-Schuhmuseum, Offenbach;

38. Yellow high-heeled shoe,
Italy, 1960, 18 x 20.1 cm,
Deutsches Ledermuseum-Schuhmuseum, Offenbach.

9. POLYNESIAN TATTOO
Front: video projection of a Maori man.
Back: objects in glass case,

1. Anthropomorphic figure, Maori, New Zealand,
accomplished in 1956, 24.9 cm,
Ethnographic Museum, Antwerp;

2. Wooden head with facial tattoos,
Maori, New Zealand, before 1929, 60 cm,
Koninklijk Instituut voor de Tropen, Amsterdam;

3-6. Tattooing tools, Maori, New Zealand,
probably 19th century;

7. Feeding funnel, Maori, New Zealand,
probably 19th century, 19 x 13 x 12.2 cm,
American Museum of Natural History, New York;

8. Pigment bowl in lava stone, New Zealand,
Tattoo Museum, Amsterdam;

9. Kokui nuts, New Zealand,
Tattoo Museum, Amsterdam;

10. Resin of the Kauri tree, New Zealand,
Tattoo Museum, Amsterdam.

Video, 'About Face', *Singapore Airlines.*

10. NDEBELE
Front: video projection of a Ndebele woman.
Back: objects in glass case,

From left to right:

1. Golwani with pins, South Africa,
28 x 8.5 cm,
Private collection;

2. Pair of two superimposed red izigolwani,
South Africa, 30 x 10 cm,
Private collection;

3. Golwani with ring inside,
South Africa, 28 x 10.5 cm,
Private collection;

4. Pair of two superimposed blue izigolwani,
South Africa, 22 x 14 cm,
Private collection;

5. Iphoto,
South Africa, 35 x 40 cm,
Private collection.

Video, 'Ndebele Women',
South Africa, *TV De Wereld, Leuven.*

11. PUNK
Front: video projection portrait Cat Woman.
Back: videos, compilation:
'Interview Malcolm McLaren, Punk Clothes,
the Sex Pistols and Anarchy in the UK',
BBC, United Kingdom;
compilation:
'Punk, the Sex Pistols, God Save the Queen',
BBC, United Kingdom;
Vintage punk jacket by Vivienne Westwood
and Malcolm McLaren, 1975.
Resurrection, Los Angeles.

12. BODY-PAINTING
Front: video projection of a Wodaabe man.
Back: objects in glass case,

Foreground - from left to right:

1-5. Cylindrical stamps, Mangbetu,
Democratic Republic of Congo, 1890-1910,
American Museum of Natural History, New York;

6-8. Zigzag formed stamps, Mangbetu,
Democratic Republic of Congo, 1890-1910,
American Museum of Natural History, New York;

9. Calabash, Kaiapo,
Brazil, late 20th century, 5 x 10.8 cm,
Royal Museum for Central Africa, Tervuren;

10. Instrument used for body-painting, Kaiapo,
Brazil, late 20th century, 20.3 x 4 cm,
Royal Museum for Central Africa, Tervuren;

11. Instrument used for body-painting, Kaiapo,
Brazil, late 20th century, 23 x 1.5 cm,
Museum der Kulturen, Basel;

12. Make-up stick with small leather sack
and blue pigment, Niger, 9 cm,
Collection Van Nieuwerburgh;

13. Leather make-up bottle, Wodaabe,
Niger, *Collection 't Jolle;*

Background - from left to right:

14. Kalabas, Mangbetu,
Democratic Republic of Congo, 1890-1910,
11.5 x 8.8 cm,
American Museum of Natural History, New York;

15. Leather container with pigment, Mangbetu,
Democratic Republic of Congo, 1890-1910,
7.4 x 5.4 cm,
American Museum of Natural History, New York;

16. Instrument used for body-painting, Mangbetu,
Democratic Republic of Congo, 1890-1910,
9.3 x 1.7 cm,
American Museum of Natural History, New York;

17. Kalabas, Kaiapo, Brazil, late 20th century,
9.5 x 18.5 cm,
Royal Museum for Central Africa, Tervuren;

18-20.
Pigments used for body-painting, Wodaabe,
Niger, *Collection Van Nieuwerburgh;*

21. Part of a kalabas with yellow pigment, Wodaabe,
Niger, *Collection Van Nieuwerburgh.*

Videos, 'Waura, Body-painting', Brazil, 1964,
Institut für den Wissenschaftlichen Film, Göttingen;
'Wodaabe - Facial Make-up for the 'dance of beauty'
'Yaake', Niger, *Dominique 't Jolle, Antwerp;*
'Mangbetu', Democratic Republic of Congo,
Gérard de Boe.

13. PANIER
Front: video projection of woman with panier.
Back: objects in glass case,

1. Corset,
18th century,
Museum voor het Kostuum en de Kant, Brussels;

2. Corset,
18th century,
Historisch Museum Rotterdam.

14. PADAUNG
Front: video projection Padaung woman.
Back: objects in glass case,

1. Neckring, Padaung, Thailand,
20th century, 13 x 11 cm,
American Museum of Natural History, New York;

2. Neckring, Padaung, Thailand,
20th century, 24 x 8 cm,
American Museum of Natural History, New York;

3. Röntgen photo of the head and the neck of
a Padaung woman with neckrings,
German Röntgen Museum, Remscheid.

Videos,
compilation: 'The Secret Worlds of Asia.
The Legend of the Golden Spiral', Thailand,
Télé-images International, Boulogne;
'Padaung, Long-necked Woman',
Filmimages, Paris.

Credits:
Realization of installation: SET bvba, Aartselaar;
Videoprojection: Vidi-Square nv, Zandhoven.

CONSTRUCTIONS

In this room ten historical silhouettes have been
set up. Around these paper silhouettes the original
constructions, which give the silhouettes their
shape, are shown.

1. **'S'-silhouette**: *c.* 1900,
S-corset, *c.* 1892, *Kyoto Costume Institute;*
S-corset, 1891, *Kyoto Costume Institute;*
S-corset, *c.* 1901, *Kyoto Costume Institute;*

2. **'Tournure' silhouette**: *c.* 1885,
Bustle, c. 1870, *Kyoto Costume Institute;*
Bustle, c. 1871, *Kyoto Costume Institute;*

3. **'Empire' silhouette**: *c.* 1806,
Empire corset, 1801, *Kyoto Costume Institute;*
Empire corset, 1831, *Kyoto Costume Institute;*

4. **'Crinoline' silhouette**: *c.* 1860,
Corset, 1865-70, *Kyoto Costume Institute;*
Corset, 1881, *Kyoto Costume Institute;*
Crinoline, 1863, *Kyoto Costume Institute;*
Crinoline, 1865-70, *Kyoto Costume Institute;*

5. The **'New Look' silhouette** by Dior, 1947;

6. **Silhouette**: *c.* 1750;
Stay, 1781, *Kyoto Costume Institute;*

7. **Silhouette**: *c.* 1900;
S-corset, *c.* 1908, *Kyoto Costume Institute;*

8. **'Panier' silhouette**: *c.* 1750;
Stay, late 18th century, *Kyoto Costume Institute;*

9. **'Tournure' silhouette**: *c.* 1880;
Tournure, 1870, *Kyoto Costume Institute;*
Corset, *c.* 1892, *Kyoto Costume Institute;*

10. **'20s' silhouette**:
Three-in-one corset, *c.* 1925,
Kyoto Costume Institute;
Corset, 1920, *Kyoto Costume Institute.*

Credits:
Paper silhouettes by Isabelle de Borchgraeve
and Rita Brown, Brussels;
arrangement of historical pieces by Dirk van Saene,
Erwina Sleutel and Kyoto Costume Institute.

TRANSFORMATIONS

6 photographic prints on wall.

Photographer: Michael Williams
at Walter Schupfer Management, New York
Model: Amanda Lepore
1st Assistant: Siege Fotowork
2nd Assistant: Edwin Steinitz
Hair & Make-up Stylist: Donald Simrock
Fashion Stylist: Leslie Lessin
Films & Processing: Color Edge, New York
Equipment: Adorama, New York
Location: Consulate, New York
Prints: Claes Tradigital Photolab, Antwerp

BODY ART

Fifteen videos projected on wall.

1. **Franko B.**,
'I Miss You 1', 1999 (13 mins.)

2. **Bruce Nauman**,
'Art Make-up', 1967-8, (40 mins.)

3. **Vito Acconci**,
'Light, Reflection, Self-control', 1971 (90 mins.)

4. **Chris Burden**,
'Shoot', 1971 (2 mins.)

5. **Ron Athey**,
'Ronnie Lee', 2001 (7 mins.)

6. **Abramovic Ulay**,
'Art Must be Beautiful, Artist Must be Beautiful',
1975 (12 mins.)
Talking about 'Similarity', 1971 (9 mins.),
'Imponderabilia', 1971 (9 mins.),
'Relation in Time', 1971 (10 mins.)

7. **Sonja Wyss**,
'To Date', 1998 (7 mins.)

8. **Arnulf Rainer**,
'Confrontation with My Video Image', 1975
(18 mins.)

9. **Dennis Oppenheim**,
'Extended Armour', 1970 (2 mins.),
'Gingerbread Man', 1970 (2 mins.)

10. **Yves Klein**,
'Yves Klein réalisant une peinture de feu', 1961

11. **Gutai** on the stage Art exhibition, 1957 (4 min.)

12. **Yves Klein**,
'Antropometrie de l'époque Blue', 1960 (11 mins.)

13. **Gina Pane**,
'Psyche', 1974 (25 mins.)

14. **Elke Krystufek**,
'Aktion', 1990 (26 mins.)

15. **Orlan**,
'Omniprésence', New York, 1993 (34 mins.)

Video projections by Vidi-Square nv, Zandhoven.

FASCINATION - MR PEARL'S ROOM

Corsets and silhouettes by Mr Pearl, London.

1. Corsage of Cleo de Mérode, 1896,
Musée de la Mode, Palais Galliera, Paris;

2. Personal corset as worn by Mr Pearl;

3. Swarovski dress by Mr Pearl, 1999,
Black satin corset with velvet belt by Mr Pearl for
Christian Lacroix Skirt by Atelier Lacroix-Haute
Couture, Paris, Spring-Summer 1997;

4. Beaded 'Bleeding Torso Jacket' with undercorset
- embroidery and corset by Mr Pearl for Vivienne
Westwood - Men's Collection, Milan, 1996;

5. Red satin black metallic beaded corset with
velvet sleeves by Mr Pearl for Christian Lacroix;

6. Skirt and gold sleeves by Atelier Lacroix-
Haute Couture, Autumn-Winter 1995;

7. Hand-woven green metallic silk corset with
black sleeves by Mr Pearl for Christian Lacroix;

8. Skirt by Atelier Lacroix-Haute Couture,
Spring-Summer, 1997;

9. Black satin all-embroidered corset by Mr Pearl,
1996;

10. Bugle beaded and sequined corset
'Future Officer' by Mr Pearl for Thierry Mugler-
Haute Couture, Spring-Summer 1997-8;

11. Black jet embroidered transparent corset
with sleeves and stockings all by Mr Pearl
for Thierry Mugler-Haute Couture, Paris,
Autumn-Winter 1998-9;

12. Metallic butterfly beaded corset all by
Mr Pearl for Christian Lacroix Skirt by Atelier
Lacroix-Haute Couture, Spring-Summer 1996;

13. Gentleman's corset, 1907,
Kyoto Costume Institute;

14. Silk chiffon and beaded lace corseted dress
with stockings all by Mr Pearl for Thierry Mugler-
Haute Couture, Paris, Spring-Summer 1999-2000;

15. Sequined corseted dress 'Butterfly' all by
Mr Pearl for Thierry Mugler-Haute Couture, Paris,
Spring-Summer 1997-8;

16. 'Surgical corset' by Mr Pearl for Hussein
Chalayan-Prêt-à-porter, London, 1995.

Installations:
Twin Design, Temse & Pandora, Antwerp.

AVATARS

An installation by Frank Theys.

Interactive development: Magic Media
Software engeneering: Emmanuel Lestienne
Motion tracking design & development,
technical mangement: Yves Bernard
Scenography & realization of installation:
Central Omgevingen, Dries De Jonghe, Bert Leysen
Sound design: Missfit
(Arnoud Jacobs @ FYKE facilities)
Video realization: VOTNIK
Camera & editing: Frank Theys
Recording assistants: Hans van Nuffel,
Niels van Tomme

MIET CRABBE, MANAGER, ANTWERP
MIJAN MANN, SINGER, LA
MIQUEL BARCELÓ, ARTIST, PARIS
MITRIDATE KHERADDAND, UNEMPLOYED, PARIS/IRAN
MME HELENE DAVID WEILL, PRESIDENT, UNION CENTRAL
DES ARTS DECORATIFS, PARIS
MOLLY GRAD, FASHION STUDENT, CSM, LONDON
MONIKO MARCHADOUR, FASHION MARKETING, PARIS
MOUNA AYOUB, HAUTE COUTURE CLIENT, PARIS
NATALIE GIBSON, DESIGNER/LECTURER, LONDON
NATASJA BRACK, FASHION DESIGNER, ANTWERP
NATHALIE RYKIEL, GENERAL DIRECTOR,
SONIA RYKIEL, PARIS
NEIL CHRISTOPHER, INTERIOR ARCHITECT, SYDNEY
NELLIE NOOREN, LECTURER, FASHION DEPT, KASKA,
ANTWERP
NICOLA VERCRAEYE, HEAD OF STIJL SHOP, BRUSSELS
NICOLAS DAL SASSO, PR, THIERRY MUGLER, PARIS
NIEK KORTEKAAS, DESIGNER/DIRECTOR, ANTWERP
NIGEL ATKINSON, FABRIC DESIGNER, LONDON
NIKLAS GERTL, FASHION STUDENT, VIENNA
NINETTE MURK, JOURNALIST, ANTWERP
NOUMA BOB, PARIS
ODO MISCHITZ, STYLIST, VIENNA
OLIVERA CAPARA, FASHION DESIGNER, ANTWERP
OLIVIER JAULT, SHOE DESIGNER, VIENNA
OLIVIER RIZZO, STYLIST, ANTWERP
OLIVIER THEYSKENS, FASHION DESIGNER, PARIS
ORPHEO, WILGENSTAM SCHOOL, AMSTERDAM
OSCAR RAAIJMAKERS, FASHION DESIGNER,
OSCAR SULEYMAN, AMSTERDAM
PAMELA GOLBIN, CONSERVATOR, PARIS
PASCAL BOISSIERE, PARIS
PASCALE RENEAUX, JOURNALIST, PARIS
PATRICIA CANINO, PHOTOGRAPHER, PARIS
PATRICIA LECOMPTE, PARIS
PATRICK DE MUYNCK, LECTURER,
FASHION DEPT, KASKA, ANTWERP
PATRICK SCALLON, DIRECTOR OF COMMUNICATION, MAI-
SON MARTIN MARGIELA, PARIS
PAUL BOUDENS, GRAPHIC DESIGNER, ANTWERP
PAUL GRIVAS, DIRECTOR, PARIS
PAULA DE WINNE, MANAGER
PAULO FELICETTI, FASHION STUDENT AT CSM, LONDON
PAVEL B. SPASOVSKI, ART DIRECTOR, AMSTERDAM
PEDRO, MANAGER, AMSTERDAM
PEGGY ACKE, A.F. VANDEVORST, ANTWERP
PERRY ROBERTS, ARTIST,
PERRY TSANG, SABATICAL, ANTWERP
PETER HOLZINGER, FASHION STUDENT, VIENNA
PETER THOMAS MACGOUGH, ARTIST, NYC
PHILIP BLOCH, CNN/MTV FASHION CORRESPONDENT,
NEW YORK
PHILIP AGUIRRE Y OTEGUI, ARTIST, ANTWERP
PHILIPPE AVICE, ARCHITECT, PARIS
PHILIPPE BESTENHEIDOR, ARCHITECT, ZURICH
PHILIPPE BLONDEZ, EDITOR, BILBOK, PARIS
PIERRE GAYTE, PHOTOGRAPHER, PARIS
RACHELI CHABA, FURNITURE DESIGNER, TEL AVIV
RAF COOLEN, PHOTOGRAPHER, ANTWERP
RAF DE PRETER, ARCHITECT, ANTWERP
RAGNHILD HAUGE, KNITWEAR DESIGNER, LONDON
RAMA CHORPASH, INDUSTRIAL DESIGNER, NEW YORK
REINHARD HIRZABAUER, FASHION STUDENT, VIENNA
REINHILDE DECLAIR, ACTRESS, ANTWERP
REITER LEOPOLD, SALES MANAGER, VIENNA
REMCO CAMPERT, AUTHOR, AMSTERDAM
RIA PACQUEE, ARTIST, ANTWERP
RICK GALLAGHER, DEALER IN THE UNUSUAL, NEW YORK
RINI VAN VONDEREN, MANAGER, ZES STUDIO, MILAN
ROBERT MURPHY, JOURNALIST, WWD, PARIS
ROBERT SIDI, FURNITURE DISTRIBUTOR, SYDNEY
ROMY HAAG, BERLIN
SABINE VILLIARD, EDITOR, LUXE, PARIS
SAM GERES, MODEL, VIENNA
SANDRO FABER, FASHION STUDENT, ANTWERP
SANDY DE WOLF, ARCHITECT, ANTWERP
SARA DE BOSI, GRAPHIC DESIGNER, MILAN
SASKIA LAUWAARD, SCENOGRAPHER, ANTWERP
SEBASTIAN KAUFMANN, FASHION EDITOR, ELLE, SPAIN
SEBASTIANO NAVARRA, ART DIRECTOR, MILAN

SERDIN, FASHION DESIGNER, MOSCOW
SERKAN SARIER, FASHION STUDENT, ANTWERP
SHELLY FOX, FASHION DESIGNER, LONDON
SIMON TAYLOR, TOMATO, LONDON
SIR PAUL SMITH, FASHION DESIGNER, LONDON
SIV STOLDAL, MENSWEAR DESIGNER/TAILOR, LONDON
SODUPE MAR, ACTOR, PARIS
SONIA RYKIEL, FASHION DESIGNER, PARIS
SONJA NOEL, OWNER OF STIJL SHOP, BRUSSELS
SOON AE FELIX, STUDENT, ANTWERP
SOPHIA LAMAR, HUMAN BEING
SOPHIE PAY, A. F. VANDEVORST, ANTWERP
STEFAN SCHONING, INDUSTRIAL DESIGNER, ANTWERP
STEPHAN SCHNEIDER, FASHION DESIGNER, ANTWERP
STEPHANE CALAIS, ARTIST, PARIS
STEPHEN JONES, HAT DESIGNER, LONDON
STEPHEN PETRONIO, CHOREOGRAPHER, NEW YORK
STIJNY VAN DER LINDEN, STYLIST, AMSTERDAM
SUZANNE VAN WELL, COSTUME DESIGNER, ANTWERP
SVEN BAETENS, CREATIVE DIRECTOR, ANTWERP
SVEN GROOTEN, ARCHITECT, ANTWERP
SYLVIE RICHOUX, MUSEUM CURATOR, MARSEILLES
SYLVIE VANHOVE, OWNER OF COMME DES GARÇONS SHOP,
ANTWERP
TAKEJI HIRAKAWA, JOURNALIST, TOKYO
TAL LANCMAN, TREND VISION, PARIS
TAO, FASHION PHOTOGRAPHER, PARIS
TERRY JONES, EDITOR, I-D, LONDON
THOMAS HIRSCHHORN, ARTIST
THOMASS, STYLIST, PARIS
TIM CEUSTERMAN, ARTIST, ANTWERP
TINA GILLEN, ARTIST, ANTWERP
TITUS DUTOYA, ARTIST, PARIS
TOM LIEKENS, ARTIST, ANTWERP
TONY, ARTIST, PARIS
TRICIA JONES, I-D, LONDON
ULRIKE RATE, FASHION STUDENT, KASKA, ANTWERP
VALANTIA ROSATI, DESIGNER, MILAN
VALENTIN DE CHARTENAY, AUTHOR, PARIS
VALERIE STEELE, CURATOR, FASHION INSTITUTE
OF TECHNOLOGY, NYC
VASILLEV, FASHION DESIGNER, MOSCOW
VERA CAPARA, FASHION DESIGNER, ANTWERP
VERONIQUE NICHANIAN, DIRECTOR, MEN'S
COLLECTION/HERMES, PARIS
VICKY RODITIS, MAISON MARTIN MARGIELA, MILAN
VINCENT LAPPARTIENT, STUDENT OF ART HISTORY, PARIS
VINCENT VAN DUYSEN, INTERIOR DESIGNER, ANTWERP
VIVIENNE WESTWOOD, FASHION DESIGNER, LONDON
WERNER DE BONDT, ARCHITECT, ANTWERP
WERNER VAN DERMEERSCH, ARCHITECT, ANTWERP
WIES SCHULTE, FASHION DESIGNER, PARIS
WILLEM OOREBEEK, ARTIST
WILLY VANDERPERRE, PHOTOGRAPHER, ANTWERP
WIM DELVOYE, ARTIST, GHENT
WIM NEELS, FASHION DESIGNER, ANTWERP
WIM VAN DEN ABBEELE, ARTIST, ANTWERP
YOHANN GONFOND, STYLIST
YOKO MIYAKE, FASHION STUDENT, CSM, LONDON
YONAH FONCE, MUSEUM CURATOR, ANTWERP
YOSHIKO SHIOJIRI, STYLIST, LONDON
YSBRANT VAN WIJNGAARDEN, ARTIST, VENICE
YUKIKA YAMAZAKI, BUYER, TOKYO
YUSKE OKABE, FASHION STUDENT, ANTWERP
YVONNE DE KOCK, LECTURER, FASHION DEPT, KASKA,
ANTWERP
ZOE DELEU, GRAPHIC DESIGNER, NEW YORK
ZULEIKA, STYLIST, PARIS

SHORT FILMS INSTALLATION

171

Films by:
ARTHUR AILLAUD, ARTIST, PARIS
AUDE BUTTAZZONI, GRAPHIC DESIGNER, PARIS
AURELIE MATHIGOT, DOCUMENTARY PRODUCER, PARIS
CHRISTOPHE LUCIEN, ART DIRECTOR, PARIS
FREDERIC GUELAFF, ARTIST, PARIS
JOCHEM VANDEN ECKER, PHOTOGRAPHER, ANTWERP
JOHN WARWICKER, CREATIVE DIRECTOR, TOMATO, LONDON
JULIEN DONADA, DIRECTOR, PARIS
KOEN DE WAAL, PHOTOGRAPHER, ANTWERP
MARIE GUIRAUD, DOCUMENTARY PRODUCER, PARIS
MARINA FAUST, ARTIST, PARIS
MATHIEU BAILLOT-FREDERIC GUELAFF,
COMPOSER & ARTIST, PARIS

Featuring:
ANN DEMEULEMEESTER
MARC LE BIHAN © JULIEN DONADA
ELISABETH PAILLIE © KOEN DE WAAL
INGE GROGNARD/GEERT BRULOOT
© MAISON MARTIN MARGIELA (SHOW)
JEROME DREYFUSS © AUDE BUTTAZZONI
ROBERT SIDI © KOEN DE WAAL
CAROLINE CORNU © W< (SHOW)
PAMELA GOLBIN © AURELIE MATHIGOT
KARIN DILLEN © MARINA FAUST
OLIVERA CAPARA © MARIE GUIRAUD
SERKAN SARIER © FREDERIC GUELAFF
ELLEN MONSTREY © ELLEN MONSTREY
MICHELE SYLVANDER © KOEN DE WAAL
FAZE SGHAIER © CHRISTOPHE LUCIEN
BRUNO VERBERGT: 'PARIS IS BURNING'
© OFF WHITE PRODUCTIONS, 1991
JEAN COLONNA © AURELIE MATHIGOT
AMANDA LEPORE © JOCHEM VANDEN ECKER
CHRISTOPHE CHARON/PATRICK SCALLON/CENT
CUYPERS/LIEVE VAN GORP © AUDE BUTTAZZONI
KRISTIEN HEMMERECHTS © FREDERIC GUELAFF
SOON AE FELIX © KOEN DE WAAL
LYDIA KAMITSIS © FREDERIC GUELAFF
IVAN TERESTCHENKO © FREDERIC GUELAFF
RAF SIMONS © RAF SIMONS
TRICIA JONES © JOCHEM VANDEN ECKER
GUIDO NUSSBAUM © AURELIE MATHIGOT
MIDORI KOBAYASHI © MIDORI KOBAYASHI
SOPHIA LAMAR © FREDERIC GUELAFF/MATHIEU BAILLOT
NICOLAS VERCRAEYE © AURELIE MATHIGOT
PEGGY ACKE/GERDI ESCH © A.F. VANDEVORST (SHOW)
MARINA FAUST © MARINA FAUST
HIROFUMI KURINO: LOOK © VRT
FRED BONN © VERHELST-WOUTERS
SONJA NOEL © COMME DES GARÇONS (SHOW)
MIGUEL BARCELO/PAUL GRIVAS © ARTHUR AILLAUD
BENOIT MELEARD © MARIE GUIRAUD
PETER THOMAS MACGOUGH © FREDERIC GUELAFF
JUNE © AURELIE MATHIGOT
LINDA LOPPA © JOHN WARWICKER
GILBERT & GEORGE
RAOUL VAN DEN BOOM © RAOUL VAN DEN BOOM
BENJAMIN GALOPIN © AURELIE MATHIGOT

met de steun van
de Vlaamse regering

Met steun van de Nationale Loterij

TOERISME
VLAANDEREN

172

This catalogue, published to coincide with
FASHION2001 LANDED, forms the second part
of the catalogue FASHION2001 LANDED #1
that has already appeared.

The project comprises four exhibitions
and a range of events in Antwerp:

MUTILATE? - MUHKA
2WOMEN:
GABRIELLE CHANEL - former Royal Palace
REI KAWAKUBO - COMME DES GARÇONS
- 5 statements at various locations
EMOTIONS - Police Tower
RADICALS - 't Eilandje - Sloepenweg

FASHION2001 LANDED
26 MAY-7 OCTOBER 2001

This project is being organized by ANTWERPEN OPEN and
the FLANDERS FASHION INSTITUTE,
in cooperation with the Tourist Office for Flanders
and the Antwerp Tourist Office and enjoys
the support of the Flemish Government,
the City of Antwerp and the National Lottery.
The MoMu (Fashion Museum) and the MUHKA
(Museum of Contemporary Art of Antwerp)
are privileged partners.
The mainprivate sponsors include
KBC Bank & Insurance, Chrysler, Virgin Express
and Gazet van Antwerpen.
The media sponsors are Weekend Knack,
Weekend LeVif/L'Express, Studio Brussel, Canvas,
Planet Internet and De Lijn.
Other private sponsors are Agfa, Bulo, Evian, illy,
SET bvba, Vidi-Square and Fernmoor.

Artistic Director
Walter van Beirendonck

Art Director
Paul Boudens

Architects
B-architecten:
Evert Crols
Dirk Engelen
Sven Grooten
Sarah Peirsman
Ana Santos

Artistic Coordinator
Gerdi Esch

Communications Adviser
John Warwicker, Tomato, London

Executive Producers
Bruno Verbergt, ANTWERPEN OPEN
Linda Loppa, FLANDERS FASHION INSTITUTE

Partners from the tourist sector
Toon Berckmoes, Tourist Office for Flanders
Sandy Ceulemans, Antwerp Tourist Office

EXHIBITIONS

MUTILATE?
MUHKA
32 Leuvenstraat, 2000 Antwerp
26 May-7 October 2001

Curator
Walter van Beirendonck

in collaboration with

Dirk van Saene
Isabelle de Borchgrave
Rita Brown
for **CONSTRUCTIONS**

Amanda Lepore
Michael Williams
for **TRANSFORMATIONS**

Mr Pearl for **FASCINATION**

Frank Theys for **AVATARS**

Coordination and research
Kurt Vanbelleghem
Koen de Cauwer
Andrea Wiarda
Els Roelandt
for **A Prior**
- **Office for Artistic Production**, Brussels

Erwina Sleutel
for MoMu

Design
Walter van Beirendonck with **B-architecten**

CONSTRUCTIONS

Historical consultant
Dirk van Saene

Realization of paper silhouettes
Isabelle de Borchgrave (Brussels)
Rita Brown (Canada)

Arrangement of historical pieces
Dirk van Saene
Erwina Sleutel
Kyoto Costume Institute

TRANSFORMATIONS

Photographer
Michael Williams
for Walter Schupfer Management (New York)

Model
Amanda Lepore

Assistants
Siege Fotowork
Edwin Steinitz

Hair and Make-up Stylist
Donald Simrock

Fashion Stylist
Leslie Lessin

Films and Processing
Color Edge (New York)

Equipment
Adorama (New York)

Location
Consulate (New York)

Prints
Claes Tradigital Photolab (Antwerp)

FASCINATION

Concept
Mr Pearl

Realization of installation
Twin Design
Temse & Pandora (Antwerp)

AVATARS

An installation by
Frank Theys

Interactive development
Magic Media (Brussels)

Software engineering
Emanuelle Lestienne

Motion tracking design and development,
technical management
Yves Bernard

Scenography and realization of installation
Dries de Jonghe
Bert Leysen
for Central Omgevingen

Sound design
Arnoud Jacobs, Missfit

Video realization
VOTNIK

Camera and editing
Frank Theys

Recording Assistants
Hans van Nuffel
Niels van Tomme

Editing Assistants
Edit Kalor
Sabine Vanderlinden

Hat design
Anke Tacq

Production Assistant
Hai-chay Jiang

With the cooperation of
BRONKS
Departement werktuigkunde KUL
deSingel
Polar Video
Provinciaal Domein Kessel-Lo
Kunstencentrum STUC Leuven
Toneelgroep Amsterdam
Dierenkliniek Kerberos

Thanks to
Nina Beulens, Freek Boei, Erik Dehaes,
Danny Elsen, Pieter Hollants, Nana Jans,
Diederik Peeters, Guy Peeters, Ilonka Rozenbeek, Hans
Sonneveld

CONTEMPORARY FASHION

Participating designers
Hussein Chalayan (United Kingdom)
Comme des Garçons (France-Japan)
Angelo Figus (Belgium)
Givenchy (France)
G+N - Gerrit Uittenbogaard & Natasja Martens
(Netherlands)
Keupr & van Bentm (Netherlands)
Martin Margiela (France)
Kanya Miki (Belgium-Japan)
Ysuke Okabe (Belgium-Japan)
Carol Christian Poell (Italy)
Walter van Beirendonck (Belgium)
A.F. Vandevorst (Belgium)
Viktor & Rolf (Netherlands)
Junya Watanabe (Japan)
Yohji Yamamoto (France)

Arrangement
Linda Loppa
Chris Fransen
Yvonne Dekock
Erwina Sleutel

Thanks to all those from whom we have items
on loan and to those who have advised and assisted us
in the preparation of this exhibition

ABC (Australia)
Marina Abramovic and **Ulay**
Vito Acconci
All Video-Belgium (Antwerp)
American Museum of National History (New York)
Argos (Brussels)
Ron Athey
BBC (London)
Valerie Boone
Chris Burden
Canadian Museum of Civilisation (Hull, Quebec)
Canal + (Paris)
Carol Kaufmann South African National Gallery
(Cape Town)
Centraal Museum Utrecht
Coccodrillo (Antwerp)
Collectie Ferry Bertholet (Amsterdam)
Copyright Art and Architecture Bookshop
Costume Gallery (London)
Professor Dr Degryse, KLINA,
radiology department (Brasschaat)

Els de Palmenaer (Etnografisch Museum Antwerpen)
Barbara Deslé, Zuiderpershuis (Antwerp)
Deutsches Ledermuseum-Schuhmuseum (Offenbach)
Electronic Arts Intermix (New York)
Etnografisch Museum Antwerpen
Eyefocus videoproductions (Kapellen)
Filmimages (Paris)
Filmmuseum (Amsterdam)
Filmmuseum (Brussels)
Franko B
Galerij Christian Drantman (Brussels)
Gallery Hauser & Wirth (Basel)
John Galliano (London-Paris)
German Röntgen Museum (Remscheid)
Gutai
Historisch Museum (Rotterdam)
Harry Houben (Antwerp)
Jef Houben (Kwaadmechelen)
Institut für den Wissenschaftlichen Film (Göttingen)
Stephen Jones (London)
Lydia Kamitsis, conservator
at the Musée de la Mode et du Textil (Paris)
Yves Klein'
Lilette Koch (South Africa)
Koninklijk Instituut voor de Tropen (Amsterdam)
Koninklijk Museum voor Centraal-Afrika (Tervuren)
Koninklijke Musea voor Kunst en Geschiedenis
(Brussels)
Elke Krystufek
Kyoto Costume Institute (Japan)
Rhoda Lurie (Santa Monica)
Lux Centre (London)
Paul McCarthy
Maison Christian Lacroix (Paris)
Maison Thierry Mugler (Paris)
Kanya Miki
Montevideo (Amsterdam)
Musée de la Mode et du Textil (Paris)
Musée Galliera (Paris)
Musée Internationale de la Chaussure
(Romans-sur-Isère)
Museum der Kulturen (Basel)
Museum voor het Kostuum en de Kant (Brussels)
Nationaal Schoeiselmuseum (Izegem)
Bruce Nauman
Nederlands Audiovisueel Archief (Hilversum)
Nederlands Leder- en Schoenenmuseum (Waalwijk)
Ysuke Okabe
Dennis Oppenheim
Orlan (Paris)
Gina Pane
Pathé Archives (Paris)
Arnulf Rainer
Resurrection (New York, Los Angeles)
Singapore Airlines
Stay-tuned (Brussels)
Dieter Suls (MoMu-Antwerp)
Tattoo Museum (Amsterdam)
Télé-images International (Boulogne)
José Theunissen, Centraal Museum Utrecht
Dominique t'Jolle
TV De Wereld (Leuven)
Ufer! Art Documentary (Kyoto)
Jacques van Nieuwerburgh
Gustaaf Verswijver
(Koninklijk Museum voor Centraal-Afrika, Tervuren)
Vivienne Westwood
Sonja Wyss
ZDF (Germany)

Bart Baes and technical personnel
and attendants MUHKA

2WOMEN:
GABRIELLE CHANEL
Former Royal Palace
50 Meir, 2000 Antwerp
26 May-7 October 2001

Curator
Dirk van Saene

Coordination and administration
Linda Loppa
Tom Sluyts
for MoMu
Design
Dirk van Saene with **B-architecten**

Thanks to all those from whom we have items
on loan and to those who have advised and assisted us
in the preparation of this exhibition

Maison Chanel (Paris):
Mme de Clermont-Tonnere, director
Marika Genty and **Cécile Goddet**
for the Chanel-conservatoire
Veronique Perez

Didier Ludot (Paris)
Sylvie Richoux, curator of the Musée de la Mode
(Marseilles)
Erwina Sleutel and **Ellen Machiels**
for MoMu (Antwerp)
Filmmuseum Antwerpen
Monkey Business

2WOMEN:
REI KAWAKUBO - COMME DES GARÇONS
5 statements at various locations and dates

Kawakubo video presentation:
Former Royal Palace
50 Meir, 2000 Antwerp
26 May-7 October 2001

Rei Kawakubo - Comme des Garçons
Collection Autumn-Winter 2001-2

With the support of Comme des Garçons Tokyo-Paris

Concept
Rei Kawakubo
Walter van Beirendonck

Coordination and show production
Jan Michiels for Trois-Quarts

Statement #1

Make-up
Aaron de Mey and team

Hair
Julien d'Ys
Guido Michiels and team

Music
Uwe Doll

Sound
The Image and Sound Factory

Light
Mark Vandebroeck
Wim Michiels
for Lites & AED

Video
Michiels-Jensen for Fac's

Statement #2

Make-up
Inge Grognard & assistants

Hair
Ed Moelands assisted by **Guido Michiels** & team

Music
Comme des Garçons
Walter van Beirendonck`
Pedro van der Eecken

Sound
The Image and Sound Factory

Light
Lites

Video
Michiels-Jensen for Fac's

With thanks to
Comme des Garçons (Tokyo-Paris):
Rei Kawakubo
Adrian Joffe

EMOTIONS
Police Tower
5 Oudaan, 2000 Antwerp
26 May-7 October 2001

Curator
Bob Verhelst

Design
Bob Verhelst with **B-architecten**

Film Directors
Arthur Aillaud
Mathieu Baillot
Aude Buttazzoni
Koen de Waal
Julien Donada
Marina Faust
Frederic Guelaff
Marie Guiraud
Christophe Lucien
Aurelie Mathigot
Jochem vanden Ecker
John Warwicker

With thanks to all the interviewees
and all those who have advised and assisted us
in the preparation of this exhibition

Christian Achman
Miquel Barceló
Marie Claude Baud
Karin Dillen
Pamela Golbin
Lydia Kamitsis
Ninette Murk
Monique Nagielkopf
Mari Otberg
Wies Schulte
George Ville
Marc Wouters

RADICALS
Sloepenweg
Scheldt Quays near 't Eilandje, 2030 Antwerp
26 May-7 October 2001

Curator
Walter van Beirendonck

Coordination and administration
Gerdi Esch

Design
Walter van Beirendonck with **B-architecten**

Participants

Bless
(photographs: 1., 3. Bless;
2. Courtesy of Windsor Collection)

Veronique Branquinho
(photographs: 1. Willy Vanderperre, make-up: Peter
Philips, hair: Guido Palau; 2. Raf Coolen, make-up:
Peter Philips, hair: Guido Palau; 3. Corinne Day,
make-up: Ezi Wakematsu, styling: Panos y Iapani)

Hussein Chalayan
(photographs: Marcus Tomlinson)

Susan Cianciolo
(photographs: 1. Susan Cianciolo; 2. Rosalie Knox;
3. Annette Aurell)

Comme des Garçons
(photographs: Comme des Garçons Comme des Garçons)

Angelo Figus
(photographs: 1., 2., 3. Ronald Stoops;
3. Jewel: Steven Blum)

G+N - Gerrit Uittenbogaard & Natasja Martens
(photographs: 1. Miss Liz Wendelbo; 2. Jossy Albertus
and Annabel Oosteweeghel; 3. Miss Liz Wendelbo)

Anke Loh
(photographs: 1. Frederik Hamelynck; 2. Geert Samon;
3. Anke Loh, model: Susan Hengartner)

Jessica Ogden
(photographs: Ellen Nolan)

Marjan Djodjov Pejoski
(photographs: 1. Mert Alas and Marcus Piggot;
2. Henrik Halversson; 3. Donna Troupe
Graphics: Victoria Magniant)

Jurgi Persoons
(photographs: Ronald Stoops)

Carol Christian Poell
(photographs: 1. Graça Fisher; 2. Stephan Zeisler;
3. Frances Melhop)

Raf Simons
(photographs: 1., 2. Anonymous; 3. Willy Vanderperre)

Olivier Theyskens
(photographs: 1. Pascal Demeester; 2. Ali Mahdavi;
3. Les Cyclopes)

Walter van Beirendonck
(photographs: 1. Ronald Stoops; 2. Jens Boldt;
3. Ronald Stoops)

A.F. Vandevorst
(photographs: Ronald Stoops)

Dirk van Saene
(photographs: Ronald Stoops)

Viktor & Rolf
(photographs: 'Le Regard Noir' - Anuschka Blommers
and Niels Schumm)

Junya Watanabe
(photographs: Junya Watanabe Comme des Garçons)

Bernhard Willhelm
(photographs: Carmen Freudenthal & Elle Verhagen)

With thanks to
Gemeentelijk Havenbedrijf Antwerpen
Rota Panel, Leeuwarden
Elke Segers
Jo Raman
for Claes Tradigital Photolab (Antwerp)

COLOURED LANDMARKS

Design and concept
Walter van Beirendonck with **B-architecten**

Realization and arrangements
Acrotech (Deurne)
Poly-Ned (Wezep)

With thanks to
Monuments and Sites Division - Antwerp
Alcatel (Antwerp)
**Environment and Infrastructure Division - Waterways
and Marine Affairs Administration**
Flanders Fashion Institute (Antwerp)
KBC - Antwerp
MUHKA (Antwerp)
NV Vooruitzicht
Development Compagnie:
**Planting - Municipal Architect's Department -
Preservation of Monuments and Sites - Heritage**
Provinciale Hogeschool Antwerpen
Zur Shamir Belgian Properties (Antwerp)

N°A MAGAZINE

Curator
Walter van Beirendonck

Guest Creator for N°A
Dirk van Saene

Editor-in-chief
Gerdi Esch

Creative Director
Manon Schaap

Art Directors
Paul Boudens
Madeleine Wermenbol

Editorial Coordinator
Ellen Monstrey

Publisher
Gijs Stork, Artimo
Bruno Verbergt, Promotie Antwerpen Open vzw

MERCHANDISING

Artistic Director
Walter van Beirendonck

Coordinator
Ron Deckers, Promotie Antwerpen Open vzw

STAFF

General Coordinators
Bruno Verbergt, Antwerpen Open
Linda Loppa, Flanders Fashion Institute

Business Manager
Steven Warmenbol

General Communications Coordinator
Annette van Soest

PRODUCTION

Production Manager
Dre Demet

Production Manager
2WOMEN: REI KAWAKUBO - COMME DES GARÇONS
Jan Michiels
Assistant Production Manager
Helga Duchamps

Catering Coordinator
Didier Maes

Administrative Assistant
Denise D'Joos

Location Assistants
**Tom Adriaenssens, Sevdet Akgul, Helena Albertyn,
Nicole Battheu, Stephane Bruloot, Sophie Buytaert,
Ken Cauwelaers, Vincent Daelemans, David Daems,
Karin de Bruyn, Nadine de Haes, Siege Dehing,
Edward Dekeyser, Joseph Delme, Dirk den Aantrekker,
Catharina de Smet, Rudi de Troch, Sam Dirickx,
Katya Doms, Guy Donckers, Marc Ghesquiere,
Olivier Giroud, Gerd Hendrickx, Machteld Hermans,
Freddy Hombroux, Tim Ianna, Danny Janssens,
Karen Leemans, Sigrid Lesage, Lea Lodewykx,
Ilse Louwet, Roosmarijn Maes, Sara Morris,
Tony Peeters, Patrik Schellekens, Veerle Segers,
Carla Sleutel, Sylvie Svanberg, Jano Tamamidis,
Erwin van der Cruyssen, Tom Vandijck,
Veerle van Overloop, Tinne van Roy, Els Verbruggen,
David Vereecke, Bert Verhaegen, Saskia Verreycken,
Bart Veulemans, Victor Zaidi**

PRESS AND COMMUNICATIONS

Communications Coordinator FASHION2001
Stany van Wijmeersch

Information Manager
Roos Pauwels

Promotion Manager for Belgium
Hester Wessels

Promotion Manager for international publicity
and press
Stany van Wijmeersch

Assistant PR and Sponsorship
Aafje D'hooghe

Press Office
Géraldine Leus
Nathalie Goethals
Nathalie Pauwels
Heli Siiskonen

Press Agent
Martin Saunier, Pressing (Paris)

Communications Assistant/Website
Rafaëlle Lelièvre

Dispatches
Ian Coomans

Assistant for Dressed Up!
Ralf Nartus

Public Liaison
Roos Pauwels
Rafaëlle Lelièvre
Marijke van Eeckhaut (MUHKA)
Peggy Saey (MUHKA)
Frieda Debooser (MoMu)

Web Coordination and Design
Daniel Hansen
Jeroen van Omme
for Jedha Design (Antwerp)

Video Compiler
Eddie Gregoor

Translators
Gregory Ball
Belgian Translation Centre
Elisabeth Cluzel
Luc Franken
Sabine Reifer

ADMINISTRATION

ICT Coordinator
Koen Bachot

Personnel Officer and Financial Coordinator
Fréderique vander Elst

Accounts
May Geudens
Veerle Daeseleire
Ida van Straten

Management Secretary
Jamila Berraies
Sandra van den Bogaert

Administrative Assistants
Gabrielle van Heulst
Ingrid Claes

Data Management
Lydia Raes
Bruno Decorte

Reception
Iris Smarnakis
Cynthia Storms

Storeman/Driver
Michiel Steensels

Our special thanks to all those who have supported this project

Leona Detiège, Mayor of the City of Antwerp
Eric Antonis, Alderman of the City of Antwerp for Culture, Libraries and the Preservation of Monuments
Baron Leo Delwaide, Alderman of the City of Antwerp for the Port, Diamonds, Economy and Tourism
Hugo Schiltz, Honorary Alderman of the City of Antwerp

Frank Geudens, Deputy of the Province of Antwerp for Cultural Institutions

Patrick Dewael, Minister-President of the Flemish Government and Minister of Finance, Budgets, Foreign Policy and European Affairs
Bert Anciaux, Minister of Culture, Youth, Brussels Affairs, Sports and Overseas Development
Renaat Landuyt, Minister of Employment and Tourism

Guy Verhofstadt, Prime Minister
Rik Daems, Minister of Telecommunications and Government Enterprises and Participation

Ministry of the Flemish Community:
Coordination Department
- Division of Foreign Affairs
Welfare, Public Health and Culture Department
- Visual Arts and Museums Division
Royal Museum of Fine Arts Antwerp

Municipal Port Authority Antwerp
City of Antwerp:
Local Police
Culture and Sport
Technical, Purchasing and Logistics Department
Information and District Work
Telepolis

Antwerp Provincial Authority

Airventure, Deurne-Antwerp
Claes Tradigital Photolab, Antwerp
Fernmoor, corporate fashion partner, Brussels
ModeNatie nv
Modular Lighting Instruments, Roeselare
SET bvba, Aartselaar
ShowBox Interactive, Antwerp
Vidi-Square, Zandhoven
XL Video, Gits

We would also like to thank everyone who has helped us during the preparation of **FASHION2001 LANDED**

Martine Baeten
Nele Bernheim
Flor Bex
Dirk Bikkembergs
Boudewijn Binst
France Borel
Patrick de Groote
Ann Demeulemeester
Sandra Demilliano
Els de Palmenaer
Carl Depauw
Chris Dercon
Paul Devijlder
Denis Dujardin
Tania Fierens
Martin Franck
Eddie Gregoor
Robyn Healy
Takeji Hirakawa
Elke Hoste
Paul Huvenne
Lou Iacovelli
Dirk Imschoot
Stephen Jones
Lodewijk Joye
David Maenhout
Benoît Méliard
Gerda Mesker
Eddy Michiels
Eiko Myamoto
Ghislaine Nuytten
Loretta Perico
Anja Revenda
Etienne Russo
Peggy Saey
Aminata Sambe
Anouk Sendrowicz
Raf Simons
Valerie Steele
Jan van Alpnen
Ernest van Buynder
Paul Vandenbroek
Nico Vandevorst
Marijke van Eeckhaut
Dries van Noten
Erik Verdonck
Katleen Verjans
Gustaaf Verswijver
Veerle Windels

FLANDERS FASHION INSTITUTE

TEAM
Linda Loppa
Gerdi Esch
Dirk van den Eynden
Patrick de Muynck
Geert Bruloot
Mieke Janssens
Iris de Rijcker

BOARD OF DIRECTORS
Marc Francken, chairman
Linda Loppa, deputy chairman
Annik Bogaert
Geert Bruloot
Luc Dheedene
Peter Galliaert
Jo Rogiest
Isabelle Santens

ANTWERPEN OPEN

COORDINATION
Bruno Verbergt
Steven Warmenbol
Annette van Soest
Patrick de Groote (Zomer van Antwerpen)

BOARD OF DIRECTORS
Leona Detiège, chairman of the board and member of the management committee
Eric Antonis, deputy chairman of the board and member of the management committee
Joseph Asselbergh, member of the management committee
Annik Bogaert, member of the management committee
Baron Leo Delwaide
Johan de Muynck
Luc Meurrens
Fred Nolf
Erwin Pairon
Wilfried Patroons
Dirk Snauwaert
Maurice Velge

176 **FASHION2001 LANDED #2**

Editors
Walter van Beirendonck
Luc Derycke

Executive Editors
Luc Derycke
Ronny Gobyn

Assistant Editor
Timothy Stappaerts

Production
Luc Derycke & Co., Ghent
Tijdsbeeld, Ghent

Graphic Designer
Paul Boudens

Photographers
Elisabeth Broekaert
Kurt de Wit
Bert Houbrechts
Lieven Segers
Ronald Stoops
Wim Wauman

Author
Chris Dercon, Director
of the Boijmans Van Beuningen Museum, Rotterdam

Text Editors
Petra Gunst (Dutch)
Natascha Langerman,
in collaboration with **Denis Laurent** (French)
Lesley Levene (English)

Translations
Marie Beaumond (Dutch-French)
Karie L. Kindl (Japanese-English,
in **FASHION2001 LANDED #1**)
Alison Mouthaan (Dutch-English)

Lithography
Die Keure, Bruges

Printer and Binder
Die Keure, Bruges

Distributor
Exhibitions International, Leuven

ISBN 90-6917-007-8
D/2001/7852/10

MERZ is a joint imprint of
Luc Derycke & Co., Marot and **Tijdsbeeld**,
and is open to other publishers.